we are paper toys!

PRINT-CUT-FOLD-GLUE-FUN!

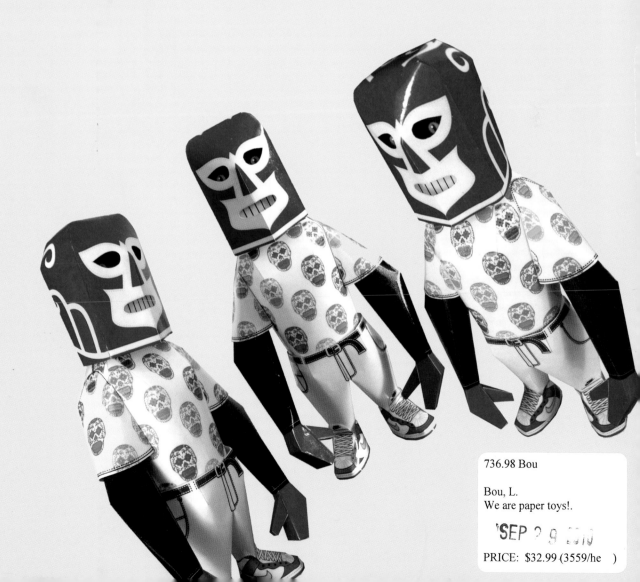

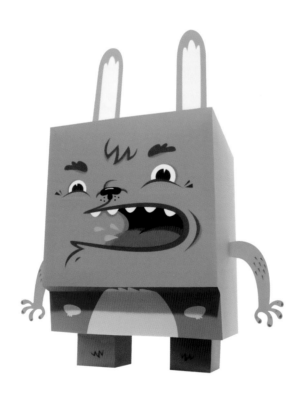

we are
paper toys!

LOUIS BOU

PRINT-CUT-FOLD-GLUE-FUN!

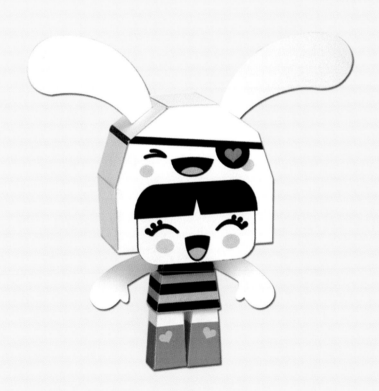

COLLINS DESIGN

An Imprint of HarperCollins Publishers

First published in 2010 by
Collins Design
An *Imprint* of HarperCollins*Publishers*
10 East 53rd Street
New York, NY 10022
Tel: (212) 207-7000
Fax: (212) 207-7654
collinsdesign@harpercollins.com
www.harpercollins.com

Distributed throughout the world by
HarperCollins*Publishers*
10 East 53rd Street
New York, NY 10022
Fax: (212) 207-7654

Editor
Josep Mª Minguet

Author, art direction, text, and layout
Louis Bou Romero
for Monsa Publications

Translation
Globulart

Library of Congress Control Number 2010923731

ISBN: 978-0-06-199512-5

Printed in Spain
First Printing, 2010

Page 01: Paper toy by Cubotoy.
Page 02: Paper toy by Tougui.
Page 03: Paper toy by Charuca.
Page 04: Paper toy by Dolly Oblong.
Page 05: Paper toy by Pep Sanabra.
Page 06: Paper toy by Kamimodel.
Page 208: Paper toy by Custom Papertoys.

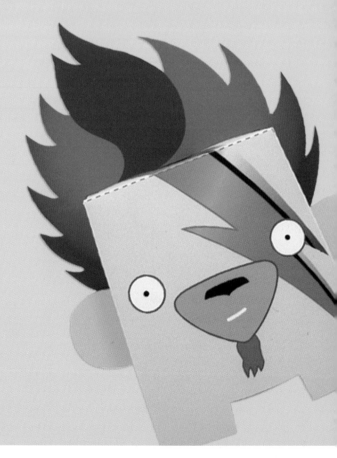

introducing paper toys! 06

custom papertoys 08

oh-sheet papertoys 20

paul shih 24

mycryptonauts 30

horrorwood 34

marshall alexander 42

badstarz 50

faisal azad 54

mundosopa! 58

kamimodel 64

loulou & tummie 70

tougui 78

kenn munk 84

shin tanaka 88

ivan ricci 96

sjors trimbach 104

dolly oblong 110

mau russo 126

creaturekebab 132

thunderpanda 138

cubotoy 142

rememberthelittleguy 152

nanibird 156

dadik triadi 162

harlancore 170

charuca 176

pep sanabra 180

dmc 184

jerom 192

macula 196

3eyedbear 200

cubeecraft 204

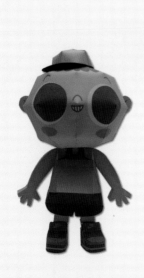

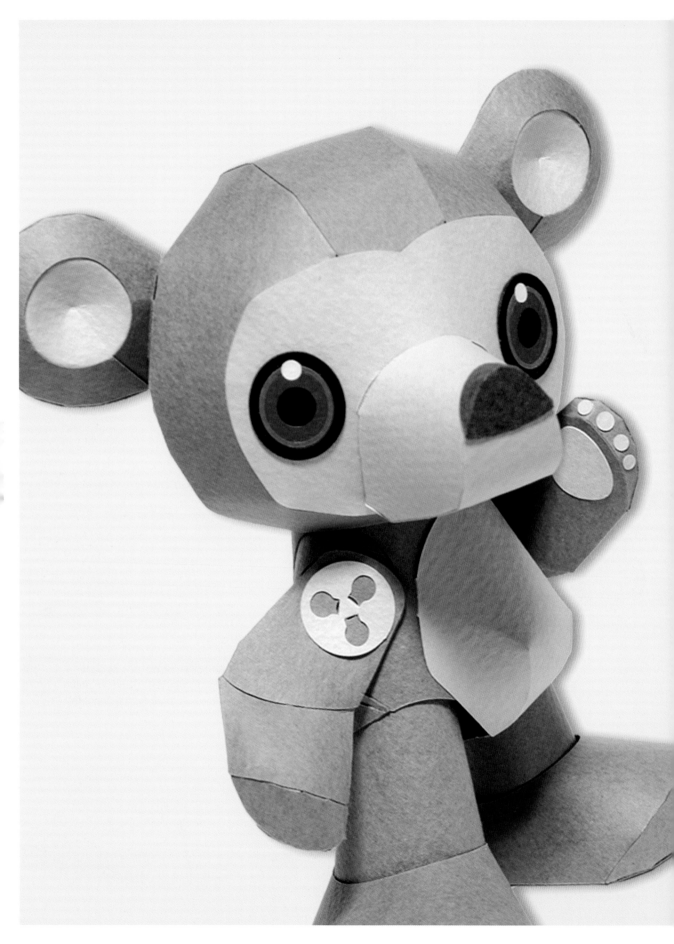

PAPER. YES, WE ARE!

Paper toys have conquered the hearts of millions of Internet users all over the world. Never before has art been so easy to do: Designers and artists create amazing paper toy templates, which they then share for free on their own Web sites and blogs. Fans download these templates and using a few basic tools—paper (that's a given), an Internet connection, printer, scissors, glue, and just a little patience—assemble these wondrous toys.

The thrilling part of the process is watching a sheet of paper transform into a three-dimensional object that's as creative as you want it to be. The cost to make them is laughable, and the ruling idea is very simple: Do it yourself!

Creators of paper toys come from the world of graphic design, graffiti, and illustration, and one of the most interesting aspects of this trend is the collaboration between artists from all over the world. Artists share their blank templates with other artists, who customize them, adding their own style to an individual paper toy. Matthew Hawkins, one of the most renowned makers of paper toys, sums up the philosophy of paper toy design in a simple and direct fashion: "It's very democratic! Anyone, anywhere on the planet with a little time to waste, can own one of my toys."

Paper toys are en vogue. Best of all, they are yet another way for artists to promote their creations; akin to a homemade advertising campaign, their creations are distributed freely and without boundaries through the Internet, with the outreach and magnitude it carries.

Anyone anywhere in the world can take part in the creation of paper toys, from the artists who design them to the fans who build them. This do-it-yourself dynamic of the movement encourages fans to become artists and vice versa.

We Are Paper Toys! presents thirty-two of the finest paper toy designers in the world. Each artist gives us a glimpse of their world and explains their passion for paper toys through a personal interview. ˙

The book includes a CD with PDF templates of some of the paper toys showcased in this book. They are ready to be printed, cut, and pasted so you can have these small works of art in your own home. It's never too soon to start cutting, folding, pasting and, above all, having fun!

Louis Bou

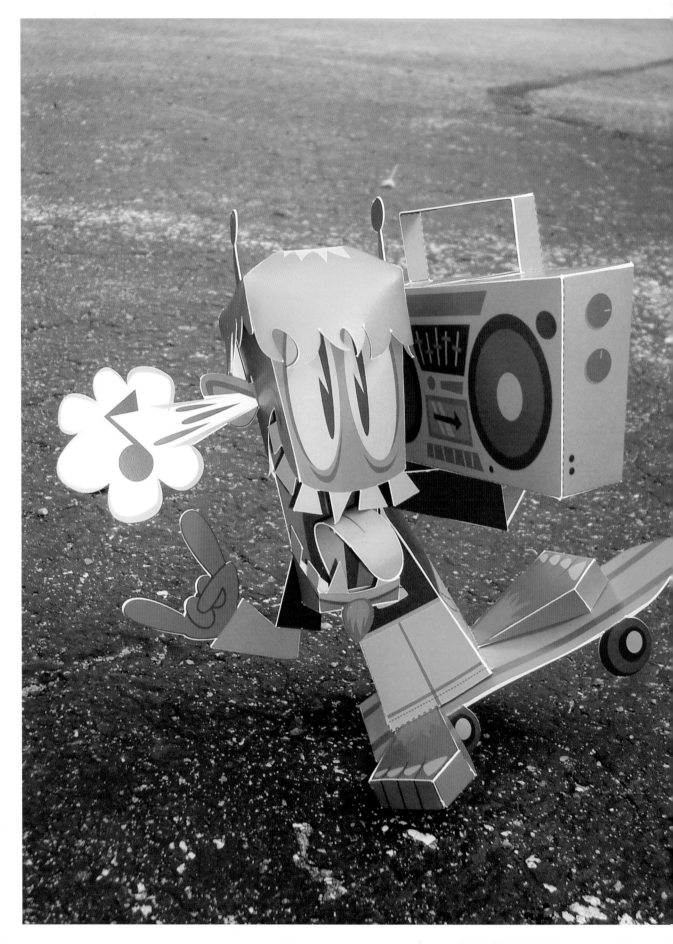

custom papertoys

www.custompapertoys.com
USA

"I just love to create, to make things with my hands. I love to challenge myself both creatively and technically, and paper toys provide that. I find it thrilling when a technical hurdle is cleared in the pursuit of a creative idea. Also, I really enjoy sharing my work and passion with others. Paper toys are a great medium for what I want to do as an artist: create, share, and grow. I've been into toy design for a long time, and paper offered me a great way to make the toys I wanted to make, and an amazing way of distributing them to those who like them. It's really democratic! Anyone, anywhere on the planet, with a little time to spare, an Internet connection, and a printer can own one of my toys. I love that building the toy requires the participation of the collector. They are basically the ones who bring my work to life, they take part in the creative act, and create a really unique bond. You just can't get that from buying a chunk of plastic made in a factory overseas, placing it on a shelf and letting it gather dust. It's so satisfying for me, being able to design toys and bringing them to life with my own hands. No factories, toxic chemicals, low-wage labor, shipping, worries about whether it will sell or not–after all, it's just paper. Good old paper, so humble, yet remarkable. And, at the end of the day, it remains a recyclable and biodegradable object. Plus there is just something truly magical about a flat piece of paper forming a 3-D object, wouldn't you agree? Paper to the people!"

This page:
BUCK SHOT
Paper toy.

Opposite:
OLIVER OLLIE
Exclusive paper toy for *Urban Paper* book.

All artwork by Custom Papertoys. All images courtesy of Matthew Hawkins.

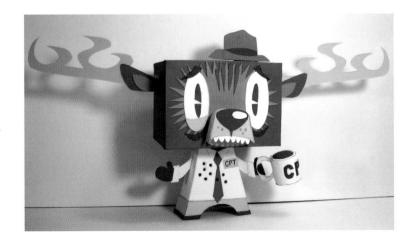

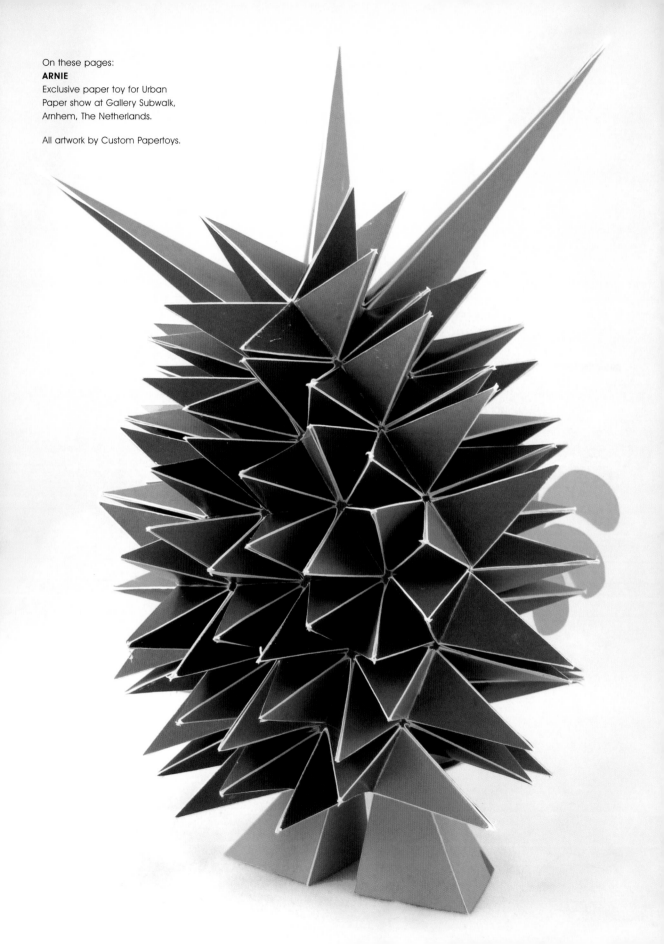

On these pages:
ARNIE
Exclusive paper toy for Urban
Paper show at Gallery Subwalk,
Arnhem, The Netherlands.

All artwork by Custom Papertoys.

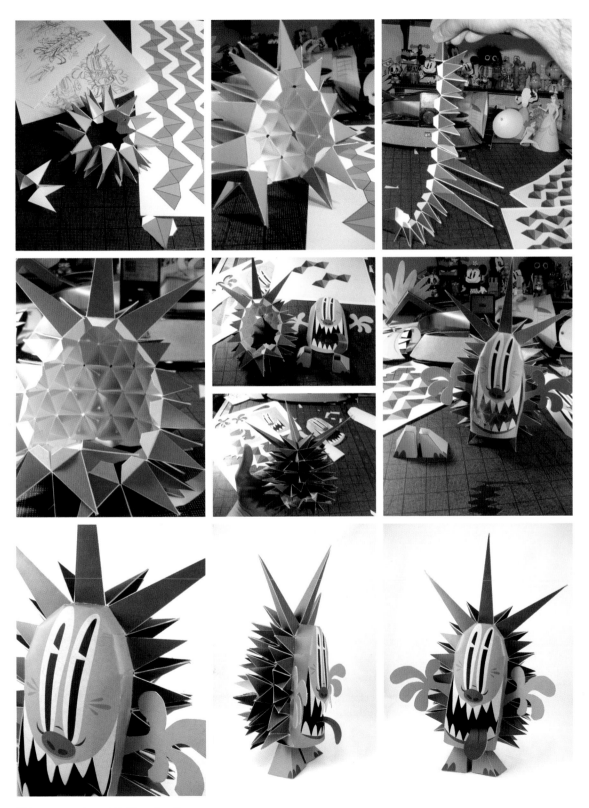

All images courtesy of Matthew Hawkins.

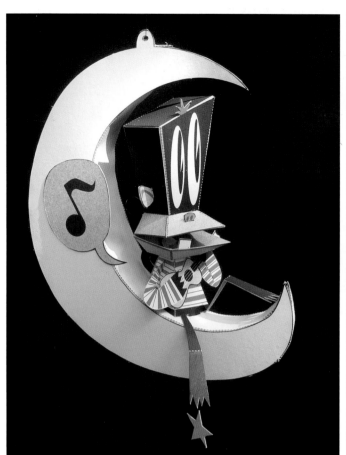

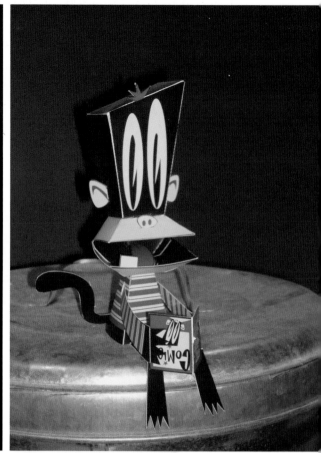

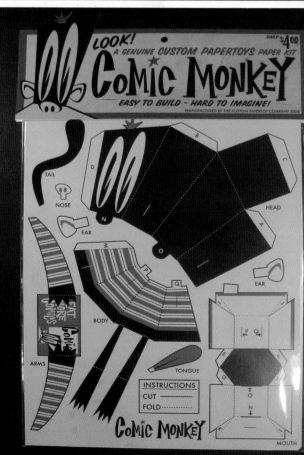

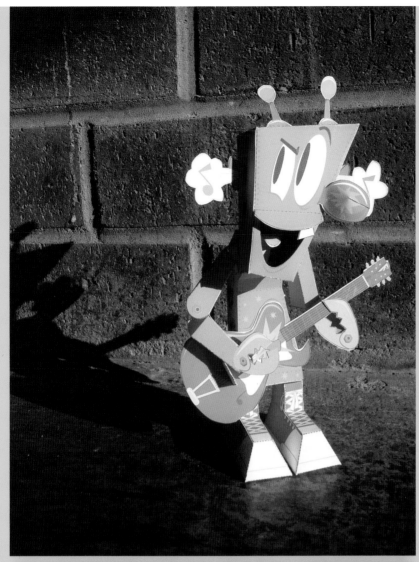

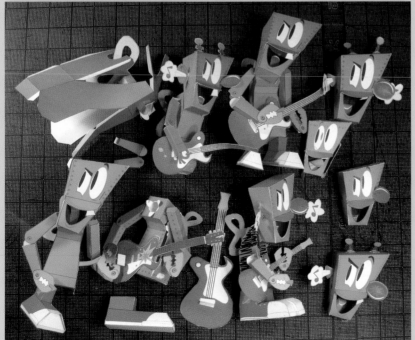

This page, top:
MR. ROBOT
Prototypes and studies.
Bottom:
MR. ROBOT
"Mr. Robot is my first paper automata.
Turn the key in his back and his head
rocks back and forth and his arms and
hands move to play guitar."

Opposite:
ONLY A PAPER MOON
Template and paper toy.
LOOK! COMIC MONKEY
Template and paper toy. Includes
a miniature eight-page comic.

All artwork by Custom Papertoys.

This page, clockwise from top:
BARK 'N' HONK
Paper toy collaborated with
illustrator Elio.
www.eliohouse.com
WILD URP
Paper toy.
BASALISK
Paper toy.

Opposite:
WILD URP
Paper toy.

All artwork by Custom Papertoys.
All images courtesy of Matthew
Hawkins.

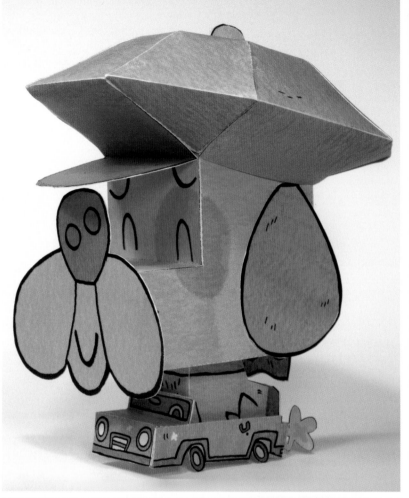

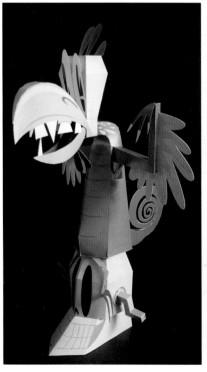

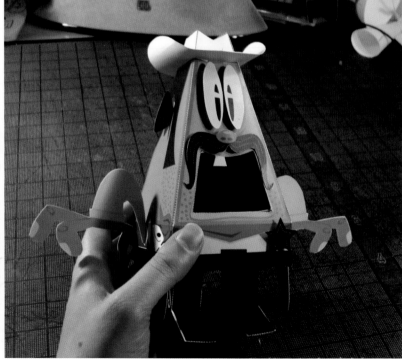

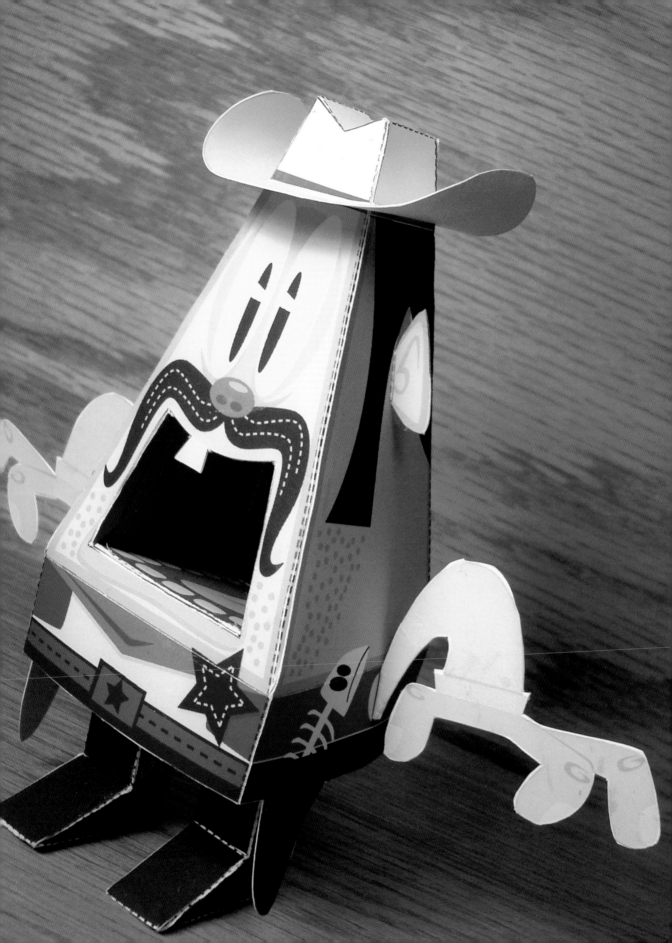

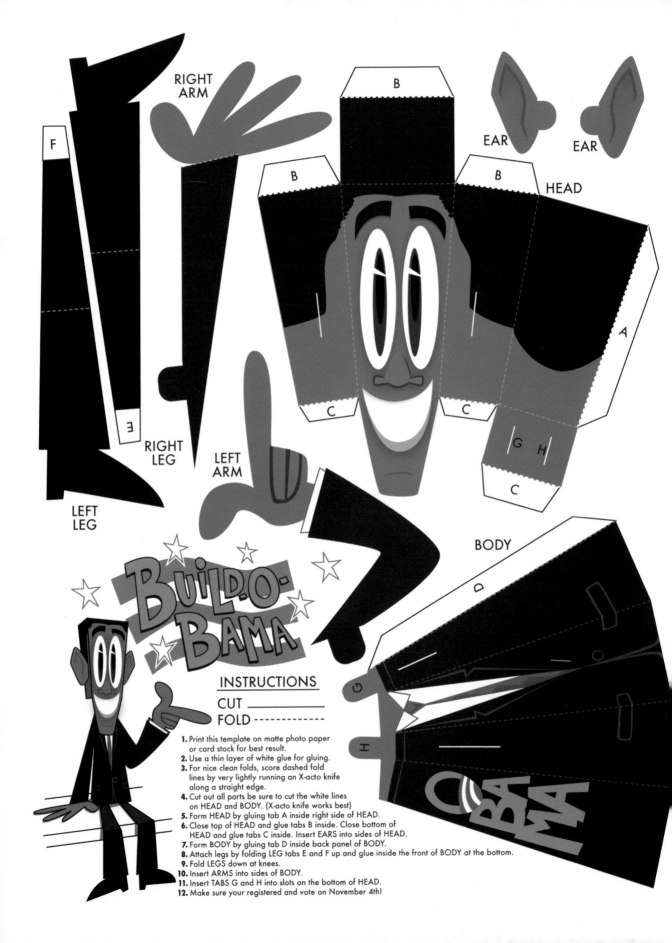

RIGHT ARM

F

EAR

EAR

HEAD

B

B

B

A

C

C

G H

RIGHT LEG

E

LEFT ARM

C

LEFT LEG

BODY

D

G

H

BUILD·O· BAMA

INSTRUCTIONS

CUT ————————
FOLD ------------

1. Print this template on matte photo paper or card stock for best result.
2. Use a thin layer of white glue for gluing.
3. For nice clean folds, score dashed fold lines by very lightly running an X-acto knife along a straight edge.
4. Cut out all parts be sure to cut the white lines on HEAD and BODY. (X-acto knife works best)
5. Form HEAD by gluing tab A inside right side of HEAD.
6. Close top of HEAD and glue tabs B inside. Close bottom of HEAD and glue tabs C inside. Insert EARS into sides of HEAD.
7. Form BODY by gluing tab D inside back panel of BODY.
8. Attach legs by folding LEG tabs E and F up and glue inside the front of BODY at the bottom.
9. Fold LEGS down at knees.
10. Insert ARMS into sides of BODY.
11. Insert TABS G and H into slots on the bottom of HEAD.
12. Make sure your registered and vote on November 4th!

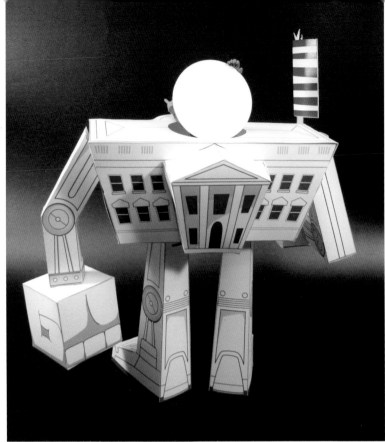

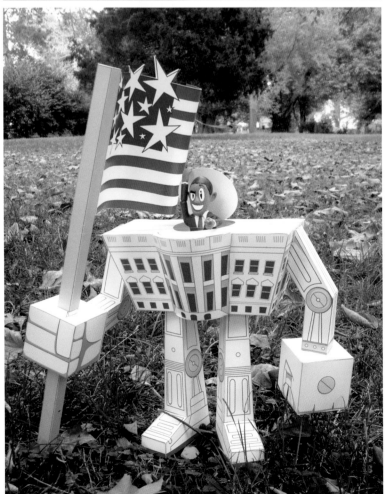

This page:
OBAMA ACTION PLAYSET
Custom-made plastic toy of
Jailbreak Toy's Obama action figure
in paper White House. Done for the
Art+Action show in New York City.

Opposite:
BUILD-O-BAMA
Template.

All artwork by Custom Papertoys.

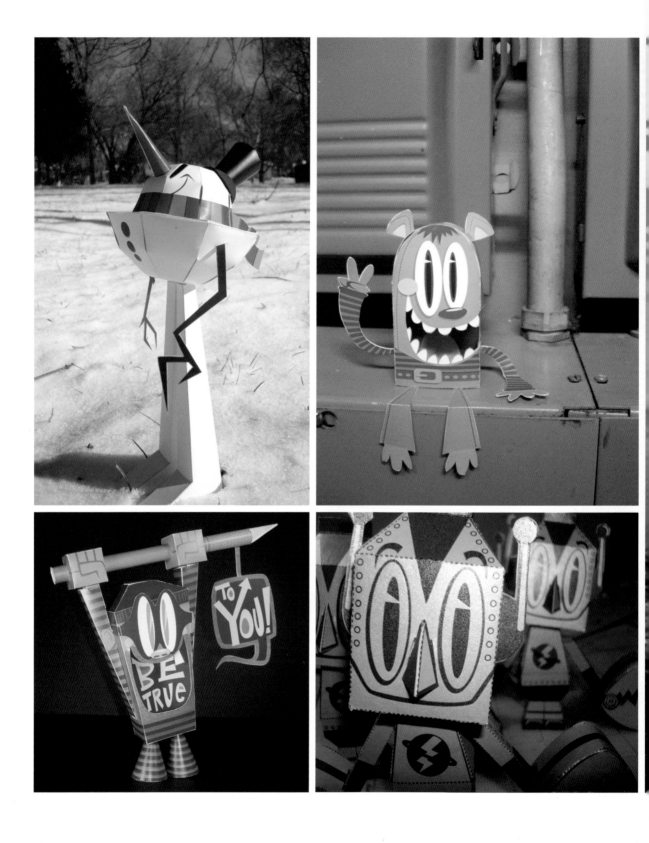

Opposite, clockwise from top left:
SNO MOE
SELF SITTER BEAR
MECHANICAL MAN
BE TRUE TO YOU
Paper toys.

This page:
SPLODEY
Paper toy and template.

All artwork by Custom Papertoys.
All image courtesy of Matthew Hawkins.

ASSEMBLY INSTRUCTIONS

1. Print this template on matte photo paper or card stock
2. Use a thin layer of white glue for gluing
3. For nice clean folds, score dashed fold lines by very lightly running an x-acto knife along a straight edge
4. Check local regulations and laws to make sure use of papertoys is not prohibited in your area
5. Glue "HEAD CONE" around into cone shape
6. Be sure to cut "ARM" slots in "BODY" and glue into cylinder shape. Fold tabs A out.
7. Fold tab B in, even with bottom of "BODY" and fold wick down
8. Put glue on white side of tabs A and glue "BODY" inside of "HEAD CONE "
9. Fold "STICK" into a square tube. Place glue on long tab and fold tube flat so you can press it flat to glue tube together and then pop it out into a tube
10. Glue "STICK" into inside of "BODY" where marked.
11. Insert "RIGHT ARM" and "LEFT ARM" into slots on "BODY"

SPLODEY
PAPERTOY BOTTLE ROCKET

DESIGNED AND DISTRIBUTED BY CUSTOMPAPERTOYS.COM

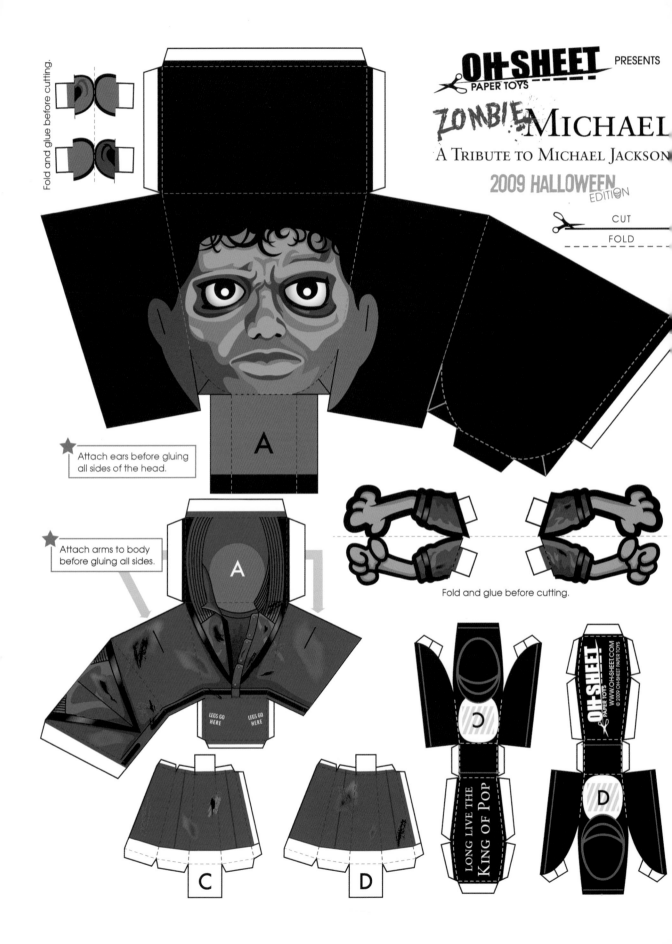

oh-sheet paper toys

www.oh-sheet.com
Hawaii
USA

"I love how versatile paper is. It can be drawn on, painted on, printed on, and transformed into any shape you can imagine. With an idea and some experimenting, you can breathe life into what is essentially a blank canvas. This is what makes paper toys so great–the transformation of one shape into another. What's also interesting is the collective nature of paper toys. They're not restricted to just one person. Everyone has the opportunity to participate in their creation, from the artist who designs the toy to the fan who builds it. Sometimes fans become artists and artists become fans. That's when the paper toy becomes more than just a vehicle for creativity, but for exchange–the exchange of ideas, cultures, even friendship."

This page:
ZOMBIE JACKSON
WEREWOLF JACKSON
Tribute paper toys to
Michael Jackson.

Opposite:
ZOMBIE JACKSON
Template.

All artwork by Oh-Sheet.
All images courtesy of
Abigail Braceros.

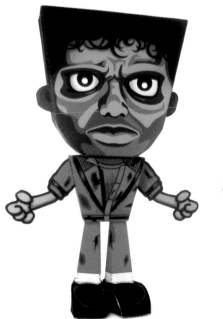

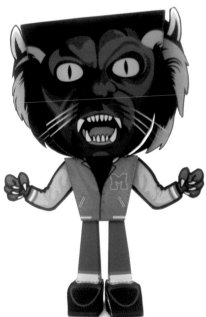

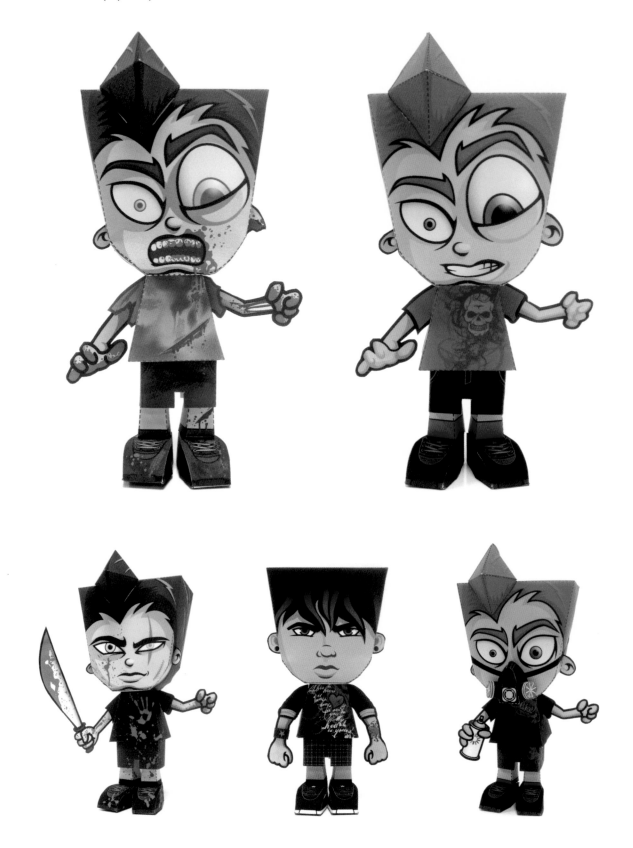

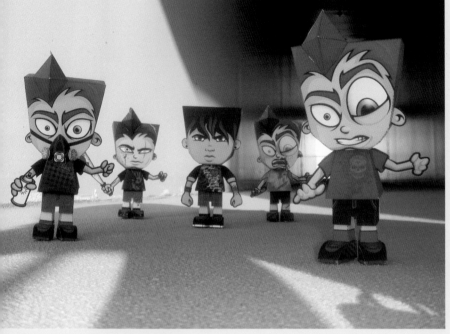

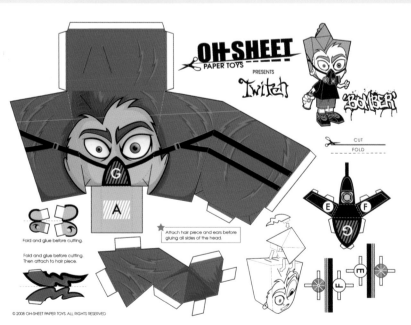

This page, top row, left to right:
TWITCH
Sketch, vector illustration,
and first mockup.
Middle row:
TWITCH SERIES GROUP
Bottom row:
TWITCH BOMBER
Original template.

Opposite, clockwise from top left:
DEAD HEAD
TWITCH
TWITCH BOMBER
XANDER
SLASHER
Paper toys.

All artwork by Oh-Sheet.
All images courtesy of
Abigail Braceros.

paul shih

www.paul-shih.com
www.hollowthreat.com
NZ/TW

"I love paper toys! I believe it has always been my calling. I've been collecting collected toys since I was a kid, and never stopped hunting for cool new toys; one of my dreams was to see my characters in 3-D form some day. As an artist, I think we all try hard to live our own dreams, so I'm constantly looking for ways to make toys. Obviously, the easiest way and the most accessible medium is paper! My first paper toy was Big-Foot, back in 2006, and the design was created as an aid for a paper diorama I did back then; it also served as a small tribute to the mythic creature called Sasquatch. The great thing about paper toys is that they are really easy to obtain; you don't need a credit card or to travel anywhere to buy them. When I uploaded my Big-Foot toy to my Web site, I asked the downloader to participate in my Big-Foot Exists Project; all they had to do was to build the toy and send a photo of the Big-Foot taken in their area, and I've been getting photos from all over the world, "sightings" of Sasquatch! I really enjoy the interaction between paper toys and those who download them. It's something regular toys can never provide; paper toys not only make me feel closer to those who like my creation, they also bring artists together. TNES and I put together the "T-Wrecks" paper toy template in '07. We invited some of our friends and favorite artists to customize it, and the outcome was mindblowing. You never know what you will get. There are just endless possibilities for paper toys."

This page:
BIG-FOOT
Character designed
by Paul Shih.

Opposite:
BIG-FOOT
Paper toy.

All artwork by Paul Shih.
All images courtesy
of Paul Shih.

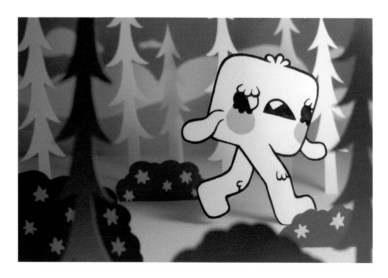

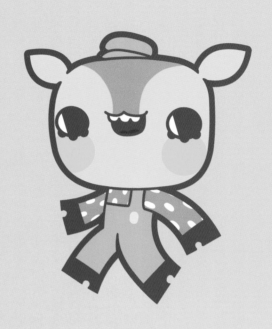

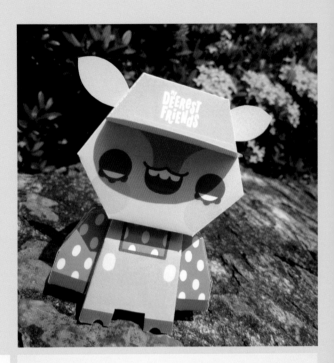

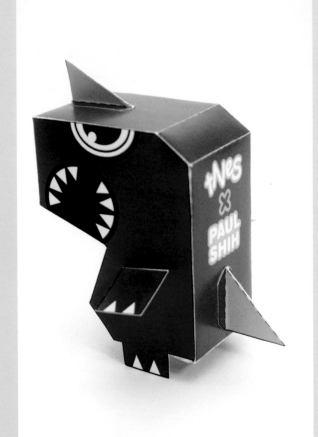

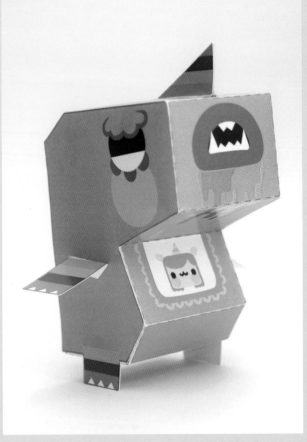

This page:
RAINBOW KAIJU
Digital artwork by Paul Shih.

Opposite, clockwise from top left:
CAPKIDS
My Deerest Friends edition
(digital artwork).
CAPKIDS
My Deerest Friends edition, template
by Grooph, and customized by
Paul Shih.
T-WRECKS
Rainbow Kaiju Edition, template by
Grooph and customized by Paul Shih.
T-WRECKS
Template by TNES and Paul Shih.
Customized by Paul Shih.

All artwork by Paul Shih.
All images courtesy of Paul Shih.

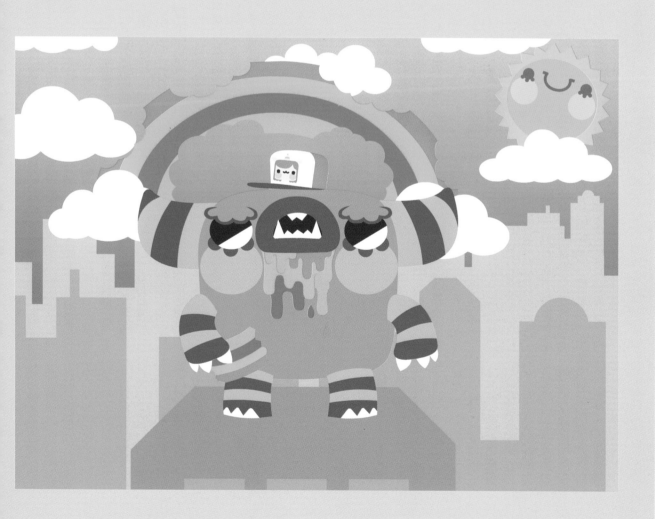

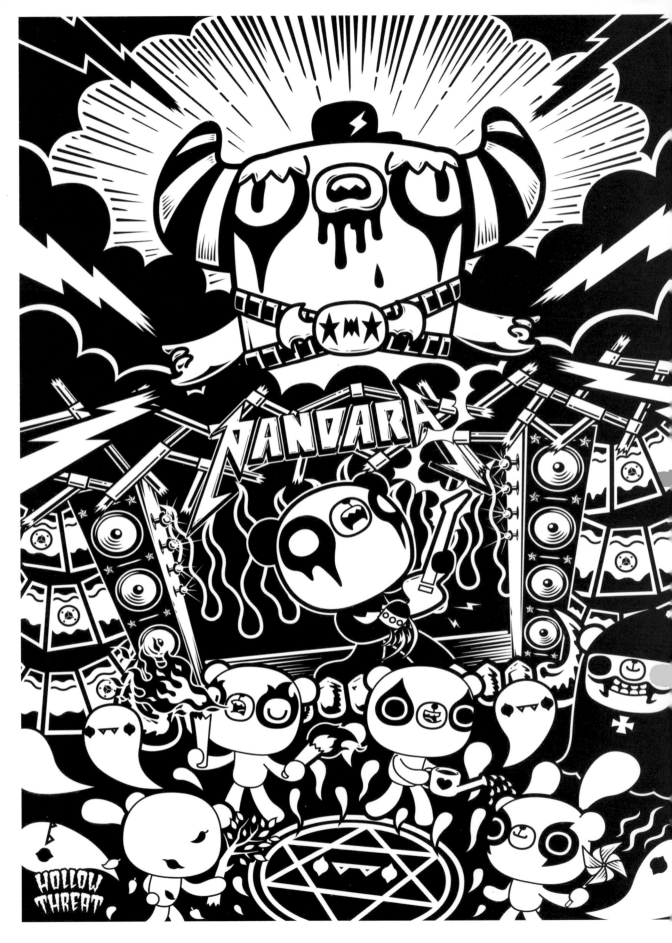

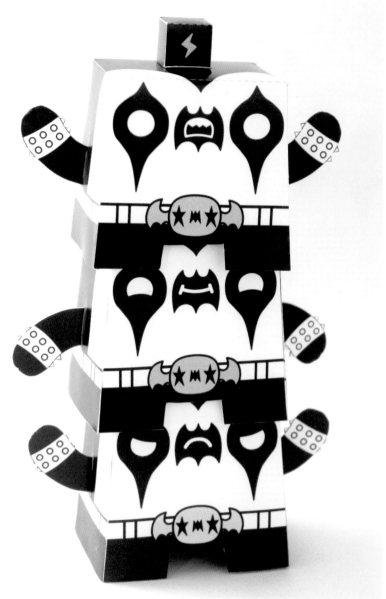

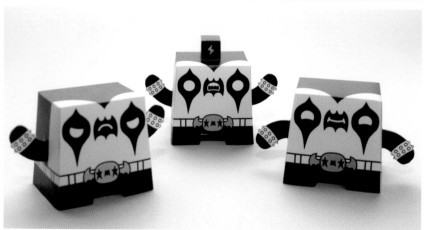

This page:
PAPER TOTEM
Hollow Threat edition, template
by Dolly Oblong, and customized
by Paul Shih.

Opposite:
HOLLOW THREAT
Digital artwork by Paul Shih.

All artwork by Paul Shih.
All images on these pages courtesy
of Paul Shih.

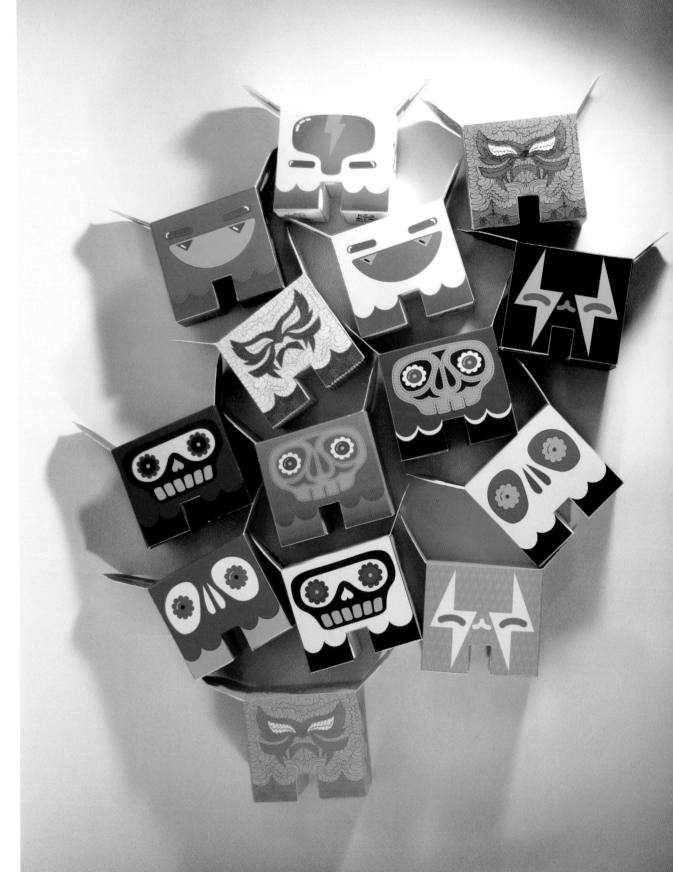

my cryptonauts

mycryptonauts.com
Honolulu
HI

"I love paper toys because paper in itself is one of the most accessible mediums that can be used to create something that's fun and enjoyable for yourself and others without having to spend a small fortune. Paper toys level the playing field in a consumer-based world of vinyl toys and plush dolls. I'm not saying that you shouldn't adopt one of my Cryptonauts, but the idea of being able to just grab a piece of paper and make a toy out of it says a lot about one's imagination and resourcefulness."

This page:
CRYPTOPAPER
Template.

Opposite:
CRYPTOPAPER TOYS
Various Cryptopaper toy designs.

All artwork by myCryptonauts. All images courtesy of Aaron Lee.

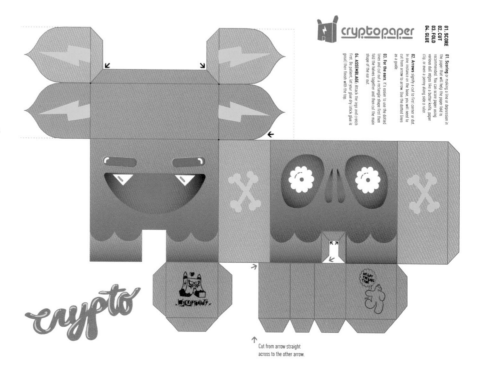

Cut from arrow straight across to the other arrow.

EYE
LOVE
PAPER
TOYS!

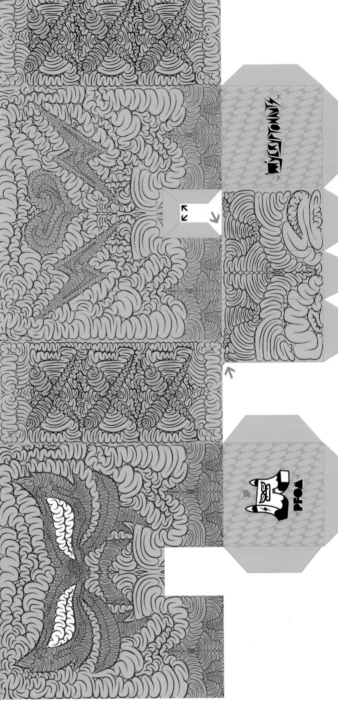

cryptopaps

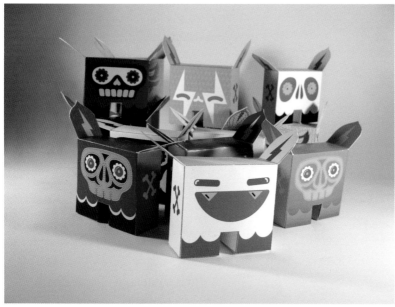

This page, top row:
CRYPTOPAPER
Various Cryptopaper toy designs.
Middle row:
SKETCHBOOK
Artist's sketchbook.
MYCRYPTONAUTS
Plush toys.
Light graffiti photo by www.honozooloo.com
Bottom row:
MYCRYPTONAUTS PLUSHIES
Plush toys series.

Opposite:
CRYPTOPAPER
Template and schematic of underlying toy construction.

All artwork by Aaron Lee.
All images courtesy of Aaron Lee.

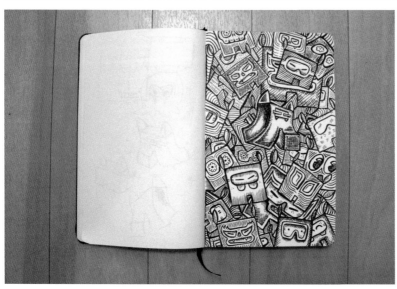

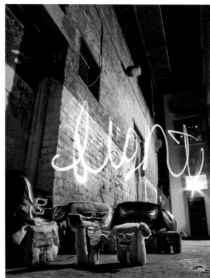

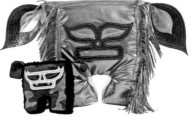

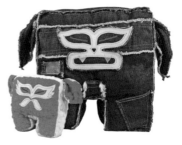

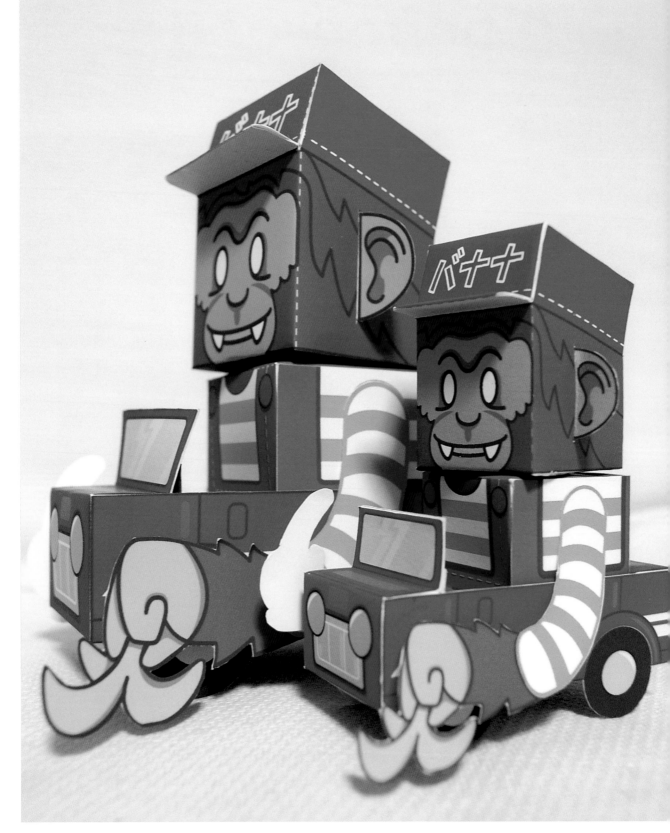

horrorwood

www.horrorwood.info
JAPAN

"Well, I love toys and I love illustration, and paper toys are a natural fusion of the two. I have always wanted to create three-dimensional objects, ideally my own toys, but my crafting skills are very limited. Therefore, paper craft gave me the means to turn my two-dimensional ideas into real world products with ease. I create most of my illustrations digitally, so shifting to creating templates for paper craft was not so hard. Paper craft is great because it brings together art, design, and craft, so I get to do all these things at once. Some time ago, I designed my first paper toys and made them available for download on my Web site. I started getting very positive feedback, after which I decided to put all of my energy into producing papercraft, and haven't looked back ever since. This is another great thing about working with paper. Thanks to the Internet, you can now easily distribute your artwork to people all around the world. Not only that, but people end up with a physical object in their hands. I can't think of any other medium that works quite like this. Unknowingly, I have found myself in the middle of a real paper boom. A couple of years ago, the papercraft scene began to explode globally, and the community is growing day after day. Everyone collaborates and communicates, and there is a constant flow of activity and new projects. This is a really exciting time to be a paper artist."

This page:
SKETCHBOOK
Original concept sketch for Go Bananas.

Opposite:
GO BANANAS AND
JUMBO GO BANANAS
Paper toys.

Designed by Horrorwood. All images courtesy of Jack Hankins.

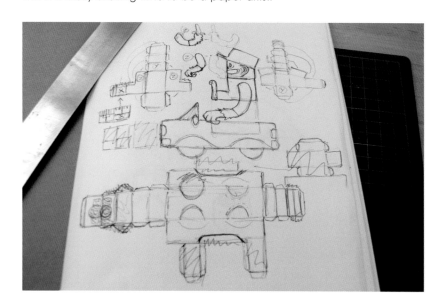

This page. top:
GO BANANAS AND
JUMBO GO BANANAS
Paper toys.
Bottom:
GO BANANAS AND
LONG PAW OF THE LAW
Paper toys.

Opposite:
GO BANANAS
Completed paper toy
and template.

All artwork by Horrorwood.
All images courtesy of Jack Hankins.

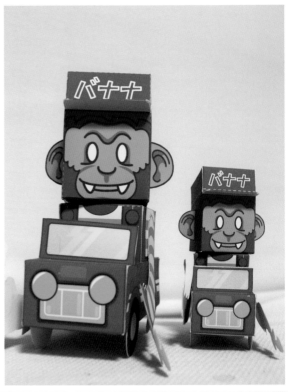

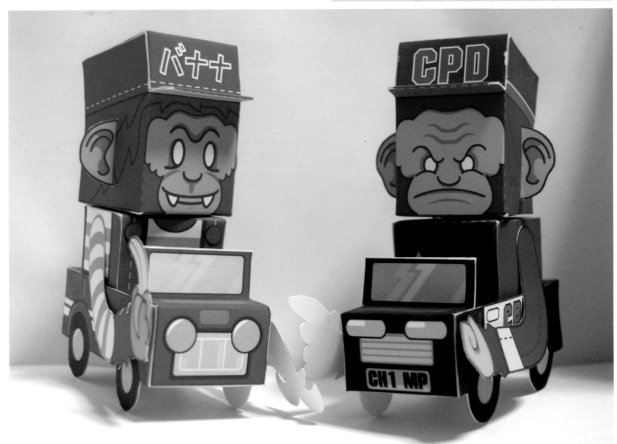

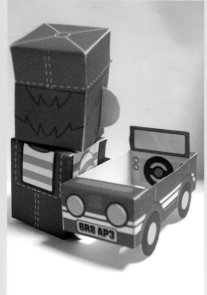
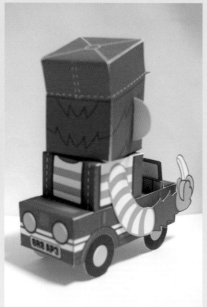
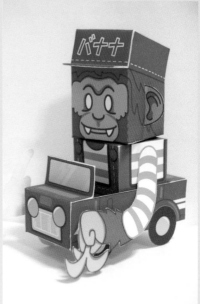

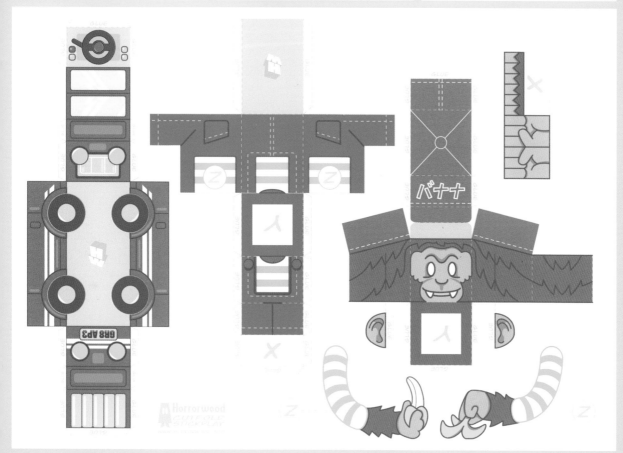

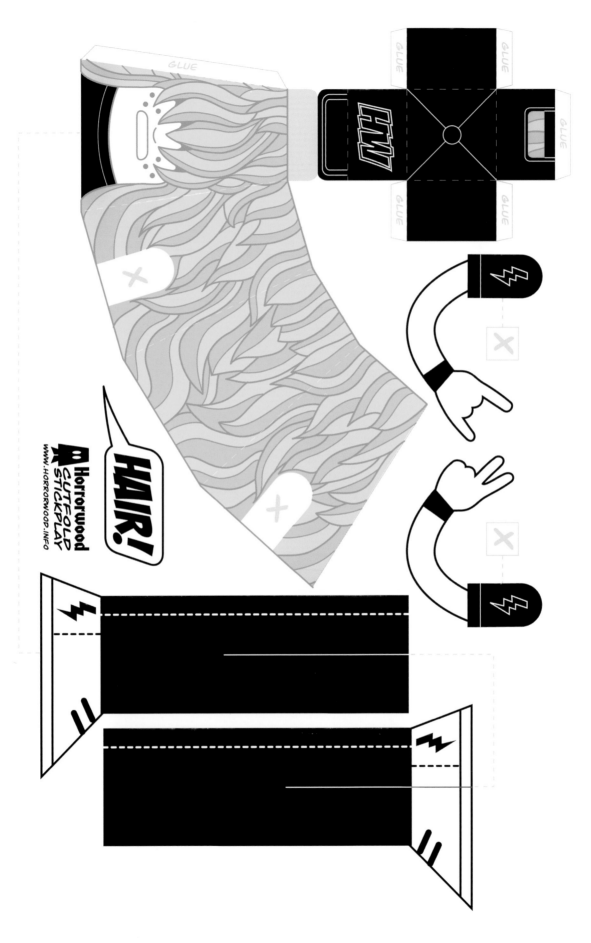

This page:
HAIR
Paper toy.

Opposite:
HAIR
Template.

Designed by Horrorwood.
All images courtesy of
Jack Hankins.

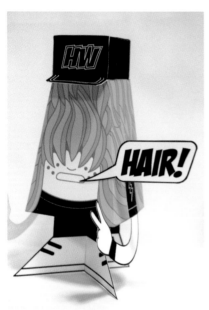

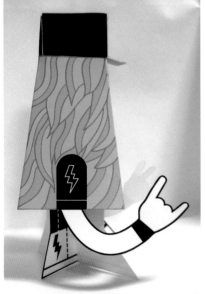

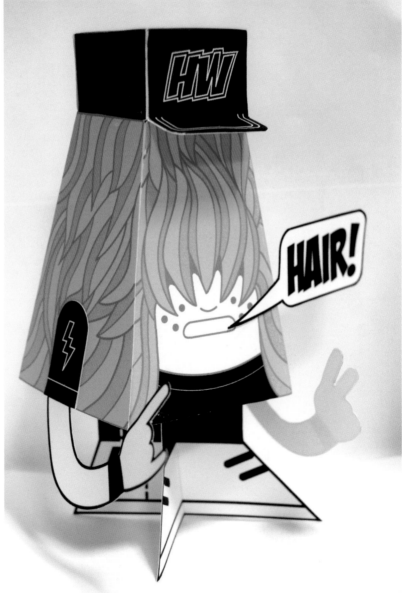

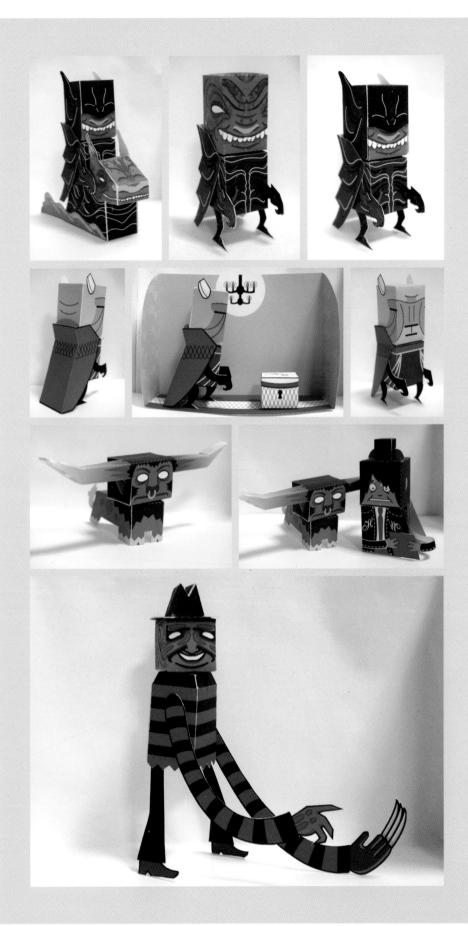

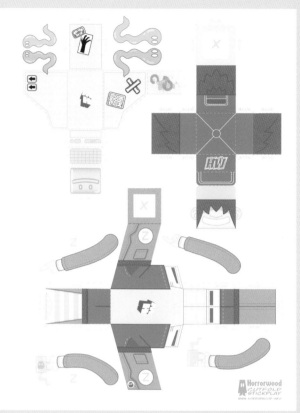

This page:
GHOSTS IN THE MACHINE
Template and paper toy.

Opposite, first row:
DARK LORD AND STEED
Paper toys.
Second row:
PAPER DEMON
Paper toy.
Third row:
TORO OSCURO
Paper toys.
Fourth row:
BAD DREAM ON BIRCH STREET
Paper toy.

All artwork by Horrorwood.
All images courtesy of
Jack Hankins.

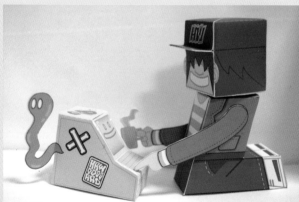

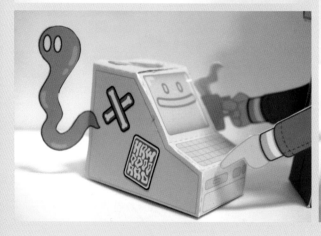

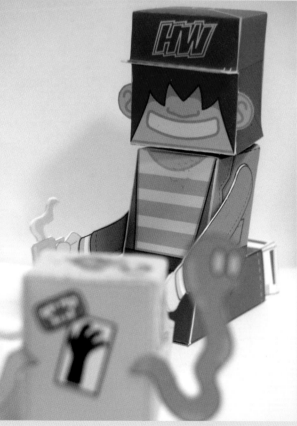

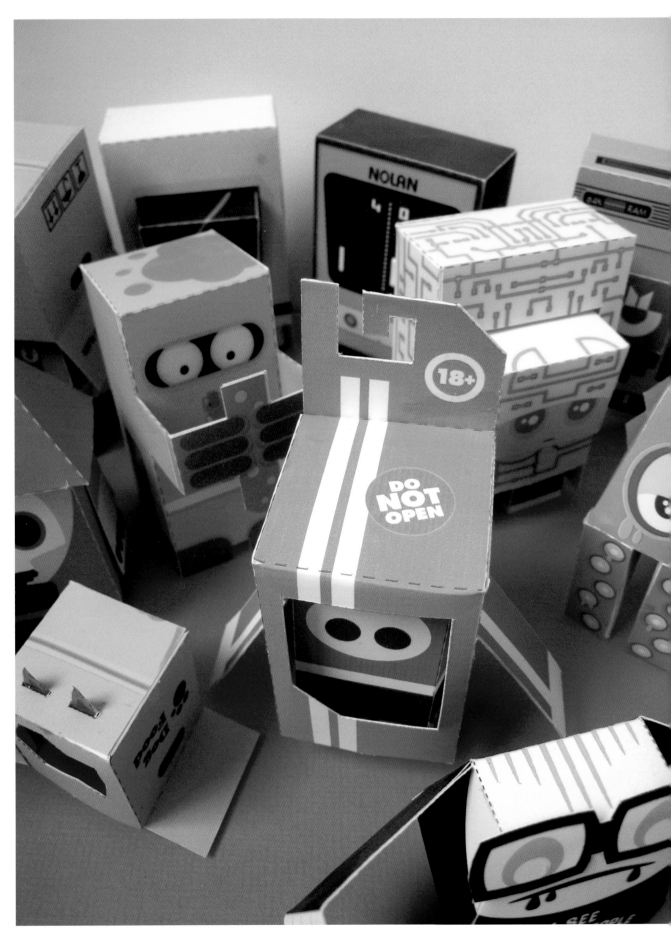

marshall alexander

www.marshallaelxander.net
THE NETHERLANDS

"I like how paper toys create extra interaction between you and your audience. Regular illustration work is consumed rather passively and sometimes gets lost in the chaos of visual information people have to process these days. With paper toys, you need to actively become part of it in order to appreciate it. What I want to achieve is making people look at one of my flat templates and wonder how the hell it is going to turn into this 3-D character. And then, hopefully, they will feel the desire to build the model so they can find out how it is done, be surprised by the process. It becomes a very tactile experience. Another attractive part is how easily you can distribute your work and the relatively simple setup you need to work with the materials. I design my models at the kitchen table and with one click of the mouse they're suddenly available to millions of people around the world. Finally, I think one of the aspects that makes paper toys so special is the whole customization scene, where paper toy designers release blank models for others to customize. This isn't just a great way for newcomers to get some hands-on experience in paper today design, but it's also an amazing opportunity for already established artists who traditionally work on flat surfaces to see these models as an exciting new canvas on which to express their work. This has resulted in some fantastic collaborations. The paper toy scene is a very active and open community that welcomes everyone who wants to give it a try."

This page:
MACHO MECHA
Paper toy.

Opposite:
PAPER TOYS

All artwork by Marshall Alexander. All images courtesy of Marshall Alexander.

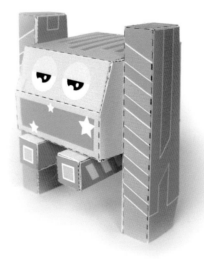

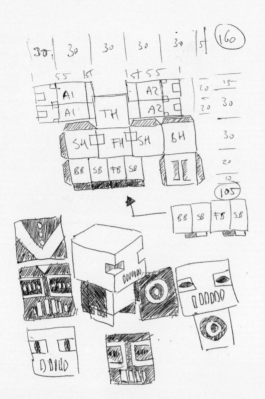

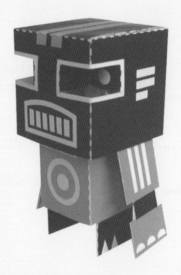

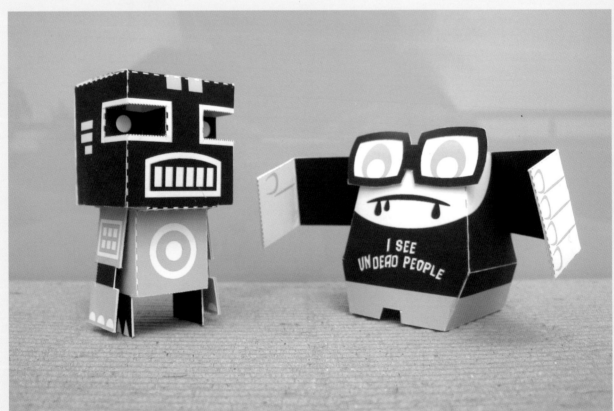

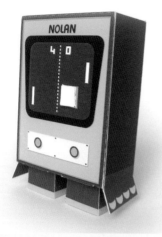

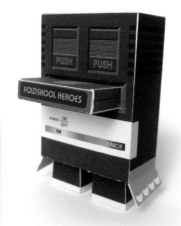

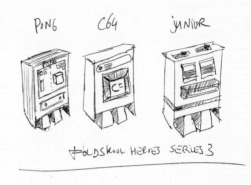

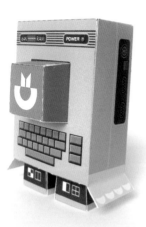

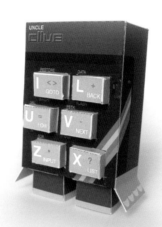

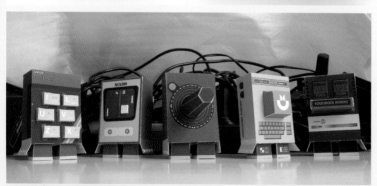

This page, first row, left to right:
NOLAN
JUNIOR
FOLDSKOOL HEROES
Sketches from series 3.
Second row, left to right:
64K RAM
UNCLE CLIVE
Third rowt:
FOLDSKOOL HEROES
Paper toys.
Fourth row, left to right:
RUBEE
Paper toy.
FOLDSKOOL HEROES
Paper toys.

Opposite, top:
FOLD-A-BOT
First sketches and paper toy.
Bottom, left to right:
FOLD-A-BOT AND
ZOMBIE GEORGE
Paper toys.

All artwork by Marshall Alexander.
All images courtesy of Marshall
Alexander.

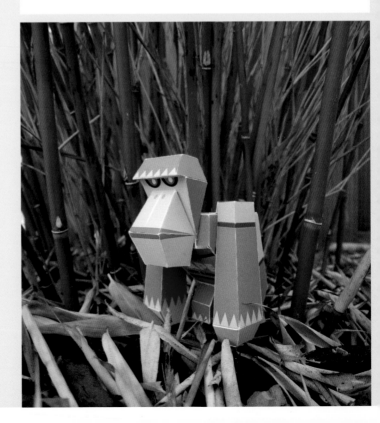

APE
NOT A MONKEY

GLUE OTHER FACE PART HERE

GLUE TO BOTTOM OF BODY

GLUE TO BOTTOM OF BODY

GLUE TO SIDE OF BODY

GLUE TO SIDE OF BODY

GLUE OTHER FACE PART HERE

MARSHALL ALEXANDER
www.marshallalexander.net

Cutout the model and score the foldlines and the glue-flaps. Construct the arms, legs and both parts of the head first. When glueing the body together, first glue the complete left side together before starting on the right side.

This page:
APE NOT A MONKEY
Sketch, template, and paper toy.

Opposite, top row, left to right:
LEAKY LOUIE
PAPER INJURY
Middle row, left to right:
YUKI 7
Paper toy in collaboration with Kevin Dart.
MACHO MECHA
Bottom row, left to right:
DESERT PALM
3D BOY
Paper toys.

All artwork by Marshall Alexander.
All image courtesy of Marshall Alexander.

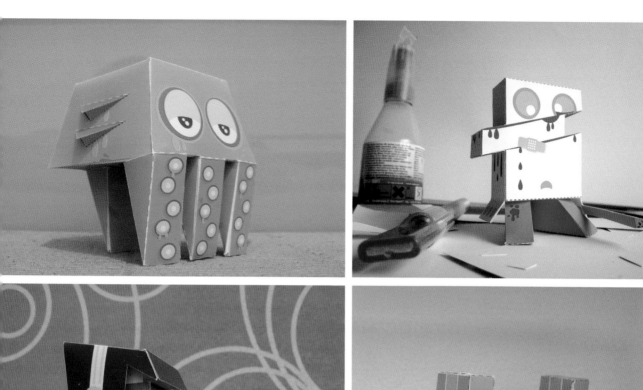

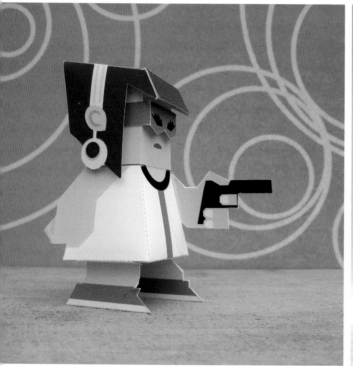

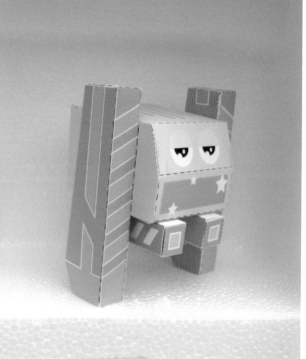

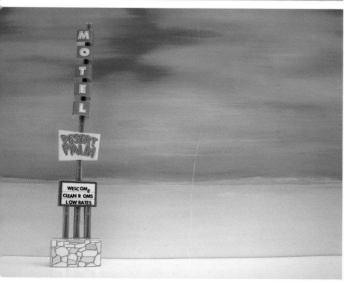

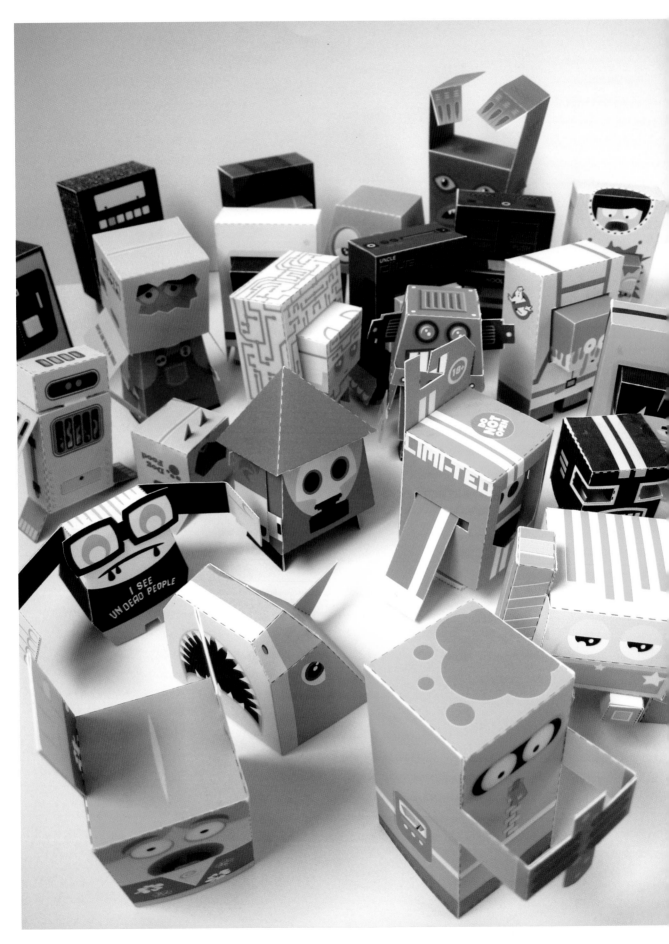

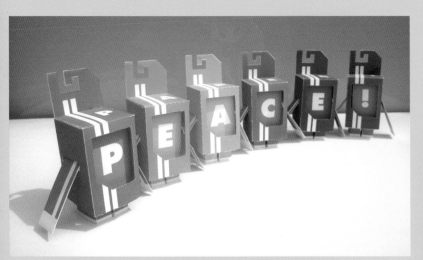

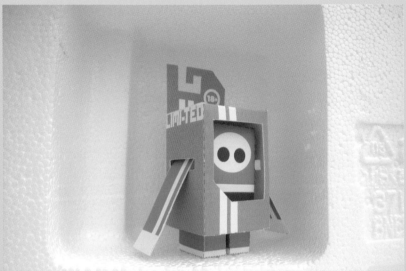

This page, top:
PEACE OF PAPER
Paper toys.
Middle and bottom:
LIMI-TED
Paper toy, template, and sketch.

Opposite:
PAPER TOYS

All artwork by Marshall Alexander.
All images courtesy of Marshall
Alexander.

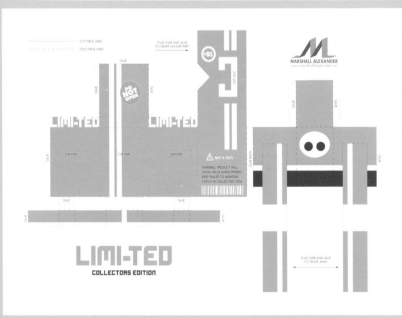

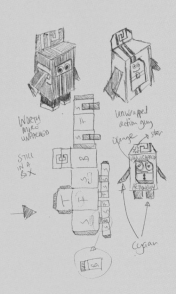

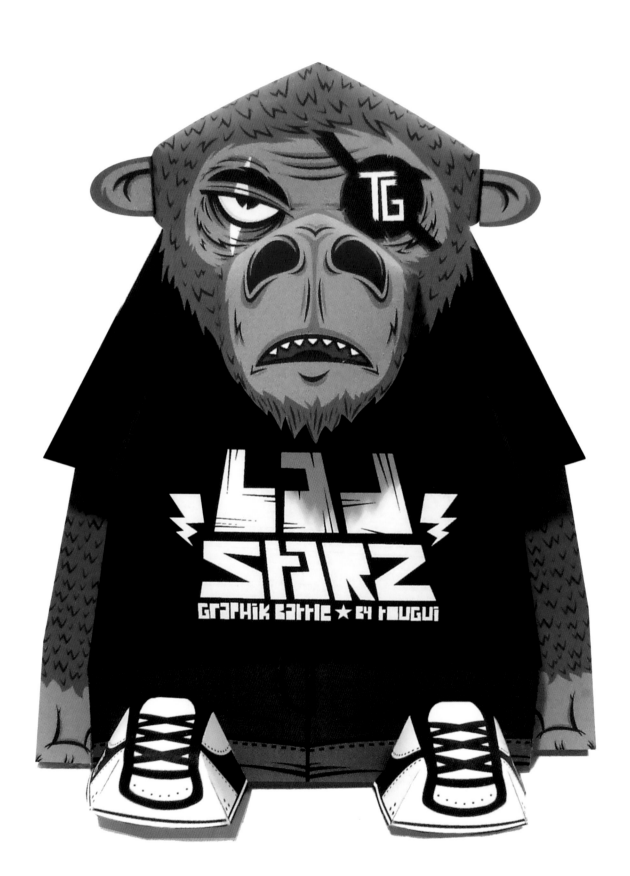

badstarz

www.badstarz.com
Toulouse, FRANCE

"I've been working for a year creating a streetwear brand called Badstarz. Through the Web site I invite everyone to participate in the creation of new imagery for the brand. This brand ultimately lead me to find out about other forms of creation and communication, such as posters and, in the end, paper toys. So I decided to transform one of the brand logos into a paper toy because I found that form of communication to be very original. This new medium has a playful side; being able to create your own paper toy from a simple sheet of paper is particularly interesting. It's like a Kinder Surprise! The most entertaining thing is building it. The result doesn't matter in the end; people wish to see what it will look like when done. Of course, there's also the concept of it being free to take into consideration and the fact that it's quickly downloaded from the Internet. Actually, for me, it's a very nice way to communicate my brand."

This page:
BADSTARZ PAPER TOY
Paper toy sticker.

Opposite:
PAPER BADSTARZ
Custom by Tuogui for Badstarz.

All artwork by Badstarz.
Shoes designed by PhilToy.
www.myspace.com/philtoys
All images courtesy of Badstarz.

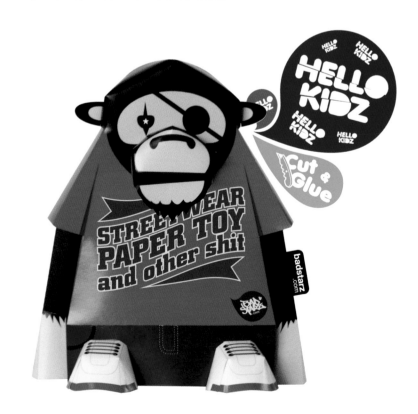

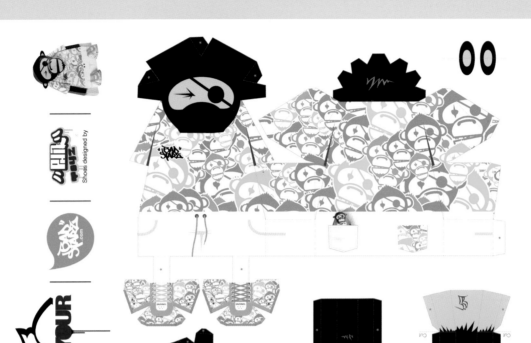

DO IT YOUR WAY !

Cut
Fold
Paste

Shoes designed by

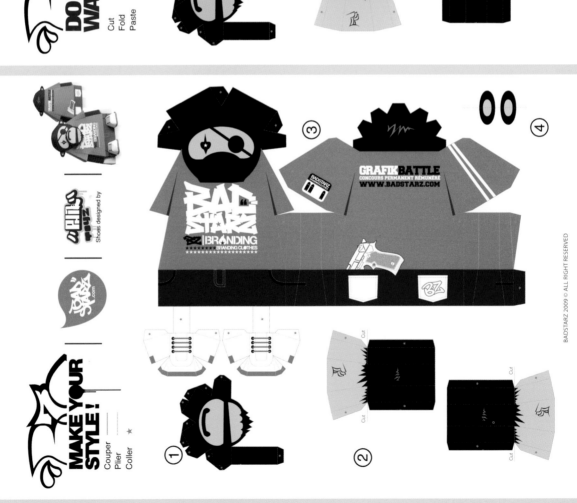

MAKE YOUR STYLE !

Couper
Plier
Coller

Shoes designed by

GRAFIK BATTLE
CONCOURS PERMANENT RÉMUNÉRÉ
WWW.BADSTARZ.COM

BAD STARZ
BZ BRANDING
BRANDING CLOTHES

① ② ③ ④

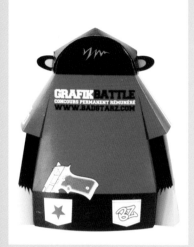

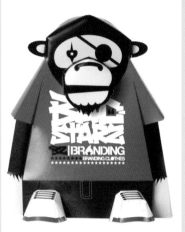

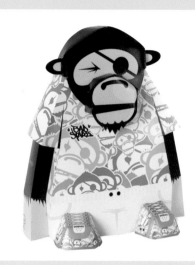

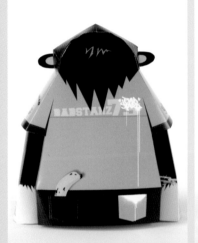

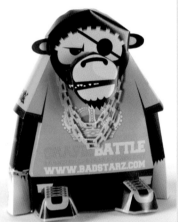

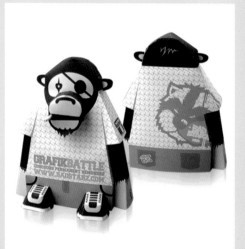

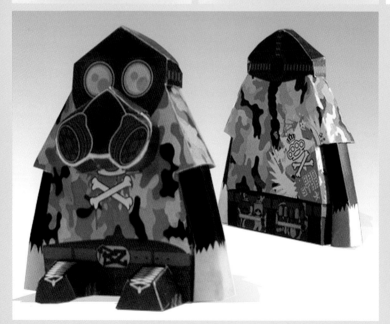

This page, top row:
BDZ CUSTOM PAPER TOYS
Middle row:
BDZ CUSTOM PAPER TOYS
Bottom:
PIX HELL STUDIO CUSTOM
www.pix-hell.be

Opposite:
PAPER BADSTARZ
Badstarz templates.

All artwork by Badstarz.
Shoes designed by PhilToy.
www.myspace.com/philtoys
All images courtesy of Badstarz.

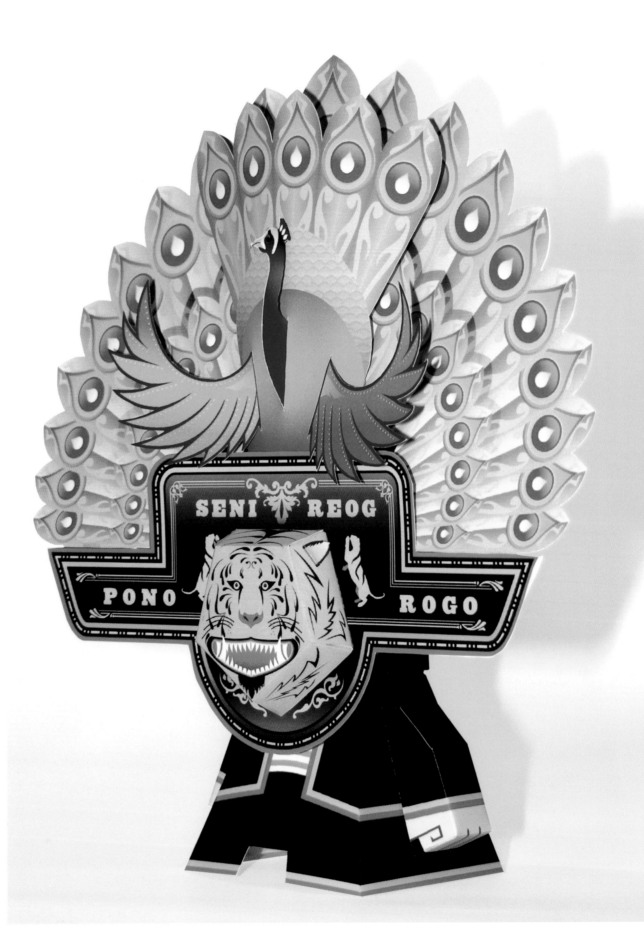

faisal azad

www.salazad.com
INDONESIA

"Paper toys are simple but unique creations. As opposed to mass-produced plastic toys, paper toys can be created according to individual taste and style. They are also very accessible and cheap, and they are really easy to distribute quickly. Paper toys are not only a blank canvas for their creators, they are also a medium for designers, builders, and fans to communicate and disseminate art."

This page:
GATOTKACA
Paper toy.

Opposite:
REOG PONOROGO
Paper toy.

All artwork by Faisal Azad.
All photographs by Riza Azad.
All images courtesy of
Faisal Azad.

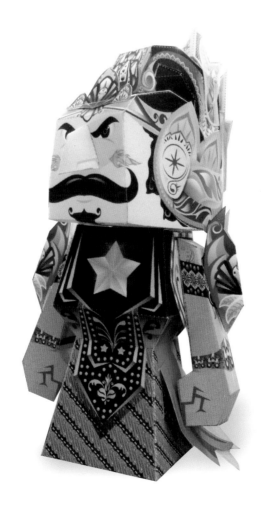

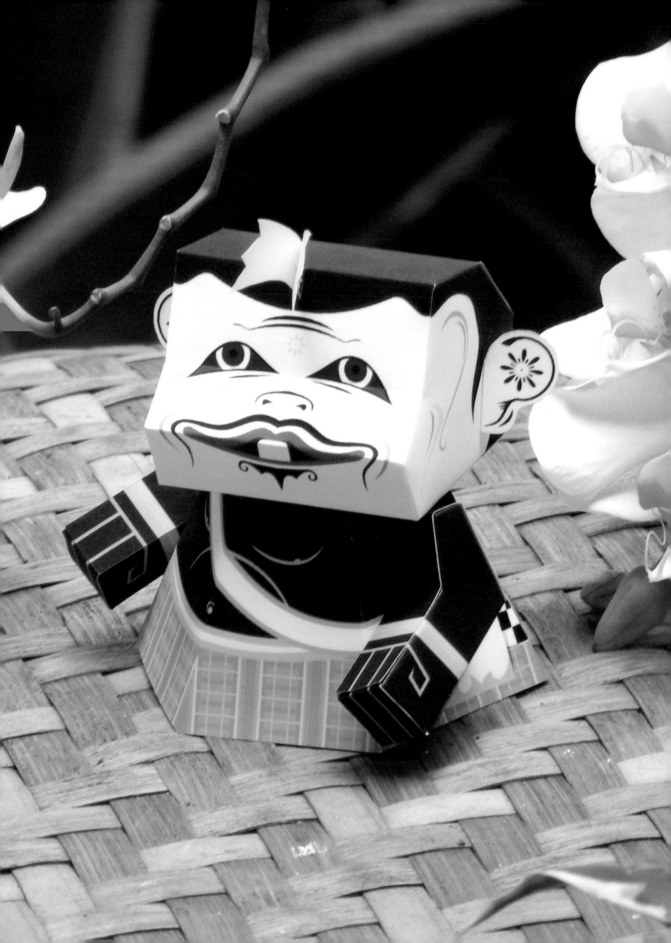

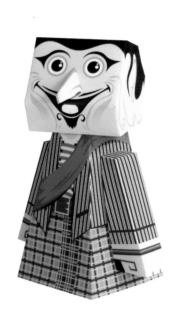

This page, clockwise from top left:
GARENG
DAWALA
KUDA LUMPING
Paper toy and template.
CEPOT

Opposite:
SEMAR
Paper toy.

All artwork by Faisal Azad.
All photographs by Riza Azad.

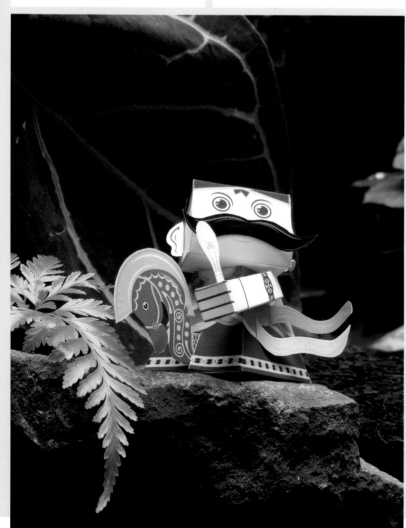

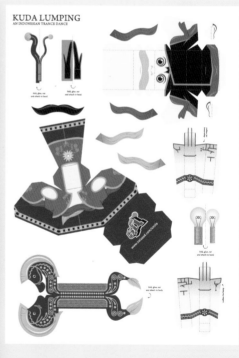

KUDA LUMPING
AN INDONESIAN TRANCE DANCE

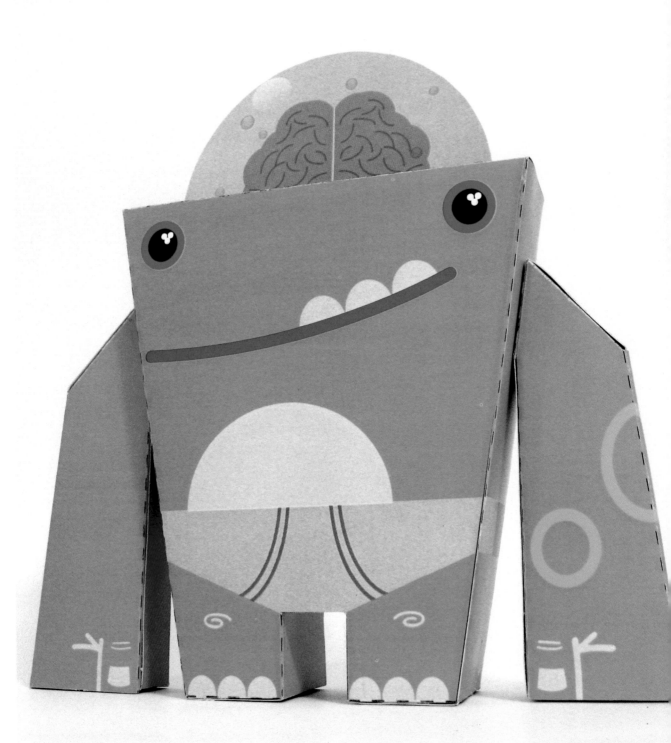

mundosopa!

www.sopa.cl
www.mundosopa.blogspot.com
www.rodrigomiranda.migueb.com
Santiago de Chile
CHILE

"Up to now I had never pinpointed the reason why I like paper toys so much. For starters, part of it has to do with the fact that I'm very fond of all kinds of toys; from the old tin toys to urban toys or toys for collectors. I remember that, as a kid, somehow I always ended up playing with paper craft toys, albeit with more classical shapes like houses or planes, and everyone liked to display them somewhere in their room. When I found out about modern paper toys, it was love at first sight. I feel they fulfill my desire of turning my characters into physical objects, and it even works the other way around: creating a 3-D model and then figuring how it would unfold in order to create its template. To think time and again about the final look of the pleats, the cutout, and the final assembly... those are challenges that make designing these characters so much more interesting. For me it's satisfying when I imagine someone, somewhere in the world, downloading a paper toy I made, assembling it, and displaying it in his or her own space."

This page:
CEREBRUS
Illustration.

Opposite:
CEREBRUS
Paper toy.

All artwork by Rodrigo Miranda.
All images courtesy of Rodrigo Miranda.

This page, top row:
NIÑO CABEZA DE RADIO
Paper toy.
Middle row, left to right:
NIÑO CABEZA DE RADIO
BOXZILLA
Illustrations.
Bottom row:
BOXZILLA
Paper toy.

Opposite, top row:
CABEZA DE HELADO
Paper toy.
Middle row, left to right:
EL FORZUDO
CABEZA DE HELADO
Illustrations.
Bottom row:
EL FORZUDO
Paper toy.

All artwork by Rodrigo Miranda.
All images courtesy of Rodrigo Miranda.

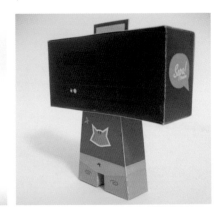

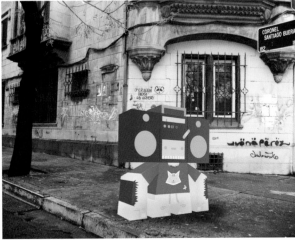

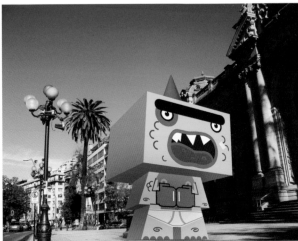

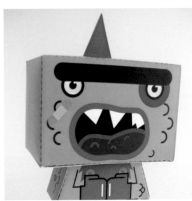

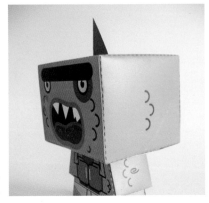

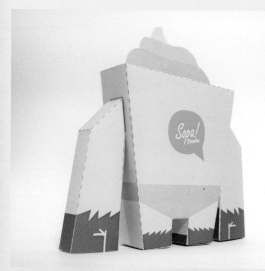

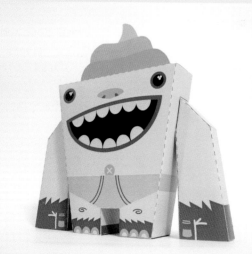

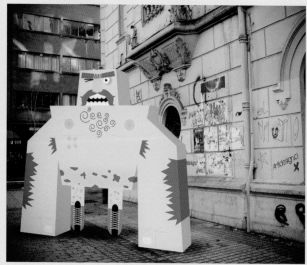

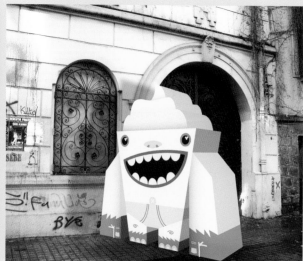

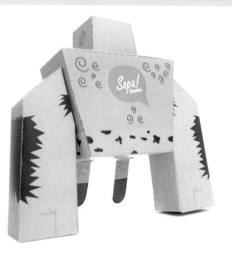

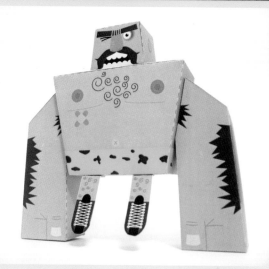

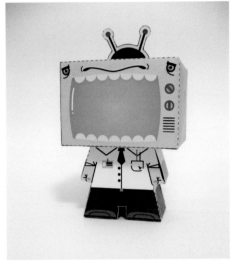

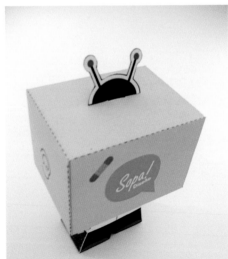

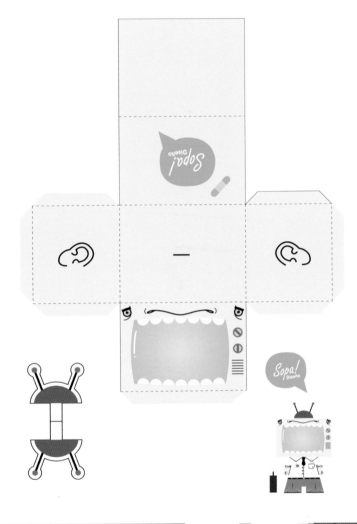

This page:
HOMBRETELE OFICINISTA
Paper toy, template, and illustration.

Opposite, top:
CABEZA DE HELADO
Middle:
NIÑO CABEZA DE RADIO
Bottom:
CEREBRUS

All Illustrations by Mundosopa!.
All images courtesy of Rodrigo Miranda.

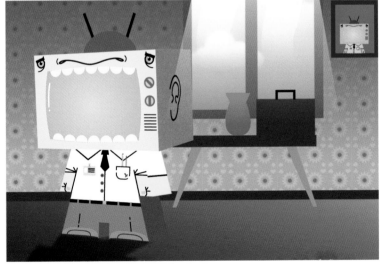

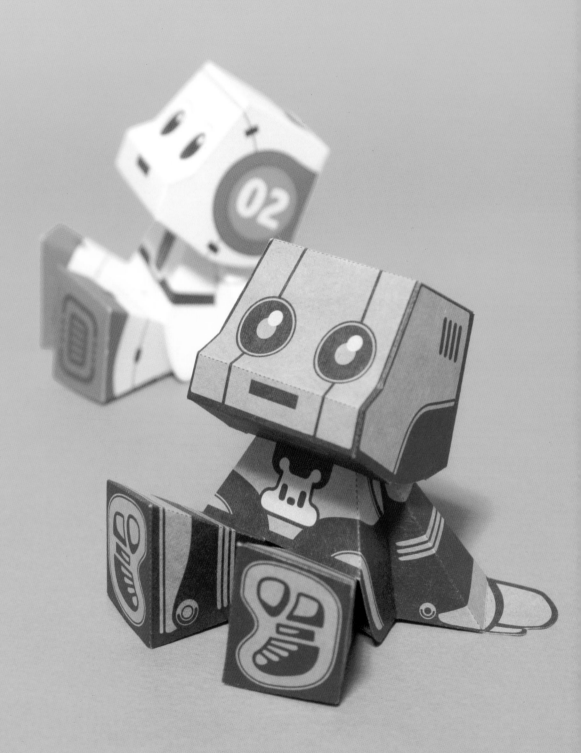

kamimodel

www.kamimodel.com
JAPAN

"I like the texture of paper. It's easy to shape into anything I want. I think it's attractive for flat surfaces to change into three dimensional objects . And I can make papercraft with simple tools.
I designed Rommy so that a beginner in papercraft could build it. If many people build it and feel an affinity for the character, I will feel very happy."

This page and opposite:
ROMMY
Designed by Tetsuya Watabe.

All images courtesy of Tetsuya Watabe.

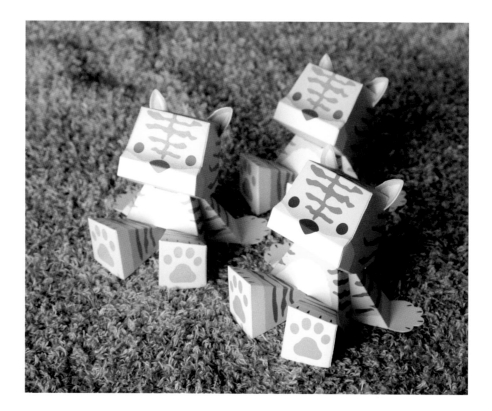

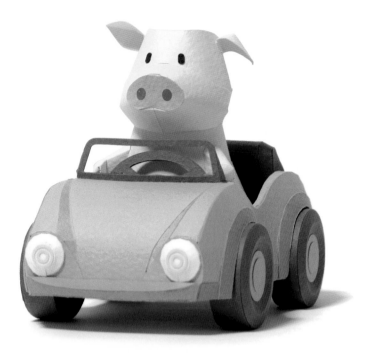

This page, top:
ELEPHANT RIDE
Paper toy.
Bottom:
PAPER DRIVOO
Paper toy.

Opposite:
ZAMBER
Template, instructions sheet,
and paper toy.

All artwork by Tetsuya Watabe.
All images courtesy of Tetsuya
Watabe.

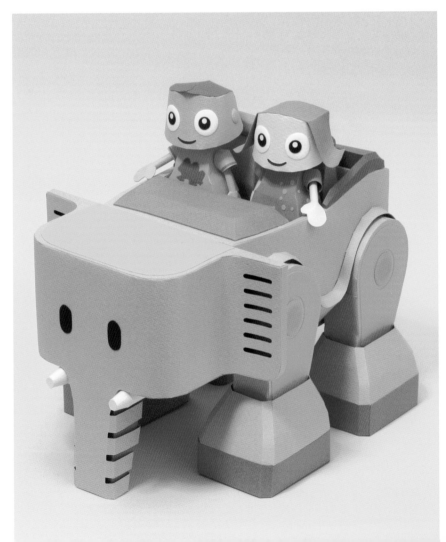

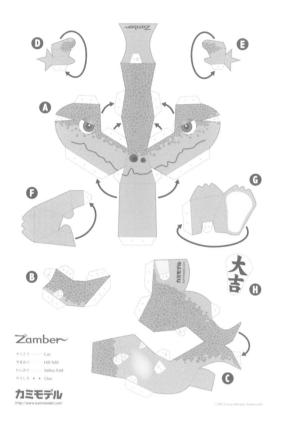

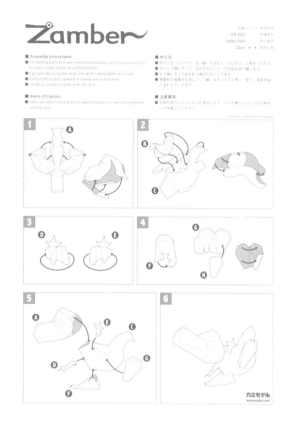

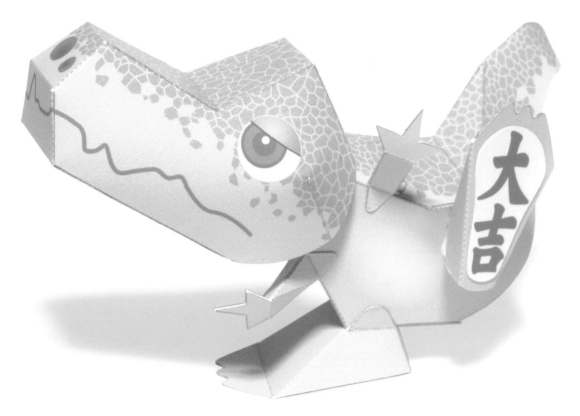

This page:
KELOMET

Opposite:
BEAR MARU

All models designed by Tetsuya Watabe.

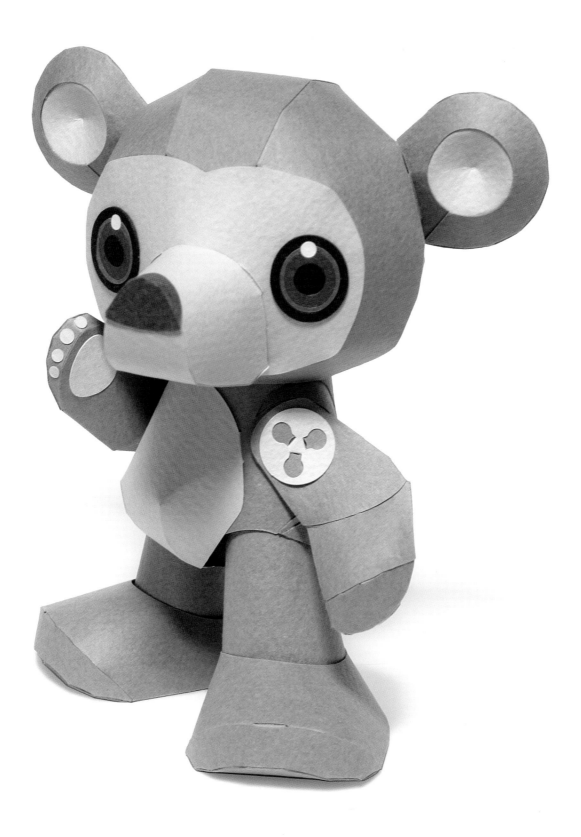

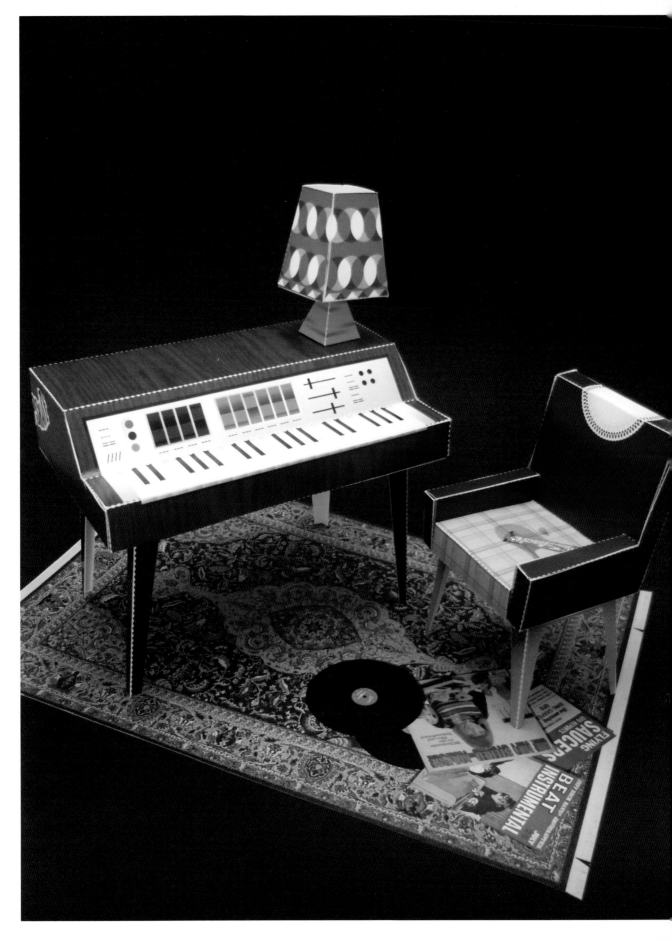

loulou &tummie

www.loulouandtummie.com
THE NETHERLANDS

"We love and collect toys, so the choice to start making our own paper toys came naturally. And, of course, it's very easy and cheap to share them with everyone around the globe! Besides those practical considerations, we also enjoy figuring out ways to fit the template for the toy on a single sheet of paper. There's fun in making the template design look good on its own, as well as coming up with ways of integrating the instructions in the design. The instructions have to be easy to follow and at the same time match the style of the overall design."

This page:
PAPER TOTEM FACES
Paper toys.

Opposite:
WALTER CHEAPSKATE
PAPER TOY SETTING.

All artwork by Loulou & Tummie.
All images courtesy of Loulou
& Tummie.

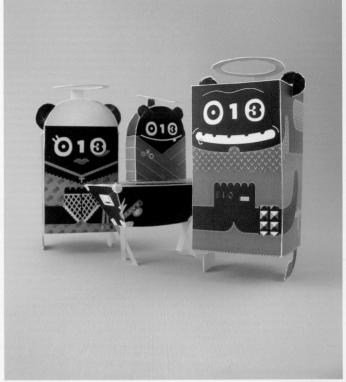

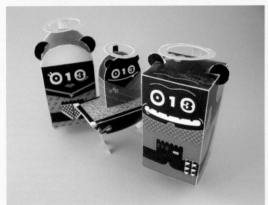

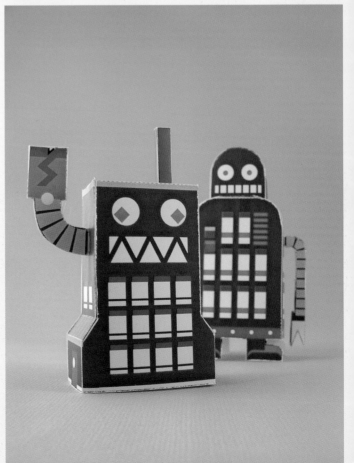

This page, top:
JESUS, JOSEPH, AND MARIA
Paper toy Christmas cards.
Designed for 013 Popcentre.
Bottom:
WOOT BOTS
Paper toy robots.

Opposite, clockwise from top left:
IDENTITYBOT
EXTORTIONBOT
SPAMBOT
Paper toy and template.
Designed for Fine Design / Norton Symantec.

All artwork by Loulou & Tummie.
All images courtesy of Loulou & Tummie.

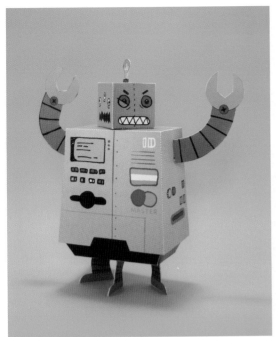

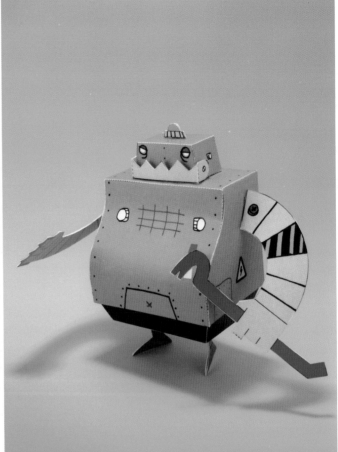

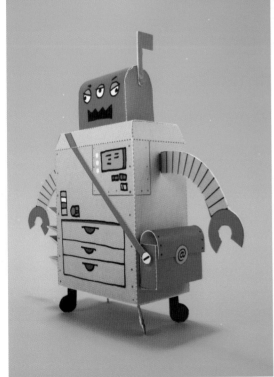

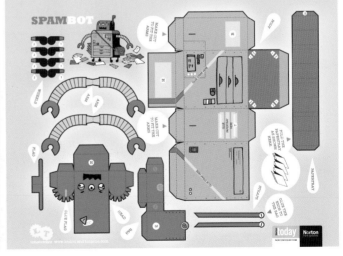

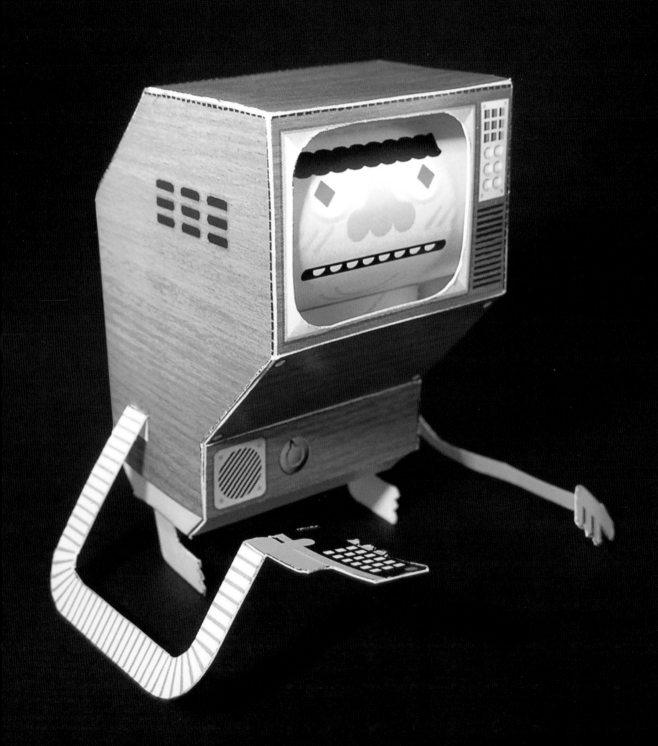

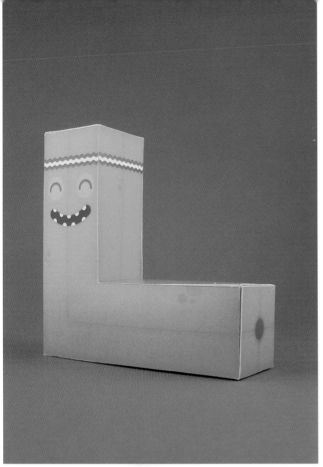

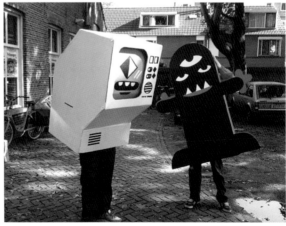

This page, top:
CUBIC FRUIT: THE BANANA
Paper toy.
Bottom, left to right:
CUBIC FRUIT: THE ORANGE
Paper toy.
BIG PAPER TOYS
For Playgrounds Festival. Loulou
on the left and Zeptonn on the right.
Photo by Eelke Dekker.

Opposite:
PLAYGROUNDS FESTIVAL PAPERTOY
Paper toy.

All artwork by Loulou & Tummie.
All images except that of BIG PAPER TOYS
courtesy of Loulou & Tummie.

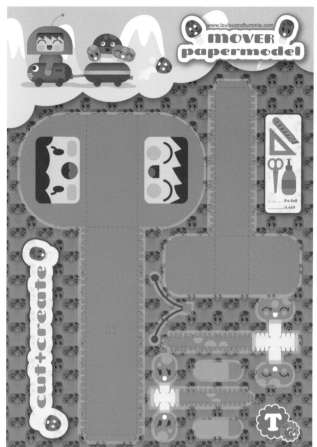

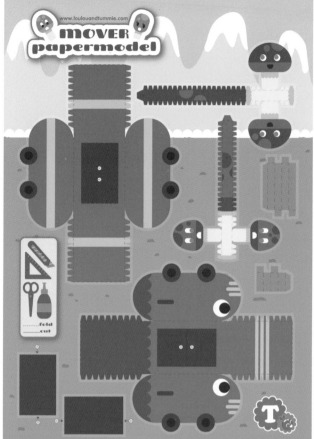

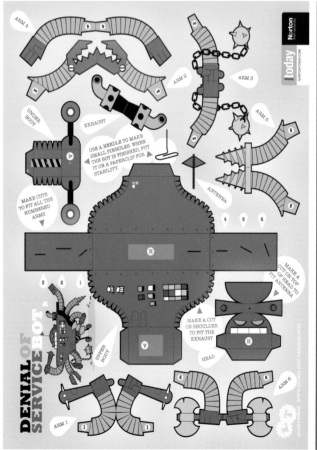

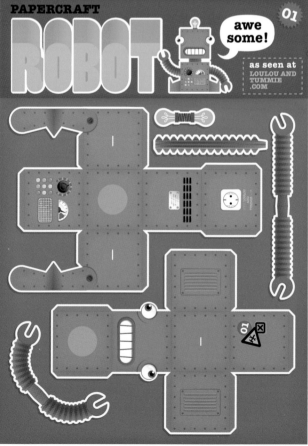

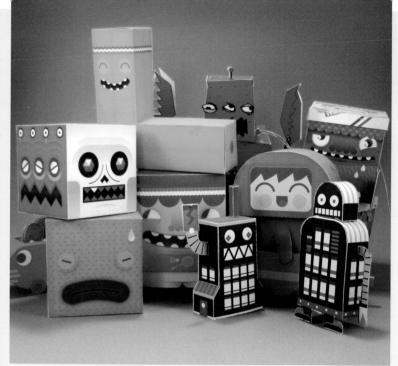

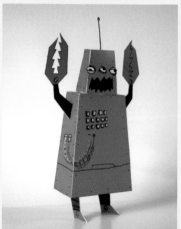 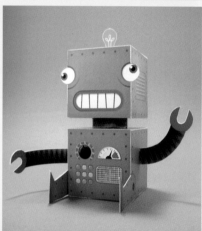

This page, top:
SMALL SELECTION OF PAPER TOYS FAMILY
Middle, left to right:
DESTROY-O-TRON
BABY ROBOT
Paper toys.
Bottom:
GIORGIO OEHLERS
Big paper toy for Shop Around / Historic Museum Rotterdam.
Photo by Atelier Licht en Kleur (LEK).

Opposite:
LOULOU & TUMMIE PAPER TOY TEMPLATES

All artwork by Loulou & Tummie.
All images courtesy of Loulou & Tummie.

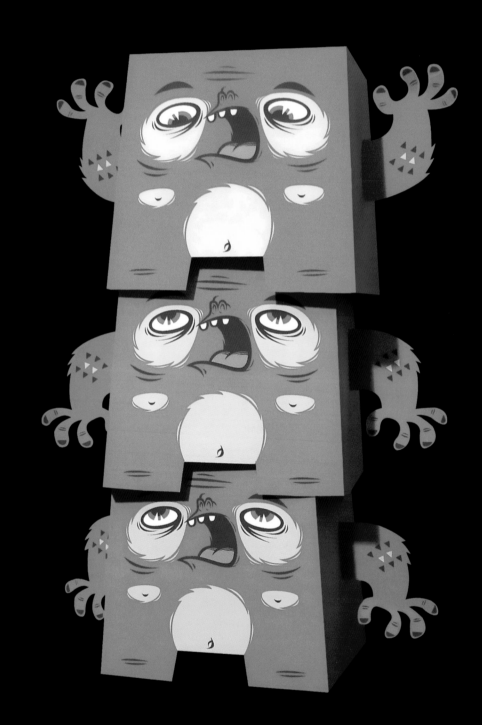

tougui

www.tougui.fr
Paris
FRANCE

"I love paper toys because of the endless possibilities! The only limit is your imagination. You can create any shape you want with a piece of paper. It costs nothing, so everybody can make one. You just need to cut it, fold it, and glue it together! I love illustration, art toys and detailed work, so with paper toys I found a great medium to express my creativity."

This page:
E440©
Template by Ring.
alle440.blog.com

Opposite:
PAPER TOTEM
Template by Dolly Oblong.
dollyoblong.blogspot.com

All designs by Tougui.
All images courtesy of Tougui.

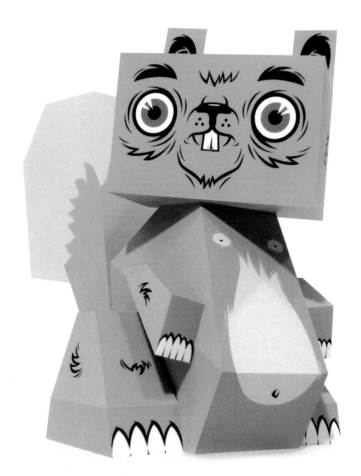

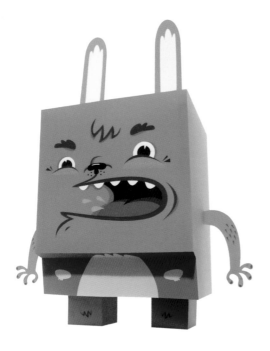

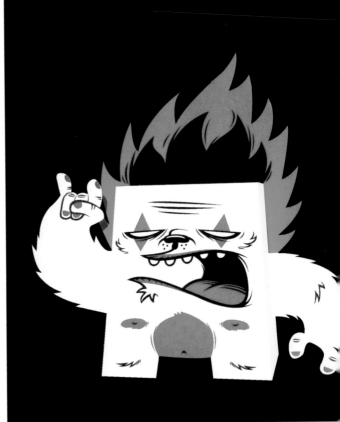

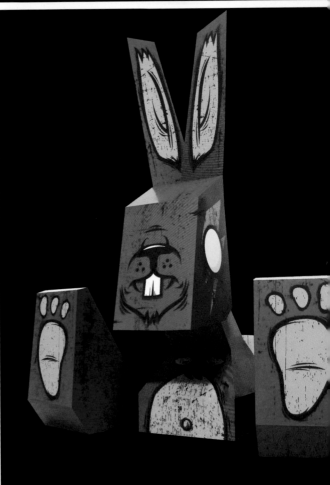

This page, clockwise from top left:
LEMI THE SPACE WANDERER
Template by Thunderpanda.
www.thunderpanda.com
ROCK THE BEAST!
Template by Dolly Oblong.
dollyoblong.blogspot.com
MECHABUNNY
Template by Nick Knite.
nickknite.com/blog

Opposite, clockwise from top left:
DESIGN YOUR OWN BOXY!
Template by Shin Tanaka.
www.shin.co.nr
NANIBIRD
Template By Josh McKible.
www.mckibillo.com
BARRY!
Template by Tougui.

All designs on these pages by Tougui.
All images courtesy of Tougui.

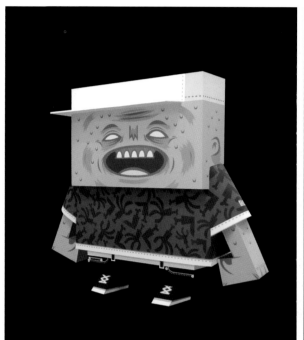

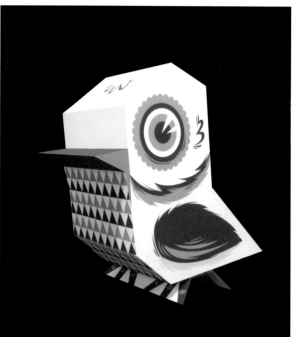

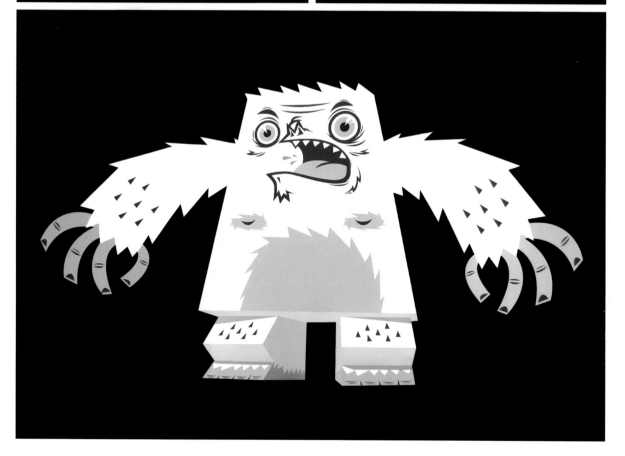

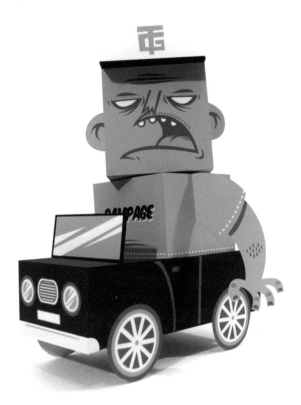

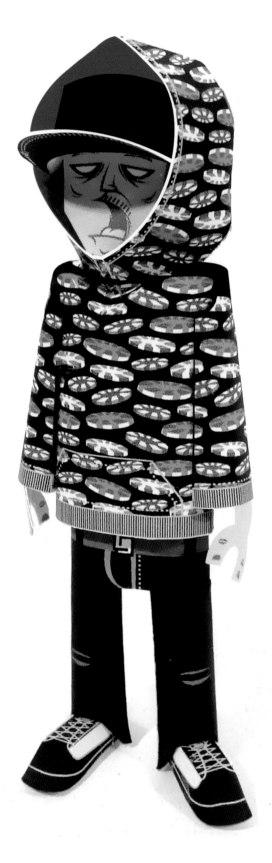

This page, left to right:
CALLING CAR
Template by HorrorWood.
horrorwood.info/blog
HOODY
Template by DMC.
dmcdmcblog.blogspot.com

Opposite:
BEHIND THE SCENES
Some images from Tougui's studio,
sketches, and paper toys.

All designs by Tougui.
All images courtesy of Tougui.

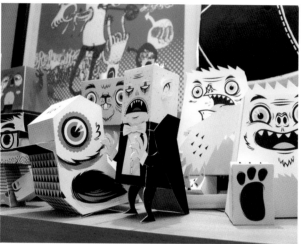

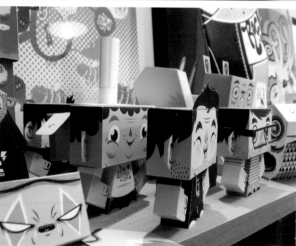

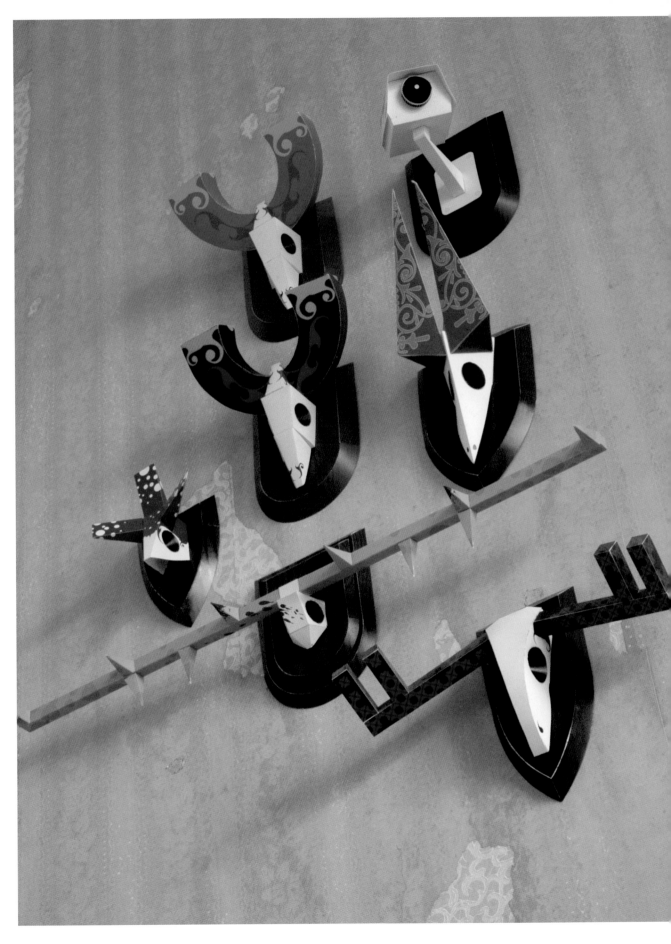

kenn munk

www.kennmunk.com
www.flickr.com/kennmunk
www.myspace.com/kennmunk
www.twitter.com/kennmunk
London, UK

"I love paper toys because I love paper. When I worked at an advertising agency, I had paper suppliers come in to present their products whenever they wanted to. A girl from Arctic Paper visited every couple of months and brought loads of samples, and we would have geeky conversations about the white stuff. I still enjoy the smell of freshly printed uncoated paper. I also did many point of sale displays and packaging designs, and I enjoyed the engineering side of the work, so that where it's started—with something pretty boring. But I had fun with the engineering aspect and soon designed my antlor hunting trophies. This was back in 2004/2005, when there weren't many "designer" paper toys around, I think Sjors Trimbach and I were amongst the first ones. Of course, I've created paper kits, what normal boy hasn't? It started in the eighties, when I made paper versions of BMX bikes in my street. My own bike was blue and yellow."

This page:
THE DEER DEPARTED
Template and finished model.

Opposite:
ANTLOR KITS
From series one of The Deer Departed and series two of Security TV.

All images courtesy of Kenn Munk.

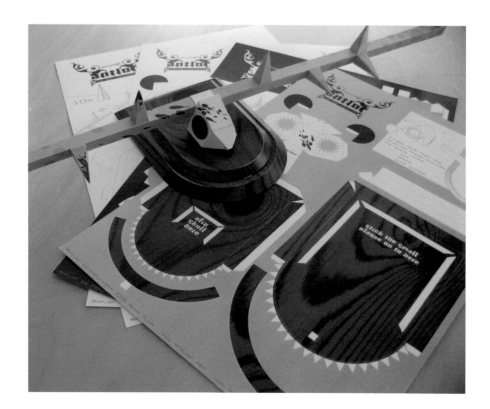

This page:
GLOBAL WARNING POLAR BEAR
Paper toy of an endangered species.

Opposite, top row:
ANTLOR SECURITV
Template and paper toy.
Middle row:
GOOD DESIGN IS NOT BLING
Postcards we send out to potential clients.
Bottom row:
Christmas card rom the year that Kenn
Munk moved his business to London.

All artwork by Kenn Munk.
All images courtesy of Kenn Munk.

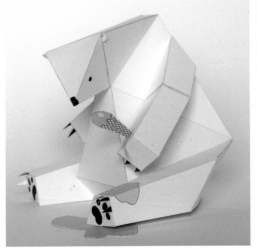

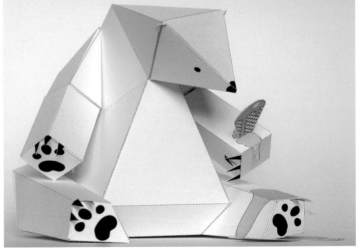

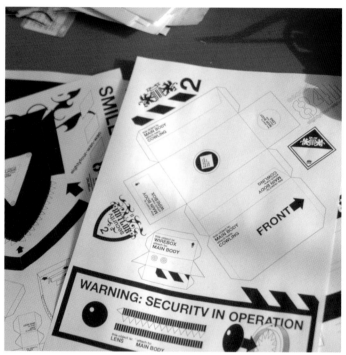

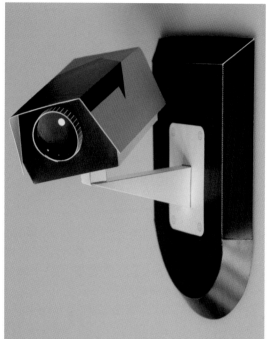

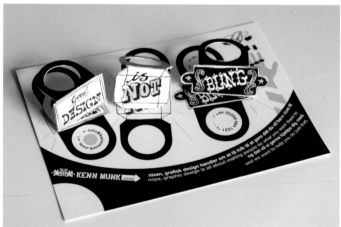

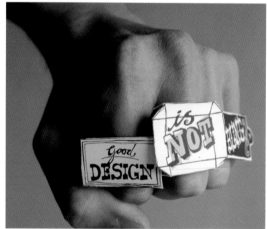

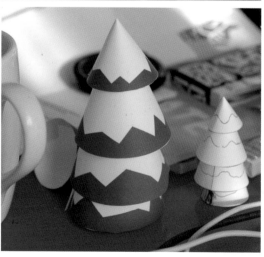

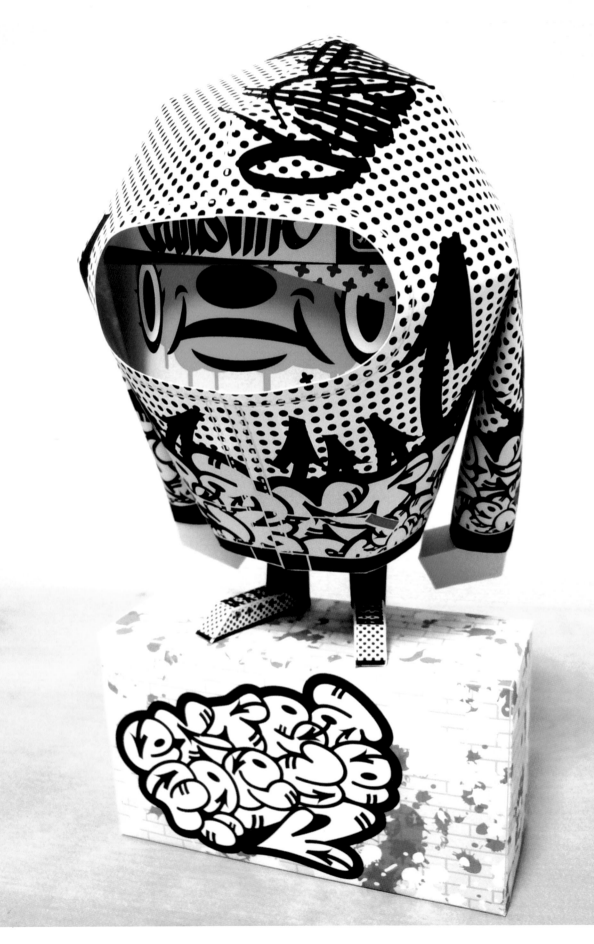

shin tanaka

www.shin.co.nr
JAPAN

"I love paper toys because paper is the most beautiful material in the world, with smooth curves and sharp lines. And it is part of daily life. People can download the templates from the Internet and exchange them. Customizing them is also easy; people can make their own paper toys. Creating with paper is much faster than with other materials, such as plastic and vinyl. Paper toys are always fresh!"

This page, top:
HOOPHY 144%
Bottom:
HOOPHY #09,
THE BIGGER, THE BETTER
Paper toys.

Opposite:
HOOPHY ON A WALL
Paper toy.

All designs by Shin Tanaka
All images courtesy of Shin Tanaka.

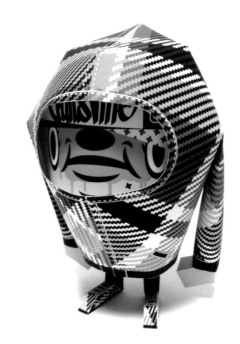

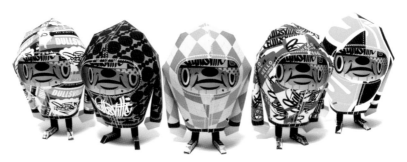

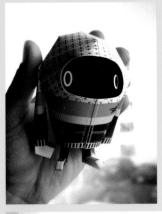
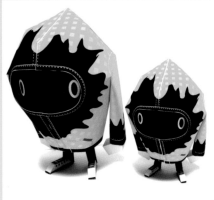

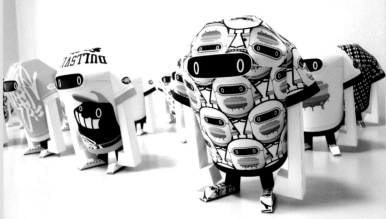

This page, top row, left to right:
HOOPHY #02 100%
HOOPHY 144% AND 100%
Splash ink on yellow.
Middle row:
T-BOY 144%
Bottom row:
4-IN-1 ROBOT
Inspired by a project with GIANT ROBO
& Toyota SCION.

Opposite:
WE DON'T NEED FAKE
Paper toy template.
www.wedontneedface.co.cc

All designs by Shin Tanaka.
All images courtesy of Shin Tanaka.

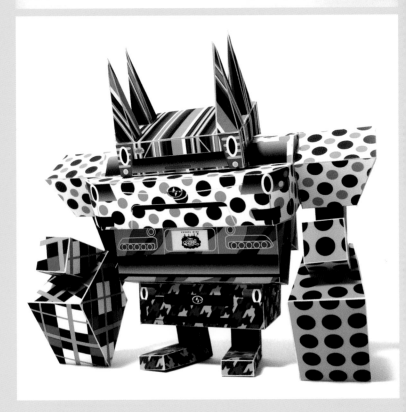

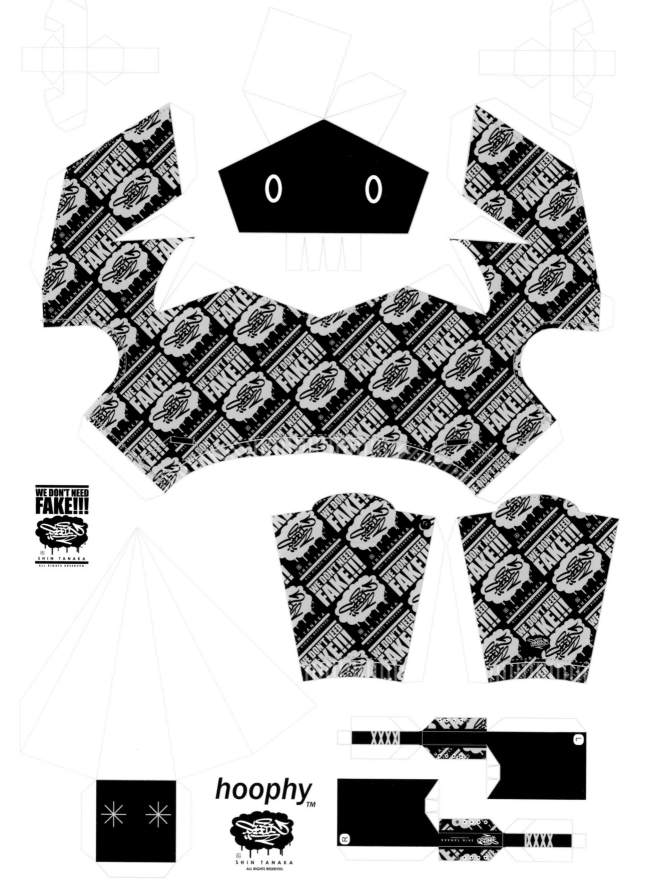

WE DON'T NEED
FAKE!!!

SHIN TANAKA
ALL RIGHTS RESERVED.

hoophy™

SHIN TANAKA
ALL RIGHTS RESERVED.

This page:
HOOPHY #01–#06
Paper toys in collaboration with other artists. Template
by Shin Tanaka. This page, top row, left to right:
Shin Tanaka, David Flores. Bottom row: Superdeux,
David Horvath, Skwak.

Images courtesy of Shin Tanaka.

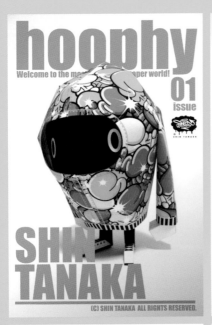

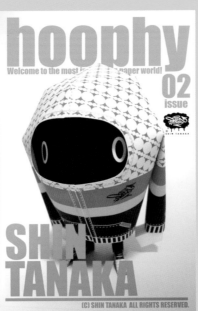

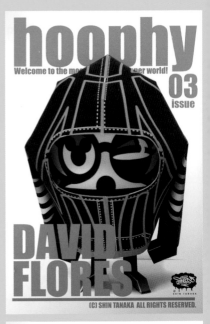

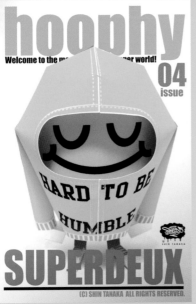

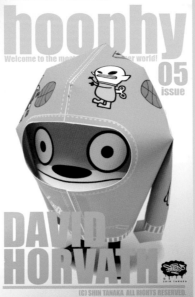

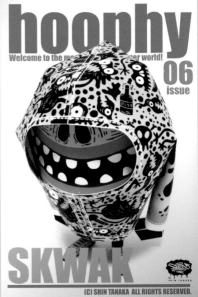

This page:
HOOPHY #07–#12
Paper toys in collaboration with other artists. Template by Shin Tanaka. This page, top row, left to right: Phoneticontrol, Koa, The Bigger, The Better. Bottom row: Jon Burgerman, Travis Lampe, and John Knonx.

Images courtesy of Shin Tanaka.

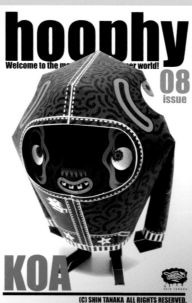

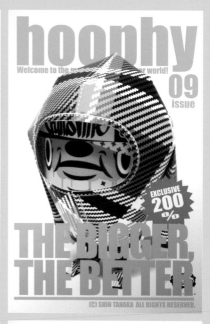

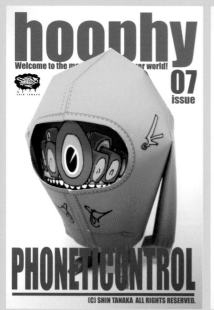

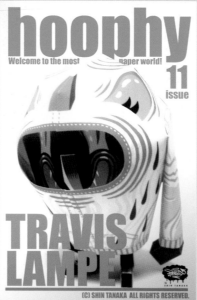

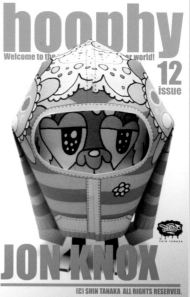

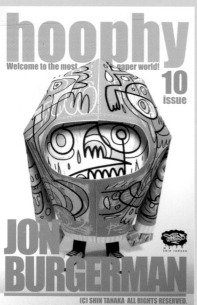

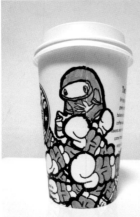

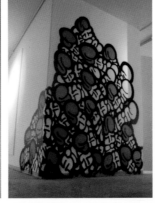

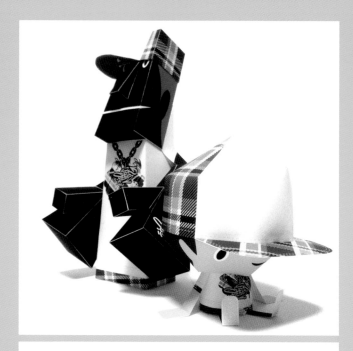

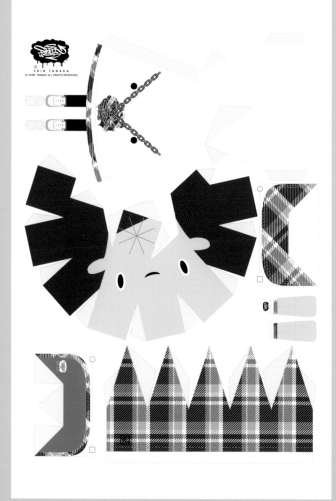

This page, top:
ZIMMY AND CHIBBY
Paper toys.
Bottom:
CHIBBY
Paper toy template.

Opposite:
**SHIN TANAKA'S SKETCHES
GRAFFITI WORKS**
Oriental museum in Sweden.
Canvas painting in collaboration
with Devil Robots and David Horvath.

All designs by Shin Tanaka.
All images courtesy of Shin Tanaka.

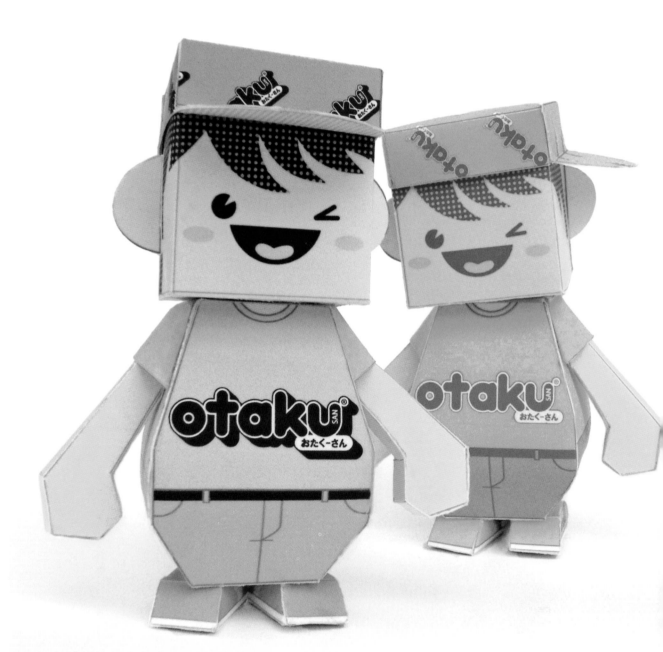

ivan ricci aka kawaii-style

www.kawaii-style.net
www.flickr.com/photos/kawaii-style
ITALY

"Paper toys are fantastic. I keep them on my desk and on the shelf above my computer because they inspire me and make me happy. I like to see my graphic works on three-dimensional objects, and I think it's wonderful to be able to share my paper toys with many other people. It's nice to know they have them somewhere in their homes, perhaps very far from here. While it's great that paper toys are free, I would love to create a commercial line using more sophisticated crafting techniques, high-quality paper, and special ink, to make them even more unique and beautiful."

This page:
THAI GHOST
From Phi Ta Khon, the Thai Ghost Festival.
Customized by Kawaii-style based on BushDoctor template by Maarten Janssens.
www.3eyedbear.com

Opposite:
OTAKU-SAN
Customized by Kawaii-style based on a Dumpy template by Dyadic.
dikids.blogspot.com
In Japanese slang, the term otaku refers to an obsessive fan of any particular theme, hobby, or topic. The true otaku is often a little stinky and fat. In this case I chose to give them a more stylish, kawaii-like look.

All artwork by Kawaii-style.
All images courtesy of Ivan Ricci.

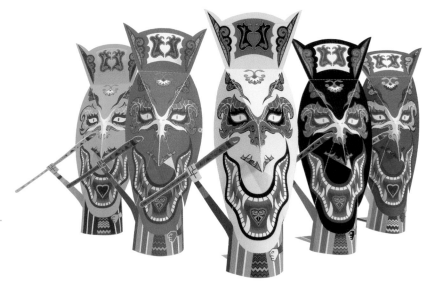

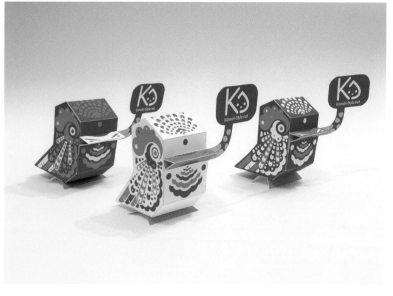

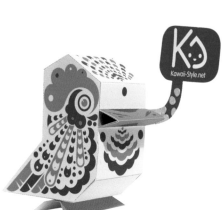

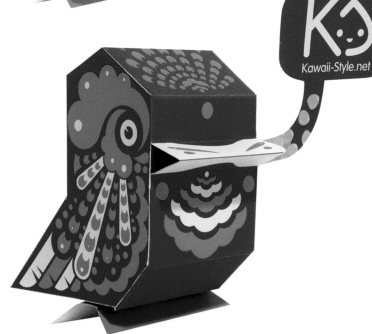

This page:
CHICCHIRICHĬ
Customized by Kawaii-style based on a NaniBird template by Josh McKible–www.nanibird.com
The name of this toy comes from the cockcrow. In italian the cockcrow is *chicchirichĭ*.

Opposite:
CHICCHIRICHĬ
Template.

All artwork by Kawaii-style.
All images courtesy of Ivan Ricci.

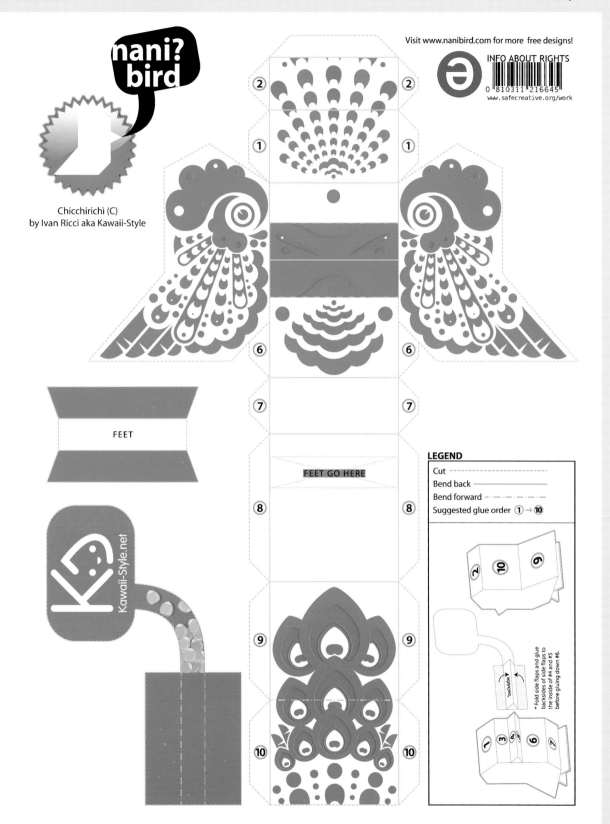

nani? bird

Chicchirichì (C)
by Ivan Ricci aka Kawaii-Style

Visit www.nanibird.com for more free designs!

INFO ABOUT RIGHTS
0 810311 216645
www.safecreative.org/work

FEET

FEET GO HERE

Kawaii-Style.net

LEGEND

Cut - - - - - - - -
Bend back ——————
Bend forward — · — · — ·
Suggested glue order ① → ⑩

*Fold side flaps and glue backsides of side flaps to the inside of #4 and #5 before gluing down #6.

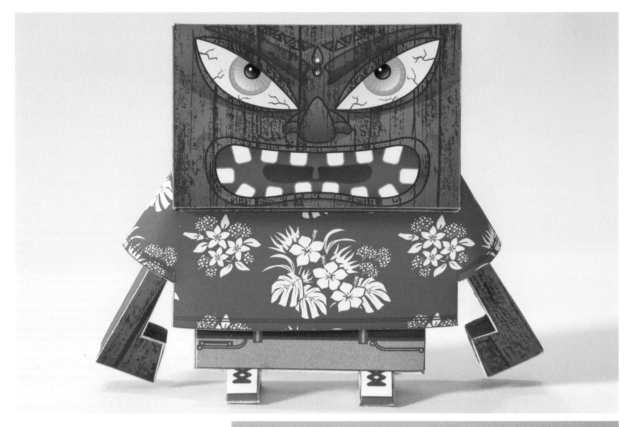

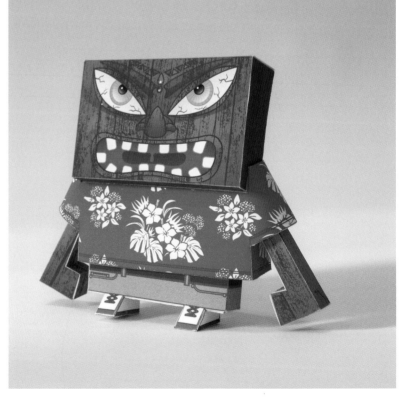

This page:
TIKI TOY
Customized by Kawaii-style based on Boxi template by Shin Tanaka.
www.shin.co.nr
I love the *hawaiian* shirts and the Tiki art!

Opposite:
KAWAII KUMA-CHAN
Customized by Kawaii-style based on Calling All Cars template by Jack Hankins.
www.horrorwood.info
I like this toy because its so interactive. The bear can be remove from the car, so they to become two toys in one!

All artwork by Kawaii-style.
All images courtesy of Ivan Ricci.

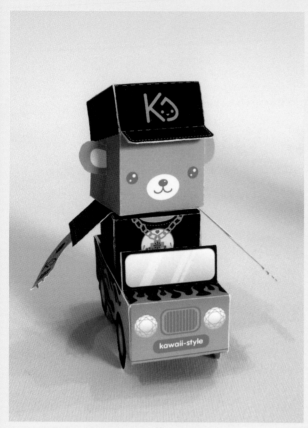

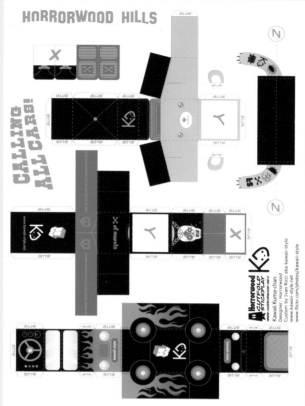

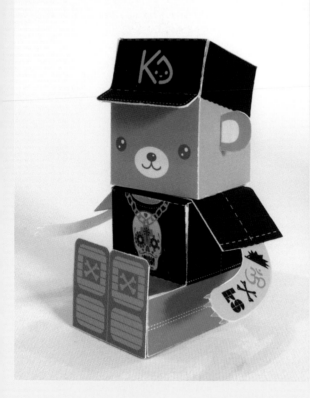

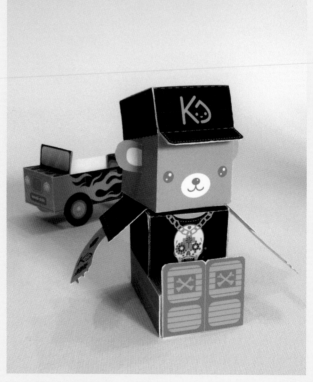

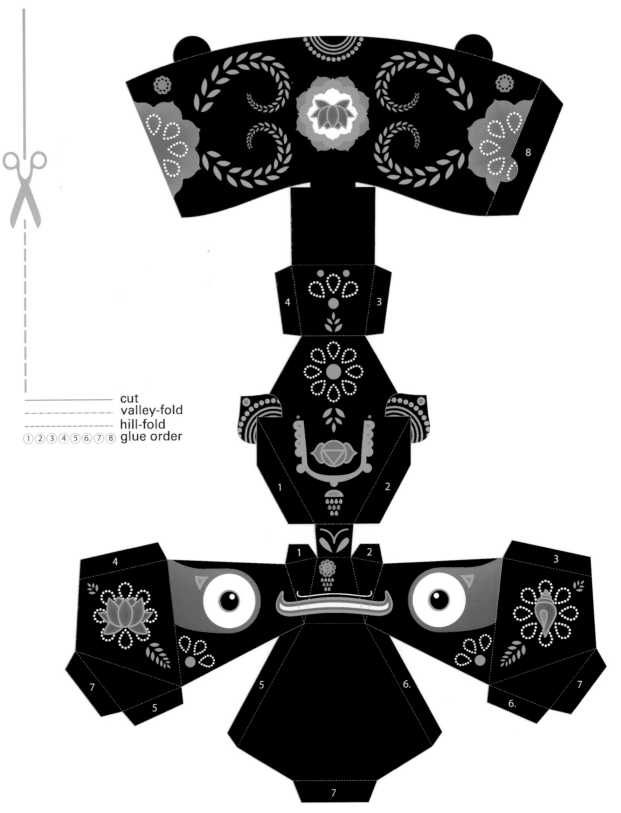

cut
valley-fold
hill-fold
①②③④⑤⑥.⑦⑧ glue order

Jagannatha black
Designer: Maarten@Bladvulling.nl ©2007
Custom by Ivan Ricci aka kawaii-style
www.kawaii-style.net
www.flickr.com/photos/kawaii-style

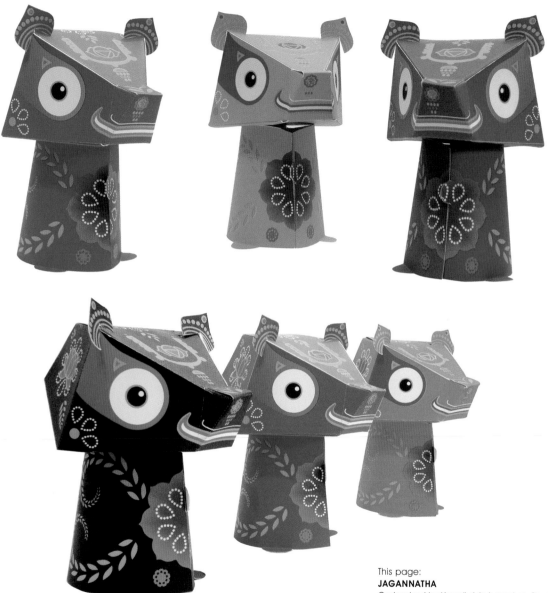

This page:
JAGANNATHA
Customized by Kawaii-style based on 3eyed-bear template by Maarten Janssens.
www.3eyedbear.com
In the Hindu religion *Jagannatha* is the name of the Lord of the Universe. This custom is the winner of a contest of the italian magazine *Bang Art*.

Opposite:
JAGANNATHA
Paper toy template.

All artwork by Kawaii-style.
All images courtesy of Ivan Ricci.

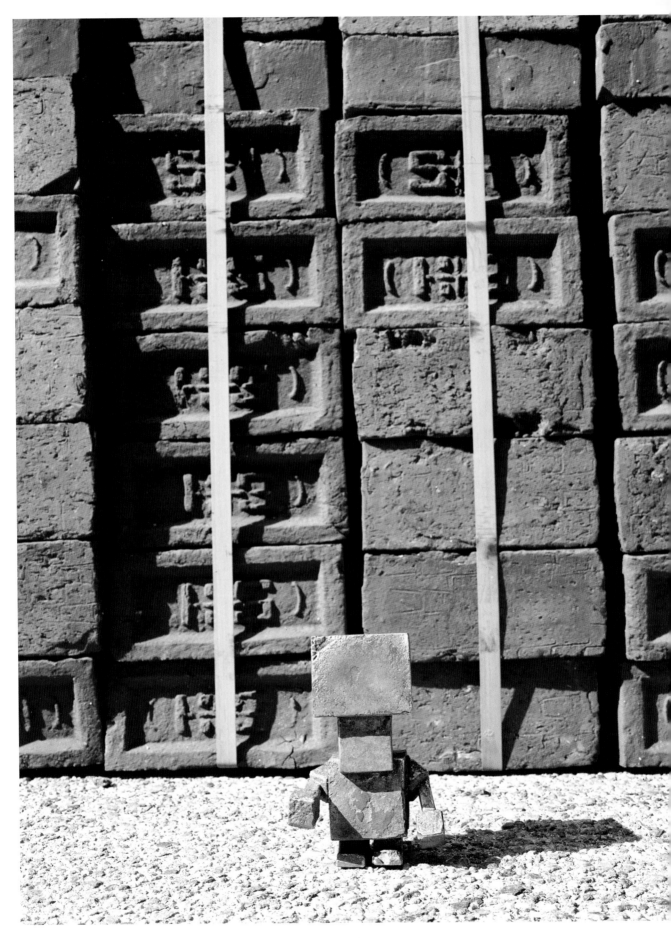

sjors trimbach

www.sjorstrimbach.com
THE NEDERLANDS

This page:
MONKEY VS ROBOT BRICKBOY
Brickboy design by Vinnie Fiorello, drummer of Less Than Jake and founder of wunderlandwar.com. It's just gorgeous.

Opposite:
BRICKBOY
Brickboy cast in bronze, made by Jim Turbert.
Photograph by Jim Turbet.
All images courtesy of Sjors Trimbach.

"I've been drawing ever since I could hold a pencil. I enjoy drawing robots, monsters, hot-rods, monkeys, and, whenever possible, a combination of them. In 2004, I created the Brickboy paper toy and was one of the first–along with Shin Tanaka–to create a paper toy template to be customized by other artists. I don't love paper toys. I happen to make them and have fun doing it. When I started with Brickboy, I wanted to make a vinyl toy and decided to design something simple. In order to see if it would work, I made a paper version and discovered out how easy it is to work with paper. And one thing led to another. It's just the easiest way to have your figures out there in the world; maybe too easy, as there is so much crap out there. That is why I decided to release my figures only in a printed format. This gives me control over the paper quality and colors, and it gives me a chance to experiment with extra layers of paint. I also love designing a nice package and making a small production out of it to go the extra mile. Through my paper toys I've met wonderful people, worked with my favorite artists, seen great places, and had my work in exhibitions all over the world. And you might say I love them for that."

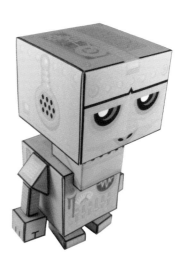

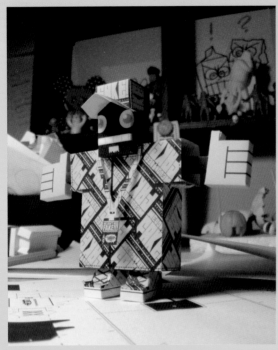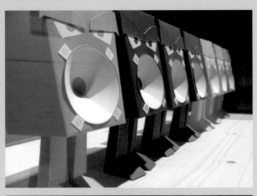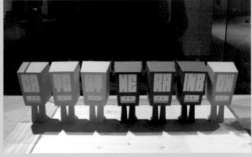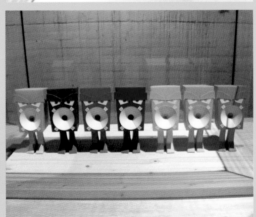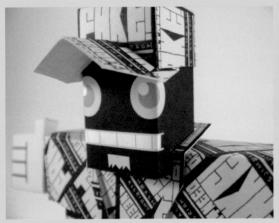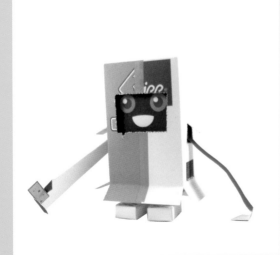

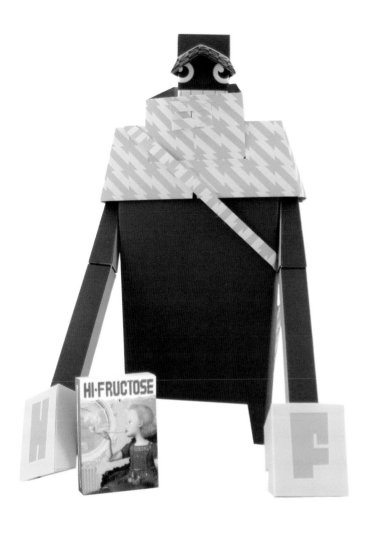

This page:
HF
Originally I'd made this figure for the Hi-Fructose Bitters & Sweets show. It was too big and fell apart. For the Hi-Fructose Collected Edition I've made a better version that came as a extra, only with the collectors box set. I'm proud of this one.

Opposite, clockwise from top left:
KEEPIN' IT REAL
Made for Shin Tanaka's project We don't need fake!!!
www.wedontneedfake.co.cc
SPEAKERBOSS: CATCH THE RAINBOW
These were made to support the fight against cancer and were sold with a shirt in a box.
BOXER: BOLLETJEXKNEIPP
Custom figure for a client as a gift for their client who left Bolletje fir Kneipp.

All artwork by Sjors Trimbach.
All images courtesy of Sjors Trimbach.

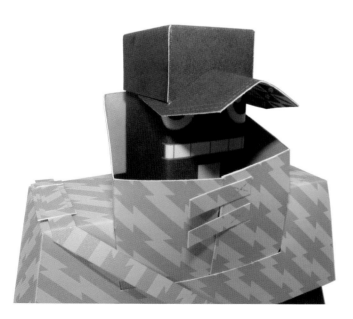

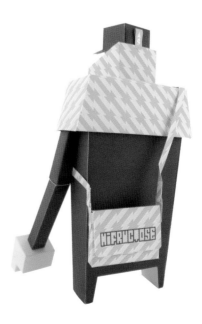

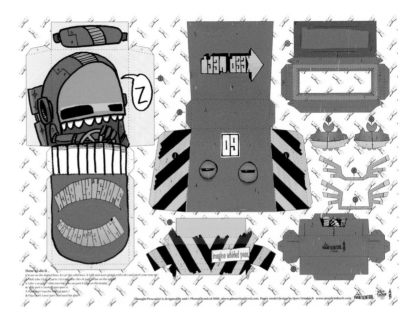

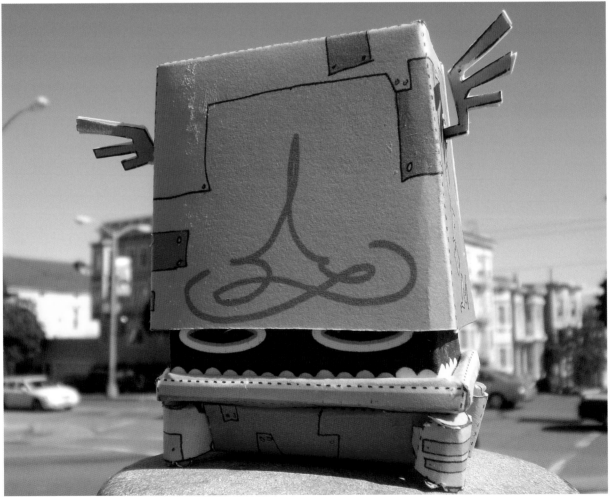

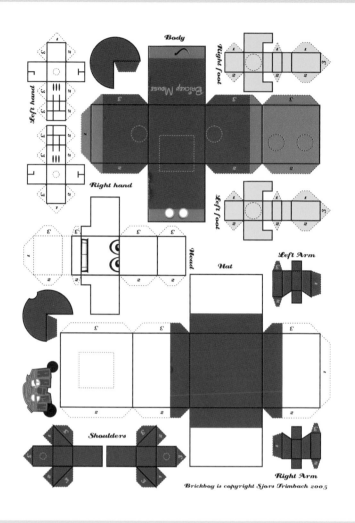

Body

Right foot

Left hand

Brickey Mouse

Right hand

Left foot

Head

Hat

Left Arm

Shoulders

Right Arm

Brickboy is copyright Sjors Trimbach 2005

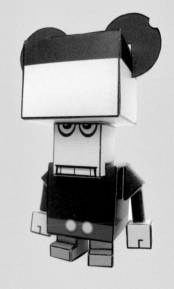

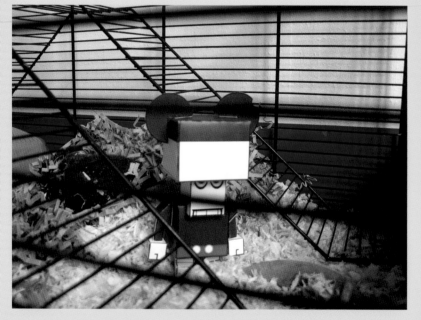

This page:
BRICKEY MOUSE
Template and paper toys.
This is my favorite personal design of my Brickboy figure. He seems annoyed from having to wear the ears.

Opposite:
THOUGHT PROCESSOR
Paper toys and template.
This is a collaboration with Phoneticontrol where he designed the character and I did the paper model. Took over a year to design but is one of my best models ever. This is my Orange Killer colorway.

All artwork by Sjors Trimbach.
All images courtesy of Sjors Trimbach.

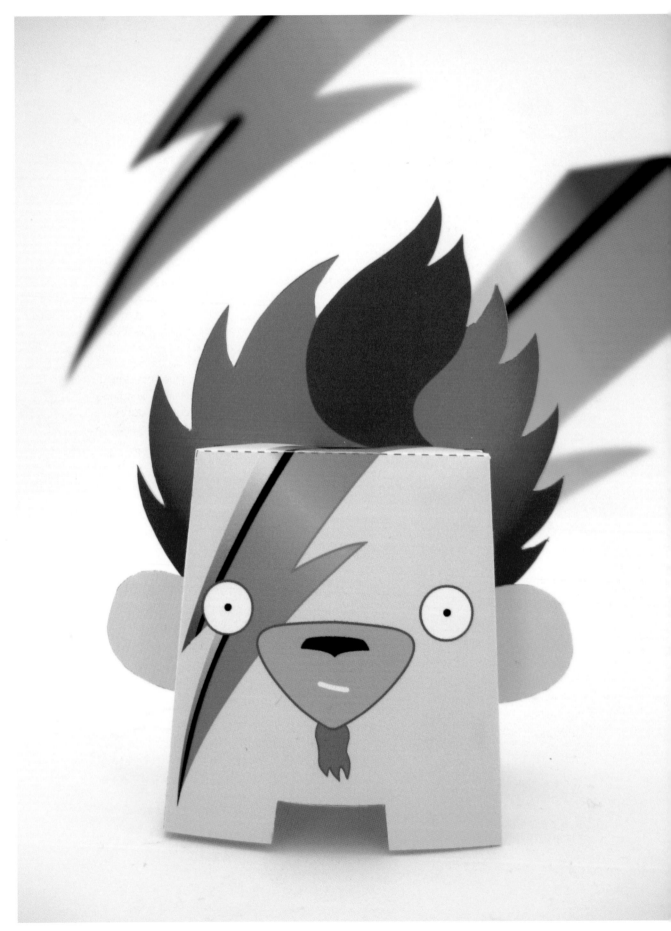

dolly oblong

www.dollyoblong.com
THE NETHERLANDS

"I'm a plush maker and paper toy designer who fills every spare minute knitting cute, cuddly creatures, building pieces of Paper Totem, doodling, designing, and keeping track of all things happening in my world on my blog. I love collecting toys, I'm mad about bunnies, and do not start a day without a cup of Earl Grey! Last but not least, I love collaborating with other artists from around the world. What I like most about paper toys is that any-body with basic materials like a printer, scissors, and some glue can start their own toy collection! As a designer, it's easy to connect with a worldwide audience, because most paper toys are freely available for download. For me, paper toys are about pushing myself creatively and getting designs out there."

This page:
PAPER PEPA
Very first paper toy design for free download to promote plush.

Opposite:
PAPER BOWIE
Limited edition paper lion inspired by famous seventies' glam rocker.

All artwork by Dolly Oblong. All images courtesy of Dolly Oblong.

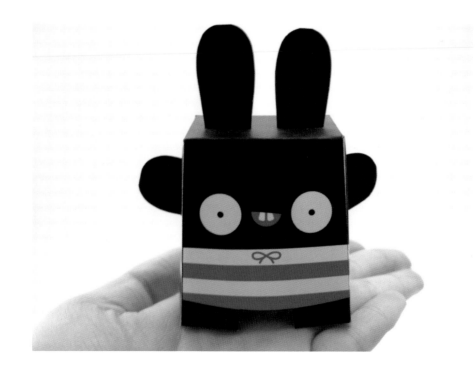

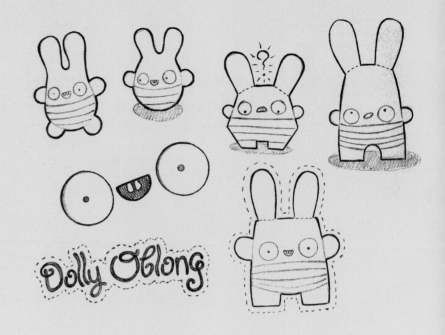

This page. top:
DOLLY OBLONG SKETCHBOOK
Middle:
BUBBLES
Paper toy.
Bottom:
BILLY BRAINS
Paper toy.

Opposite:
PAPER BUNNY SERIES
First paper toy designs based on knitted bunnies.
Seen here: BARE-BOTTOMED BALDWIN, REGGAE MARLEY, SPECKLED SALT, and FEISTY PEPA.

All artwork by Dolly Oblong.
All images courtesy of Dolly Oblong.

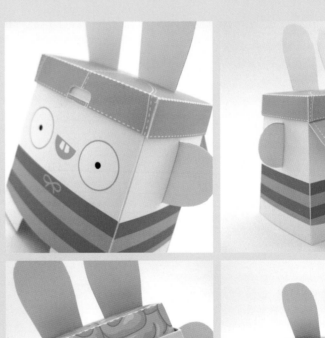

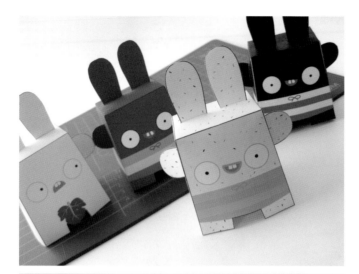

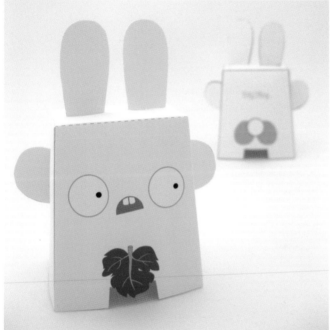

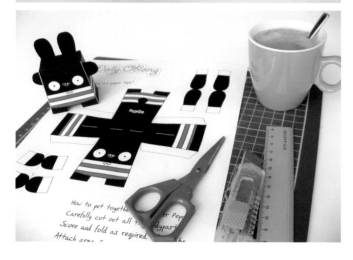

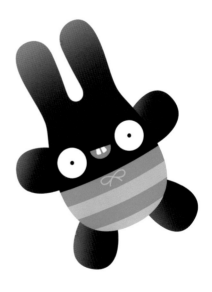

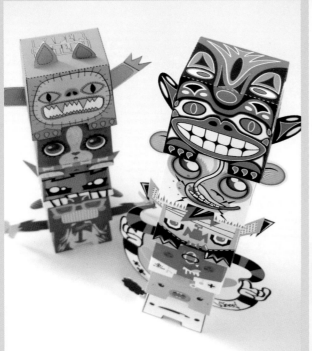

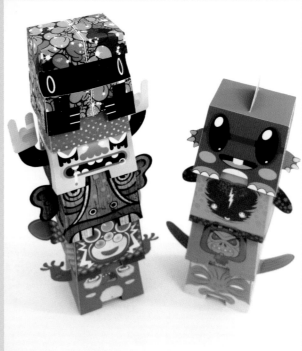

This page, top:
PAPER TOTEM!
Selection of totem pieces by the first twenty artists who contributed designs to Paper Totem!
Bottom:
SMASHER!
Totem of Smasher! a commissioned toy for the Portuguese magazine *Smash!* This photo inspired the idea of the Paper Totem! project.

Opposite:
BUBBLEBOT
Pink paper robot holding hobby knife and glue. Designed for Urban Paper Tokyo.

All artwork by Dolly Oblong.
All images courtesy of Dolly Oblong.

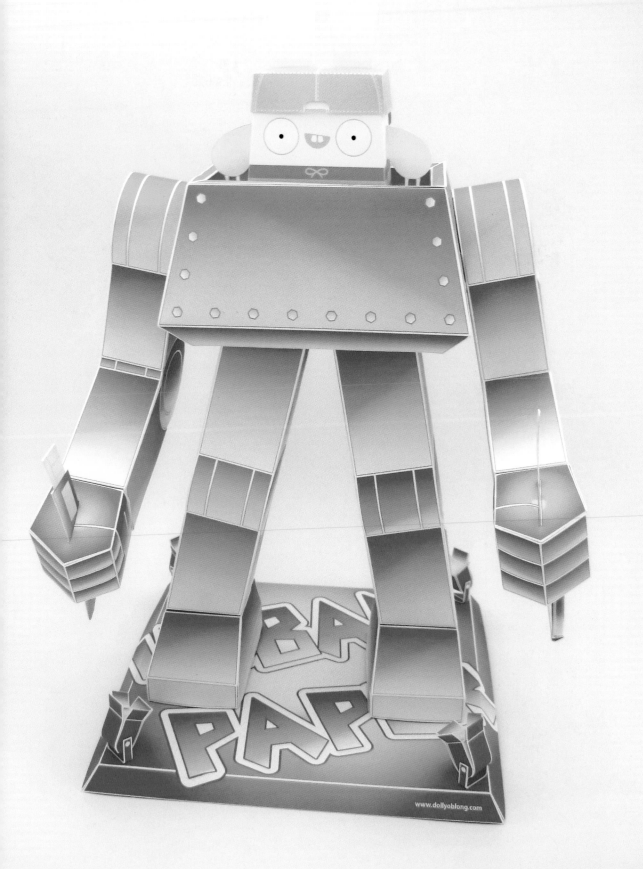

www.dollyoblong.com

This page, top:
MAJOR TOM
Plush and paper toy.
Bottom:
PAPER CAT SERIES
From left to right: MAJOR TOM,
BANG BANG, SUNNY, and ZIGGY.
Complete series of cats available
for free download.

Opposite:
LUCKY
Exclusive cat design for the Urban
Paper Tokyo show.

All artwork by Dolly Oblong.
All images courtesy of
Dolly Oblong.

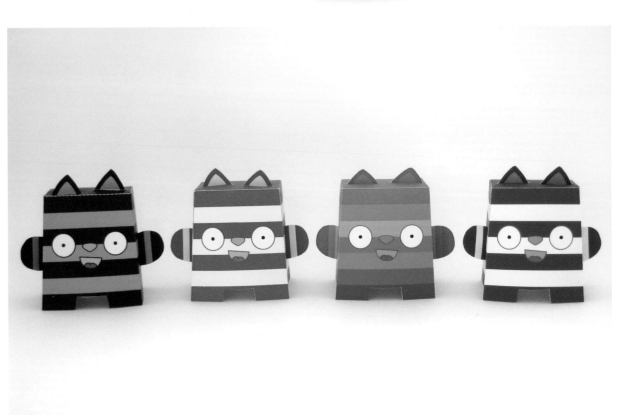

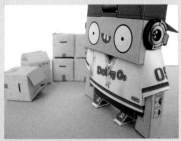

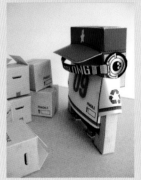
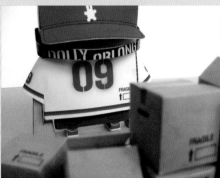

This page, first and second rows:
CARDBOARD BOXY
Cardboard custom design of
Shin Tanaka's Boxy toy.
www.shin.co.nr
Third row:
EL PICANTE!
Fourth row:
DON NOCHE!
El Picante! and Don Noche! are
two customized toys done in
Mexican lucha libre style of
Mycryptonauts' paper Cryptonauts
for his Battle Royale.
www.mycryptonauts.com

Opposite page:
PAPER LION SERIES
Complete paper lion series for free
download. Seen here: IVORY,
COLOSSUS, INDIGO, and RAMESES.

All artwork by Dolly Oblong.
All images courtesy of
Dolly Oblong.

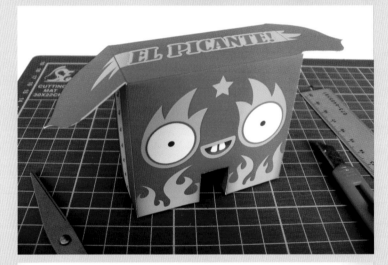

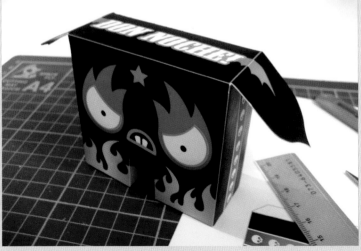

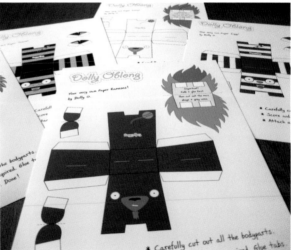

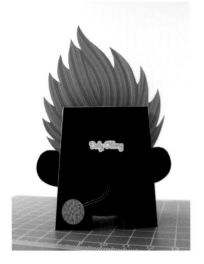

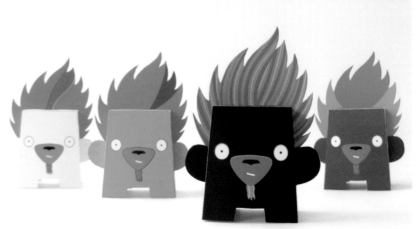

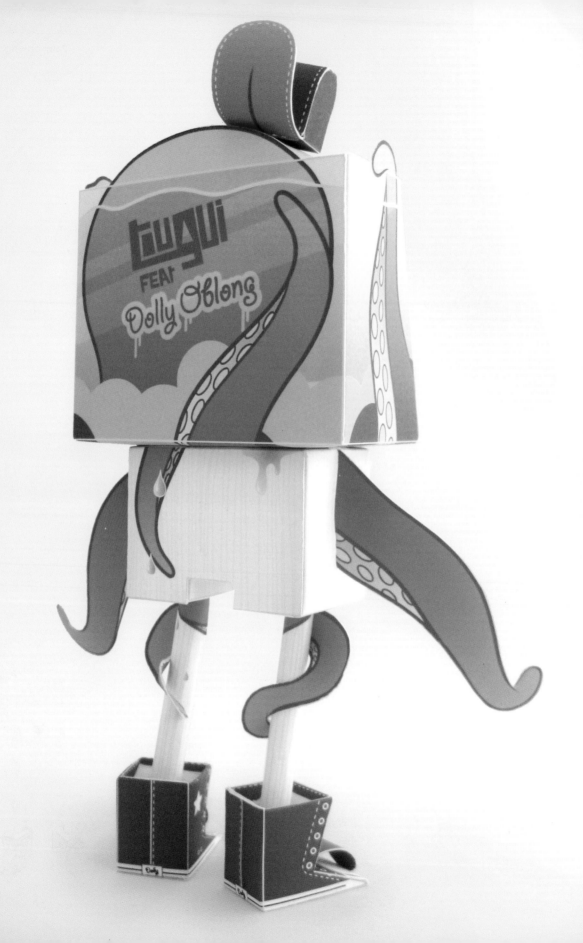

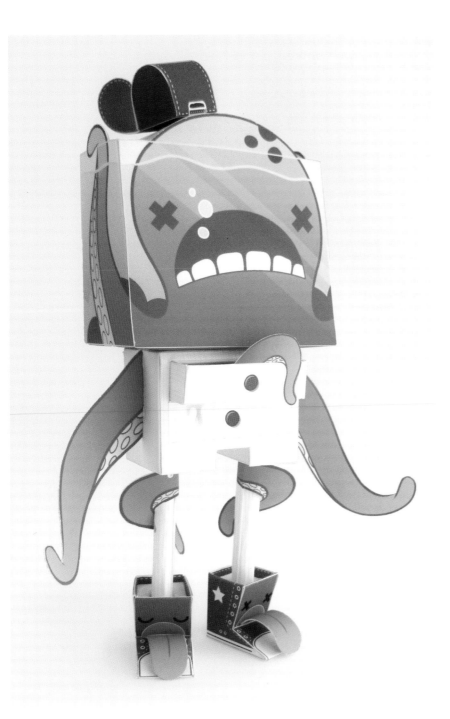

This page and opposite:
FREDDY THE FISHTANK SQUID
Fishy customized for Tougui's
RODRIGO DEL PAPEL exhibition
in Paris, France.
www.tougui.fr

All artwork by Dolly Oblong.
All images courtesy of Dolly Oblong.

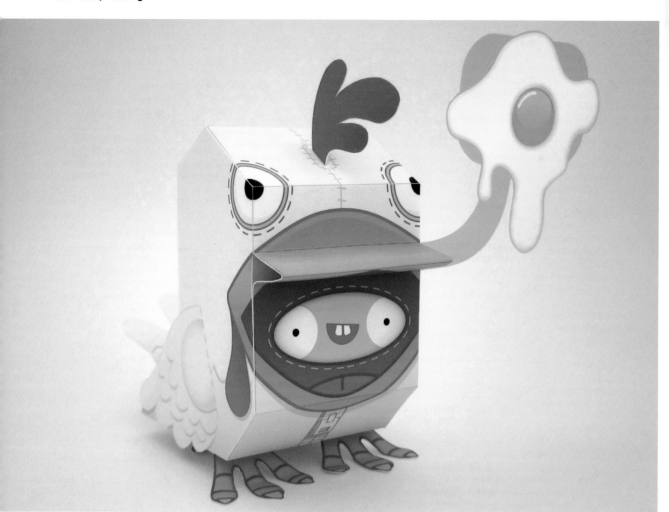

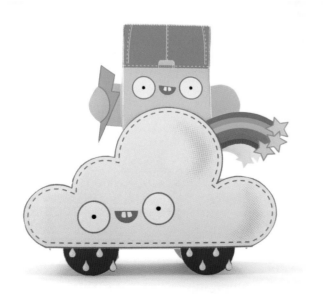

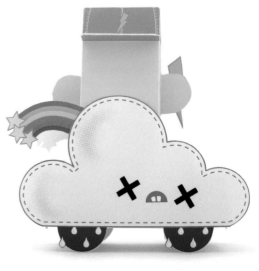

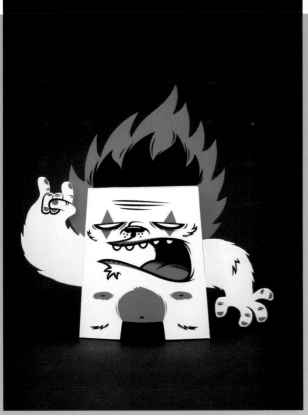

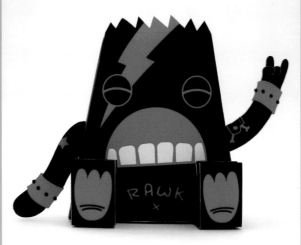

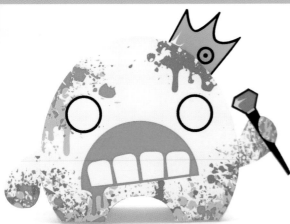

This page, top, left to right:
DOUBLE ROCK
Collaboration project with French artist Tougui.
Middle:
LIL KING GAMI
Commissed toy in CMYK colors for the Web site, pimpit3d.com.
Bottom:
PAPER STICKIES!
Series of six paper toys designed for the Brazilian Expo Stickers 2009 filled with stickers of artists participating in the expo.

Opposite page, top:
TUCKY
Customized toy of Josh McKibie's Nanibird series.
Bottom:
JIMI
Sunny cloud surfing custom for Customized toy for Jack Hankins's Calling All Cars project.

All artwork by Dolly Oblong.
All images courtesy of Dolly Oblong.

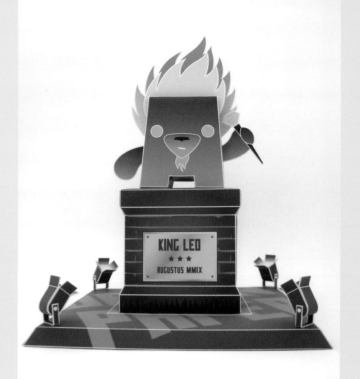

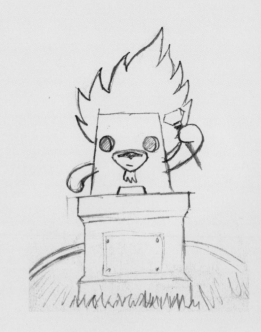

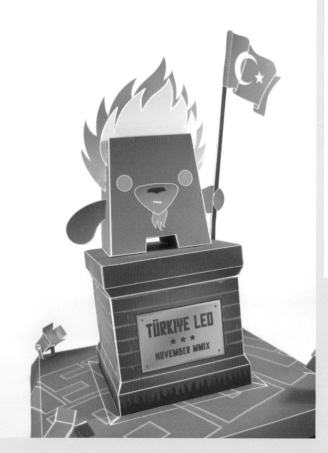

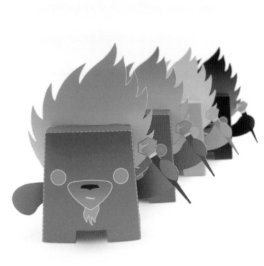

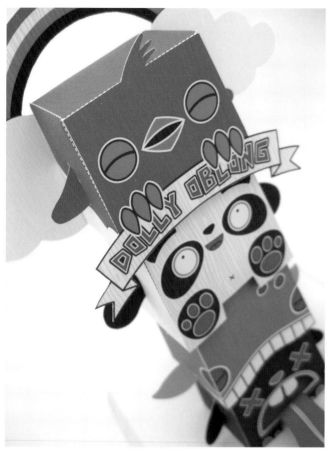

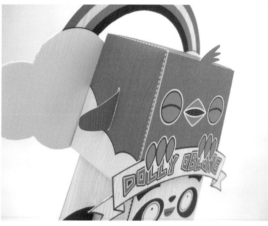

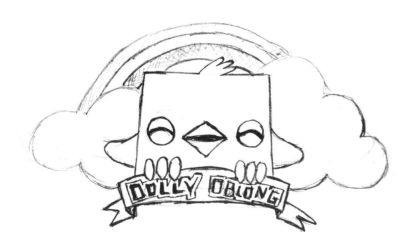

This page:
DOLLY OBLONG PAPER TOTEM!
Paper Totem! by Dolly Oblong.
Designed for the Urban Paper show in
The Netherlands.

Opposite, top:
KING LEO
Blue lion statue designed for the Urban
Paper show. Paper toy and sketch.
Bottom, left to right:
TURK_YE LEO
Red Turkish statue designed for Milk
Gallery in Istanbul.
CMYK LEO
Limited edition CMYK-colored lions
available at Playgrounds festival.

All artwork by Dolly Oblong.
All images courtesy of Dolly Oblong.

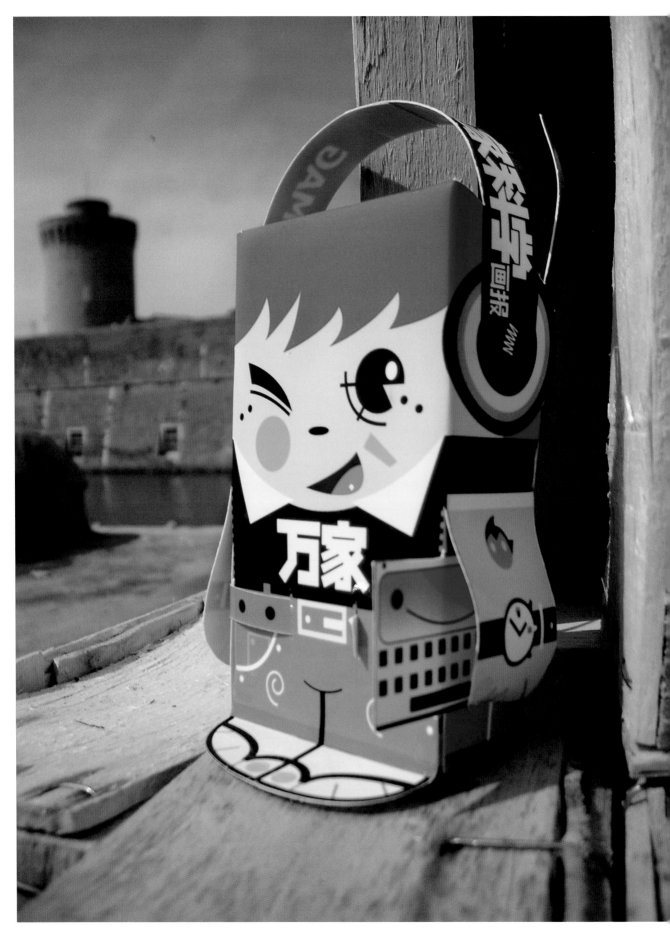

mau russo

www.maurusso.com
ITALY

"I love paper toys because, above everything else, they are toys—toys to play with and toys for company to enjoy. When I see my designs becoming a real object you can see and touch, I feel like a real artist, perhaps even a 'god' that can create life! I also love paper toys that are easy to cut and fold, so I prefer easy templates, not just paper toys to look at on the Internet, but also something that is easy to build and have fun with for all lazy guys like me!"

This page and opposite:
TECHMAG
Sketch, template, and paper toy for lifestyle Chinese magazine *Techmag*.

All artwork by Mau Russo.
All images courtesy of Mau Russo.

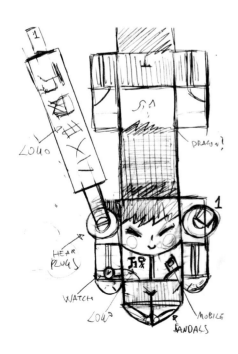

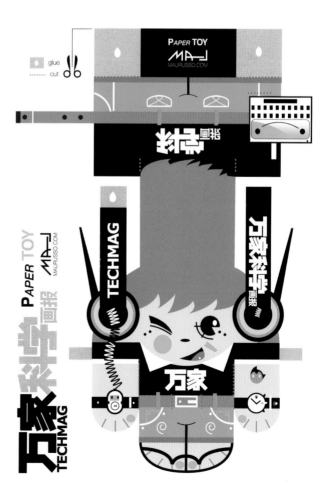

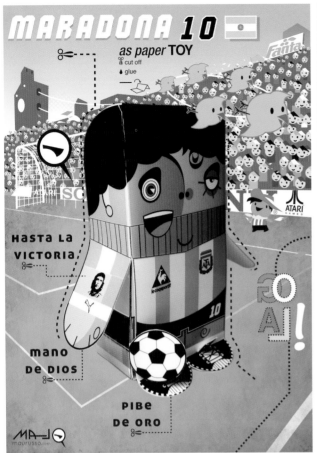

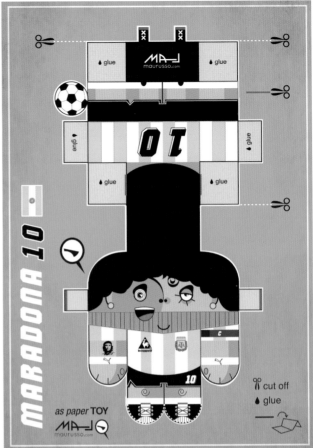

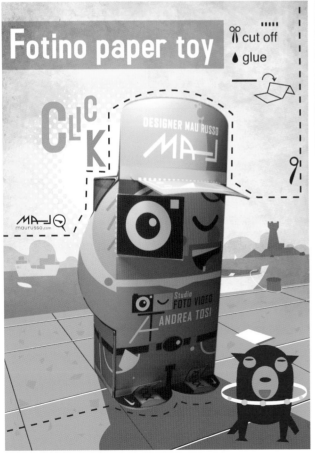

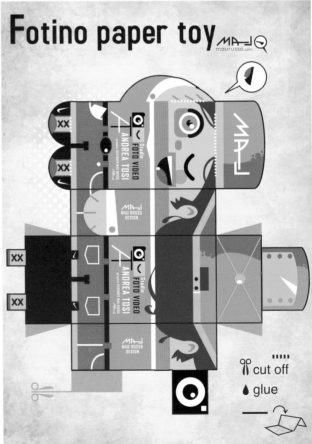

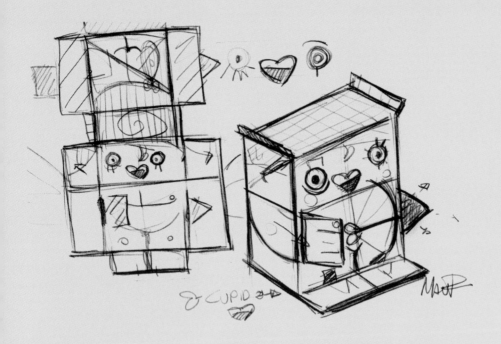

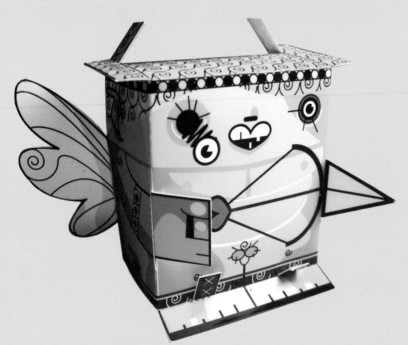

This page:
MY CUPIDO
Sketch and paper toy.

Opposite, top row:
MARADONA
Paper toy and template.
Bottom row:
FOTINO
Paper toy and template for a
photo studio.

All artwork by Mau Russo.
All images courtesy of Mau Russo.

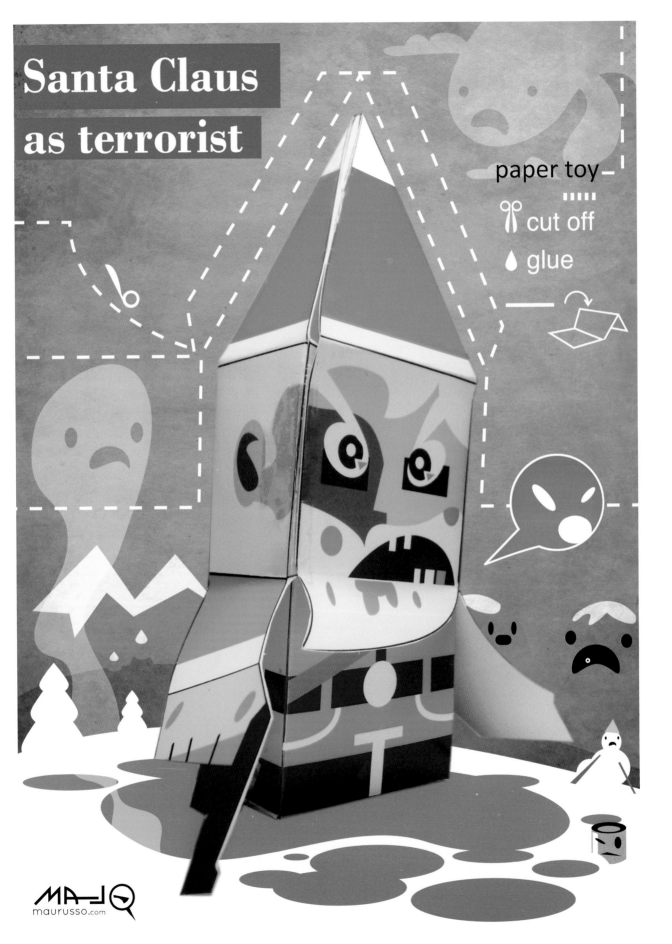

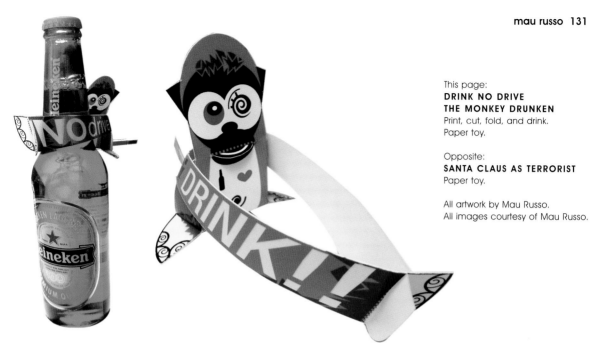

This page:
DRINK NO DRIVE
THE MONKEY DRUNKEN
Print, cut, fold, and drink.
Paper toy.

Opposite:
SANTA CLAUS AS TERRORIST
Paper toy.

All artwork by Mau Russo.
All images courtesy of Mau Russo.

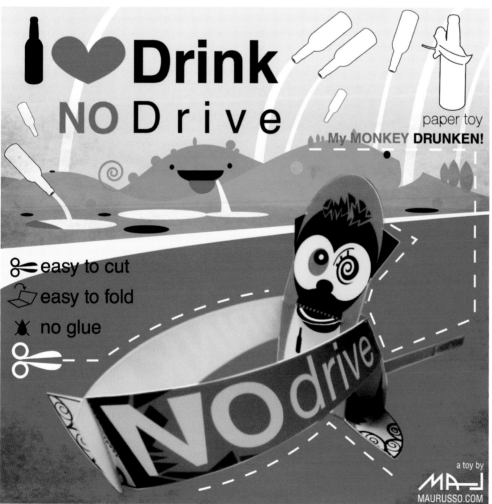

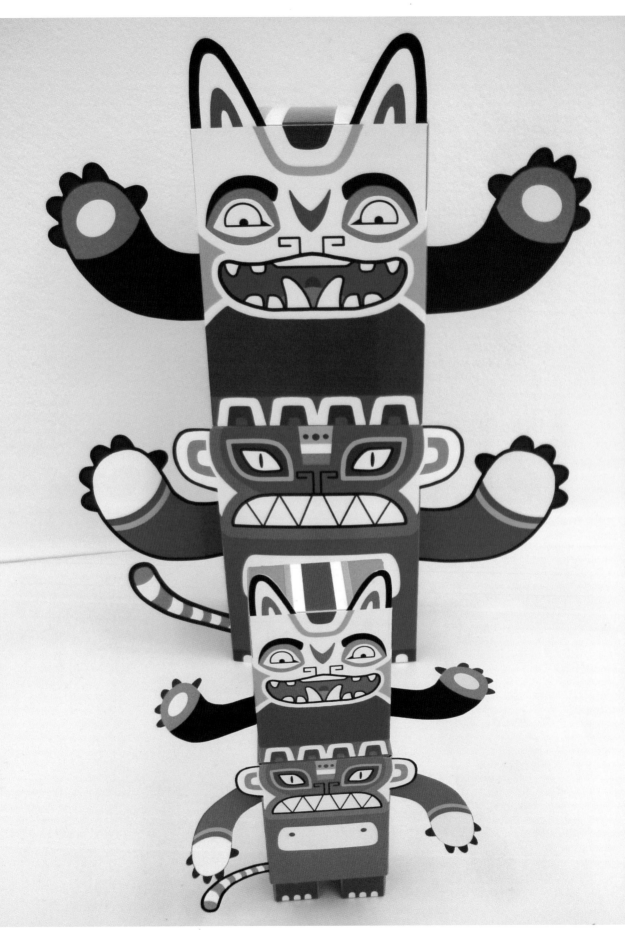

creature-kebab

www.creaturekebab.co.uk
UK

"Paper toys are fantastic! I really love taking my 2-D characters into the realm of 3-D through paper engineering. When I finish a design, I upload it to the Web for others to download and build. It's a great way to promote yourself as an artist, and also to spread some fun around the world. It makes me happy to know that office workers everywhere download my toys and secretly build them when they should be working. I currently have several paper toys in my work space. Seeing their grinning faces everyday gives me so much inspiration and joy. Remember to recycle your paper toys when they've faded or fallen apart!"

This page:
Various character designs from Creaturekebab's extensive menagerie of monsters.

Opposite:
TOTEM TYSON
Paper toy.

All artwork by Creaturekebab.
All images courtesy of Creaturekebab.

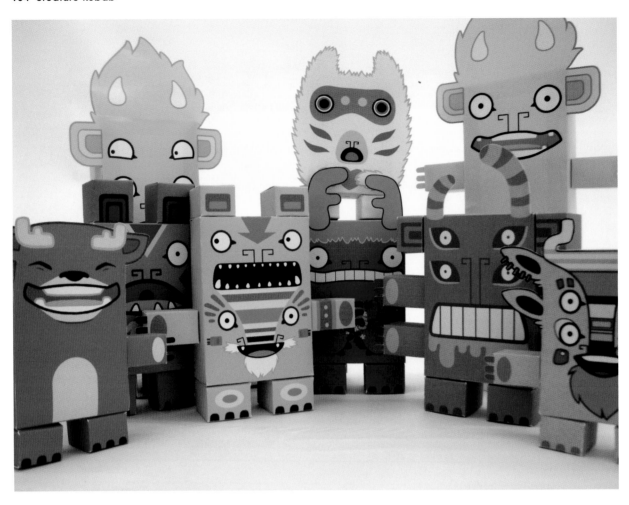

This page, top:
SERIES 1
Downloadable paper toys 2008–2009.
Bottom:
TOTEM TYSON
Illustration.

Opposite, clockwise from top left:
**BYORKIE THE POLAR BEAR AND RUDY
THE REINDEER**
Paper toys.
**BLUE BEAR, BEARZAH, AND SNEEDER
RIDING ON DANGER STEVE THE DRAGON**
Paper toys.
**TOTEM TYSON
CAPTAIN CHILLI PEPPER
BLUE BEAR AND SNEEDER
THE SNIN**
Paper toys.

Following pages:
MONSTER STAMPEDE
Creaturekebab's poster.

All artwork by Creaturekebab.
All images on these pages courtesy of
Creaturekebab.

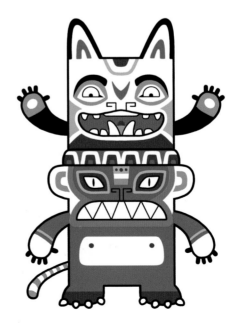

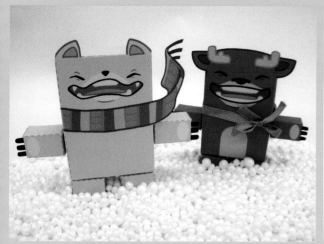

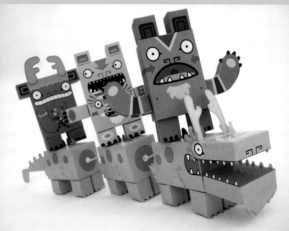

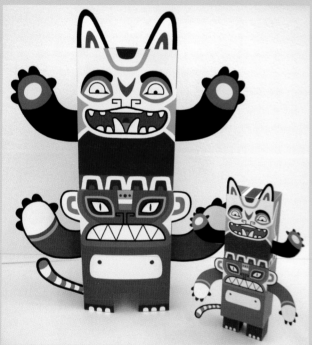

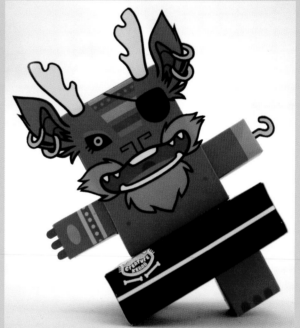

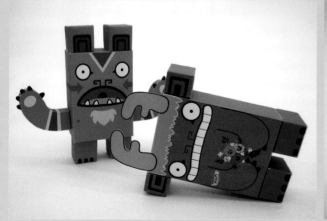

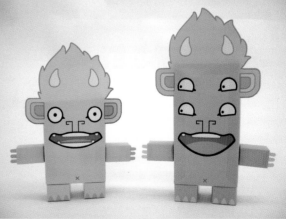

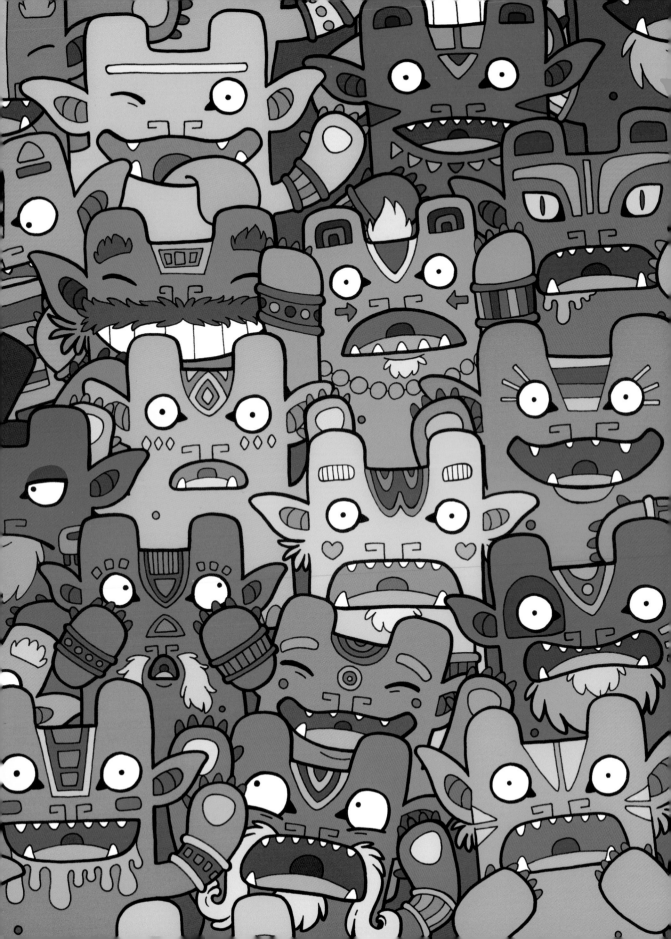

TV NINO

www.thunderpanda.com

- Cut all the parts.
- assemble them together.
- use your imagination.
- there are no basic rule.
- To see the photos check:
http://thunderpanda.com/tvnino

antenna

Pair of hand

Pair of foot

the TV
of
TV NINO

Body

www.thunderpanda.com

TV NINO

www.thunderpanda.com

thunder panda

www.thunderpanda.com
Jakarta Timur
INDONESIA

"Since the first time I saw someone making figures out of paper, the idea of creating a character out of paper seemed stimulating, and all of a sudden I was trapped in its geometrical shape, doing mathematic calculations to find the exact measurement of each part and side. This kind of activity stimulates both sides of the brain, as you have to use both sides in order to do the math and the design, and I believe my mind is clearer after each character I have created. Since paper toy design is so easy to access, I'm also able to spread my love for character design all around the world."

This page, top row, left to right:
LEMI THE SPACE WANDERER
Paper toy.
TV NINO
Paper toy.
Bottom row, left to right:
YETI LEMI
My own customs for Lemi's template. I call it Yeti Guy.
RAINBOW
Influenced by eighties color theme.

Opposite:
TV NINO
Original template.

All designs by Thunderpanda.
All photos by Eric Wirjanata, courtesy of Thunderpanda.

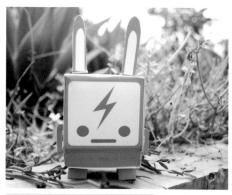
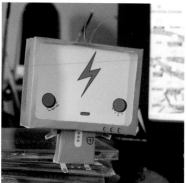

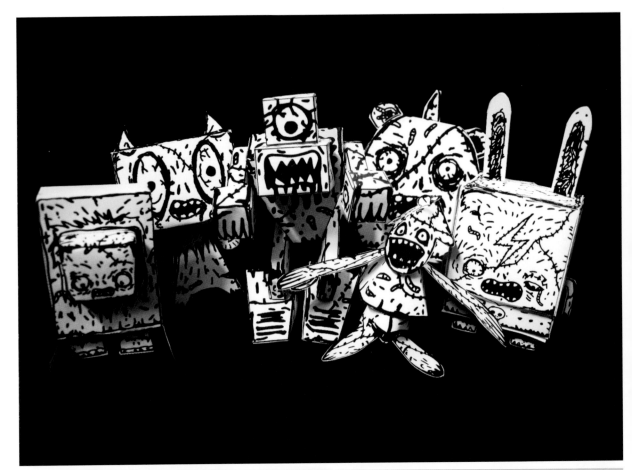

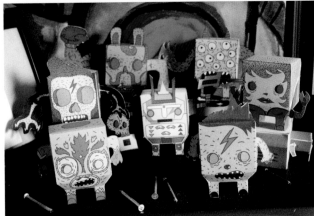

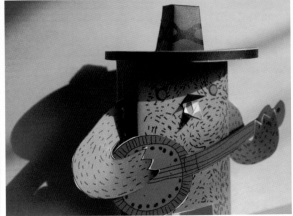

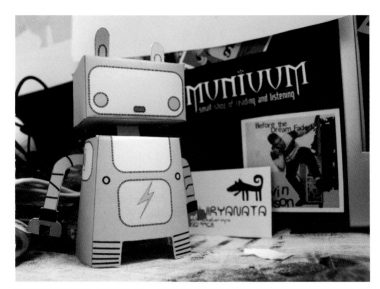

This page, clockwise from top left:
KYUU
A bunny robot character.
BUNNY PATROL
Robot sketch.
RIDE WITH ME
Child robot with tricycle illustration.
WILSON
Destructive robot paper toy.

Opposite, top:
THE ZOMBIEFIE 6
I took six different templates by other creators, and turned them into these sketch-like zombies, seen here.
They became one of the the most downloadable designs online, especially during Halloween.
Bottom, left to right:
PAPER GANSTA
Series of simple characters of complicated creatures.
BANJOBIRD
Paper toy based on Thunderpanda's Banjobird character.

All photos by Eric Wirjanata, courtesy of Thunderpanda.

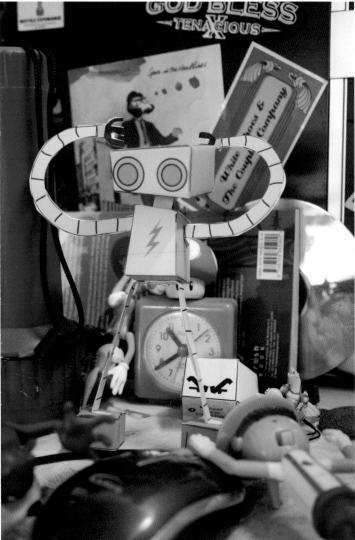

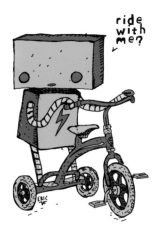

cubotoy

www.cubotoy.co.nr
www.flickr.com/photos/cubotoy
www.myspace.com/cubotoy
CHILE

"My love for toys goes hand in hand with my passion for drawing, designing, and creating. Cubotoy is all that and then some! With my brand, I play and enjoy with each creation. It allows me to communicate and build an imaginary world, and the best part is that you, him, them, and everyone else becomes part of it because they love them as much as I do."

This page and opposite:
DARTH PAPER
Paper toy.

All artwork by Cubotoy.
All images courtesy of Angello Marcello Garcia Bassi.

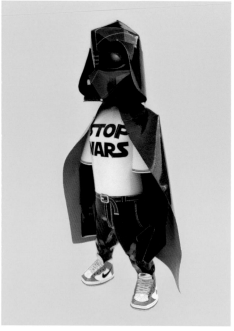

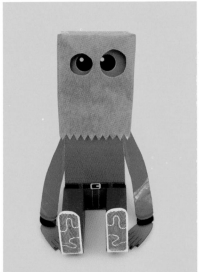
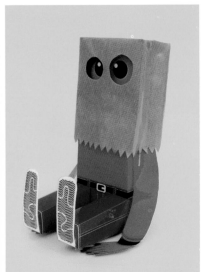

This page, top row:
MARKY
Paper toy.
Middle and bottom rows:
CUBOMON, THE SMALL MONSTERS
Paper toy.

Opposite, top row and middle row, left:
JAVIERA MENA
Paper toy and illustration for pop singer
Javiera Mena.
www.myspace.com/javieramenamusica
Middle row, right:
CUBOY
Paper toy.
Bottom row:
THE PLAY TOYS
Musical band paper toys. From left to
right: Flyboy, Cubadboy, and Cuboy.

All artwork by Cubotoy.
All images courtesy of Angello Marcello
Garcia Bassi.

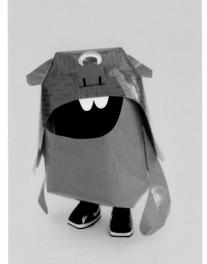
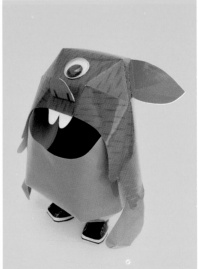
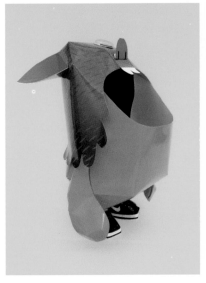
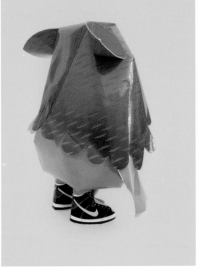

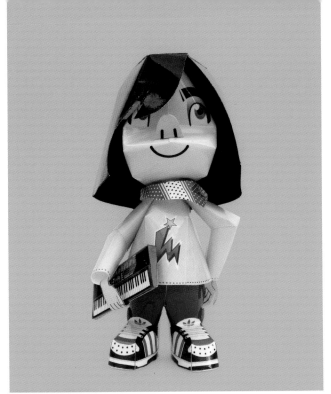

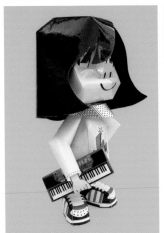
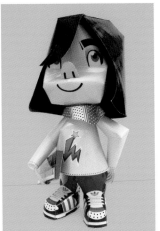

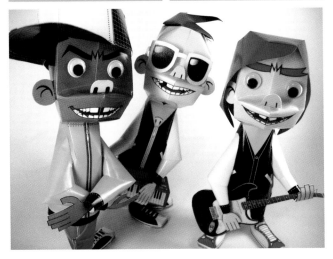
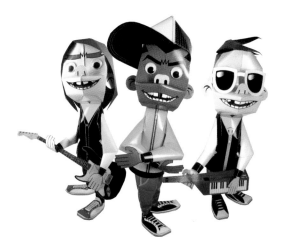

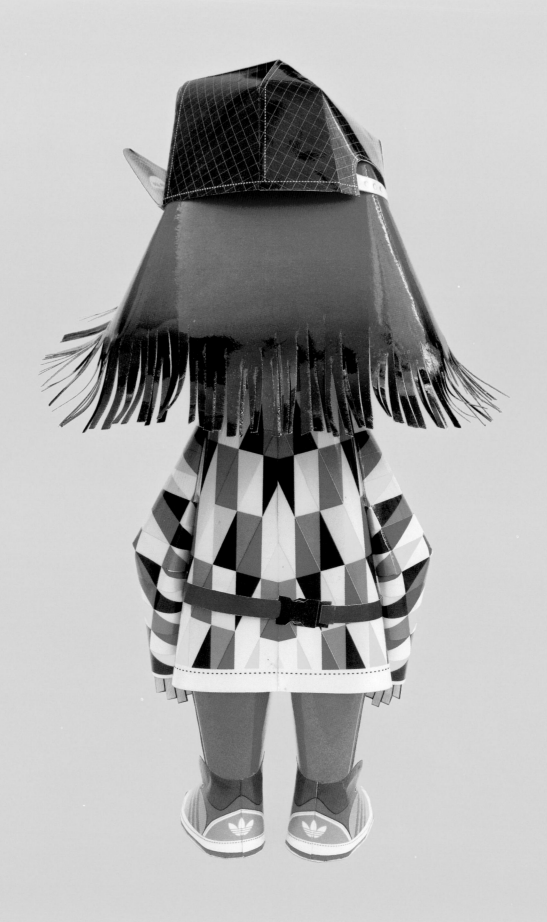

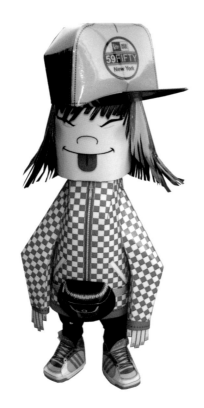

This page and opposite:
APPLE POP
Paper toys and illustration.

All artwork by Cubotoy.
All images courtesy of Angello
Marcello Garcia Bassi.

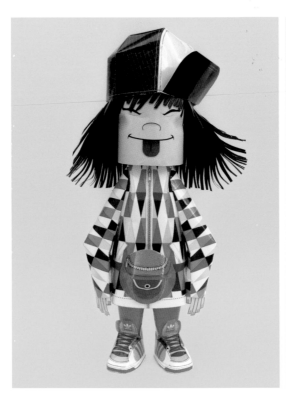

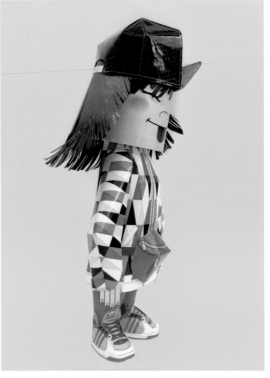

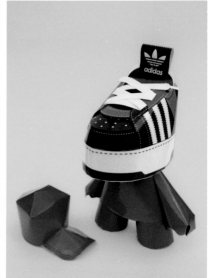

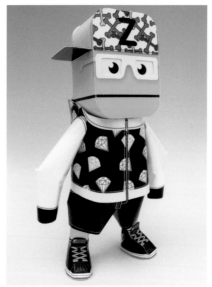
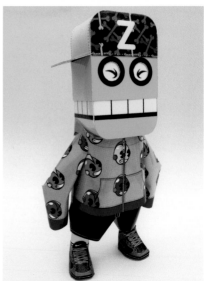

This page, top row:
KICKHEAD
Paper toy.
Middle row:
ZETA
Designed for Zoo Concept Store
in Santiago de Chile.
Bottom row:
CUBOTOY CHARACTERS
Illustration by Cubotoy.

Opposite, left to right:
JOE
FLYBOY
Paper toys.

All artwork by Cubotoy.
All images courtesy of Angello
Marcello Garcia Bassi.

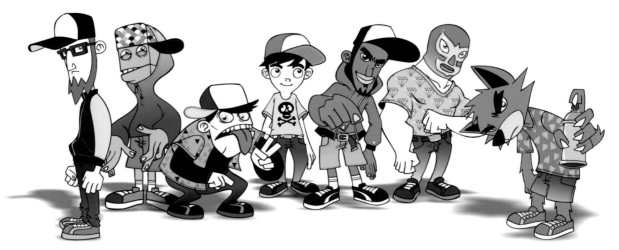

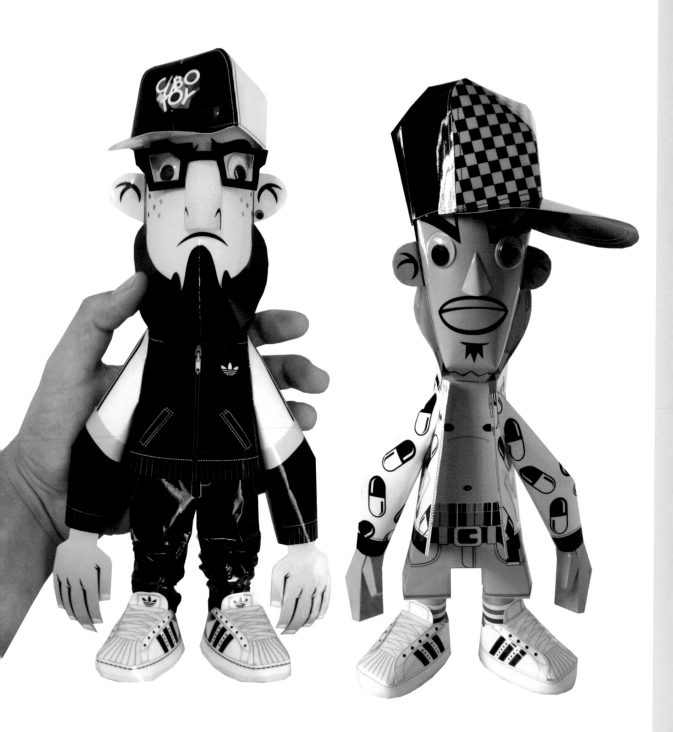

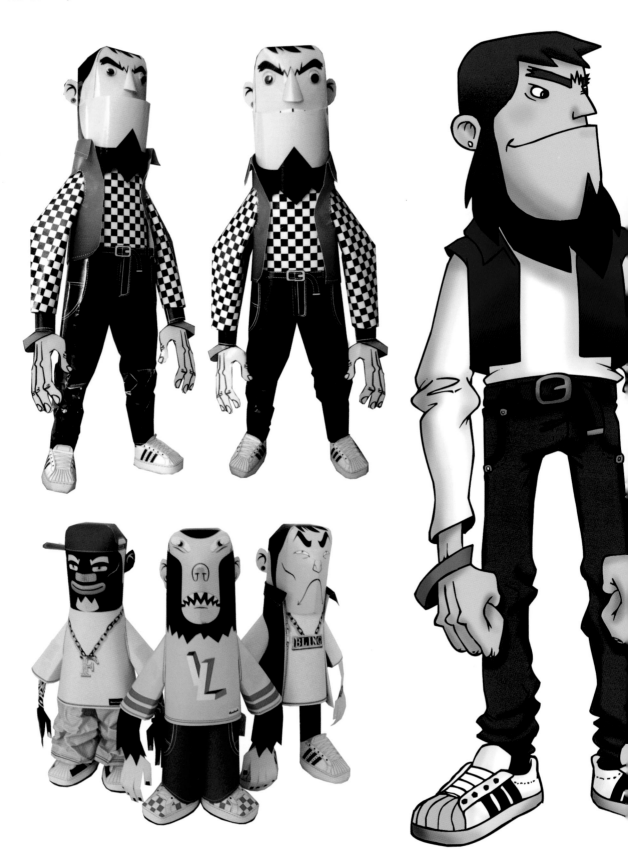

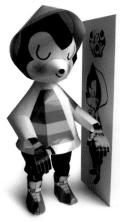

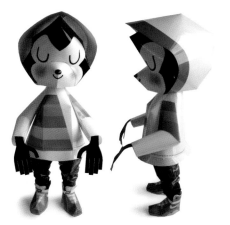
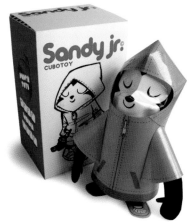

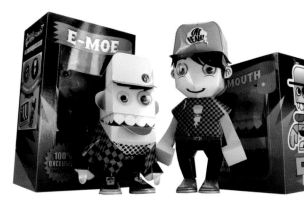
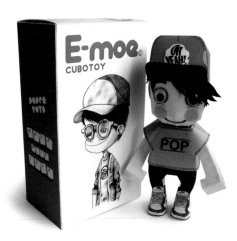

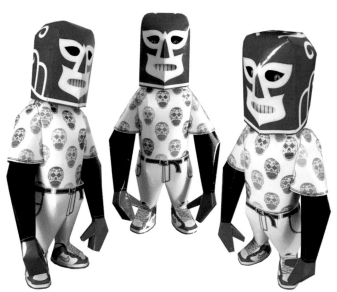

This page, top row, left to right:
SLEEPY SANDY
SANDY JR.
Middle row, left to right:
E-MOUTH & E-MOE
E-MOE
Bottom row:
CHICANO
Paper toys

Opposite:
VINCENT
Paper toy and illustration.
VATOYS LOCOS
Paper toys.

All artwork by Cubotoy.
All images courtesy of Angello
Garcia Bassi.

remember
thelittleguy

www.toypaper.co.uk
UK

"I love paper toys for one reason, really—they're easy to make! It doesn't matter who or where you are, you don't need any molds or machines, plus you need very little to get started, just a sheet of paper, really. I start every toy with a box shape, then redesign, add shapes, and cut bits away until I am left with something from which I can develop a character. Most of my toys have this simple style because I try not to make them too complicated. I want people to build them, rather than be put off by the amount of time they need to work with scissors and glue. The goal of my Toypaper project is still the same as it was when I started: an excuse to create cool things, meet some lovely people along the way, and to give away free stuff. So don't be a stranger, drop by toypaper.co.uk sometime and say hello!"

This page:
LITTLE RONALD
Ten-foot concrete monster in the Northern Quarter, Manchester.

Opposite:
SHIORI YES
No models playing out in Liverpool.

All designs by Toypaper. All images courtesy of Toypaper.

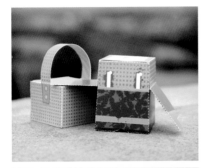

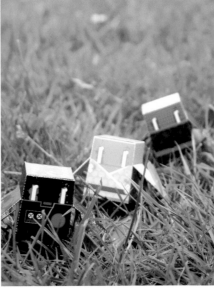

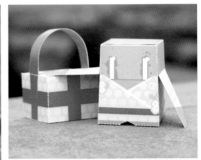

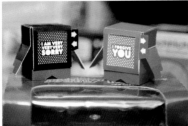

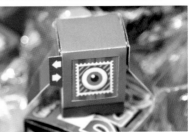

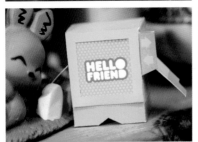

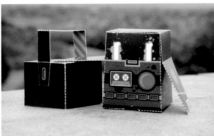

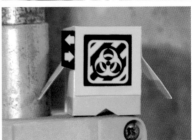

This page, top grid:
TOYPAPERS
Paper toys.
feelgoodproject.net.
someofmywork.co.uk
Bottom:
TOYPAPER MICRO RED ENJOYING SUSHI
Photograph by someofmywork.co.uk

Opposite:
Prototyping a new bookmark character
in the mN office, Manchester.
Bottom row:
SHIORI YES
Taking a holiday at Brighton beach.

All designs by Toypaper.
All images courtesy of Toypaper.

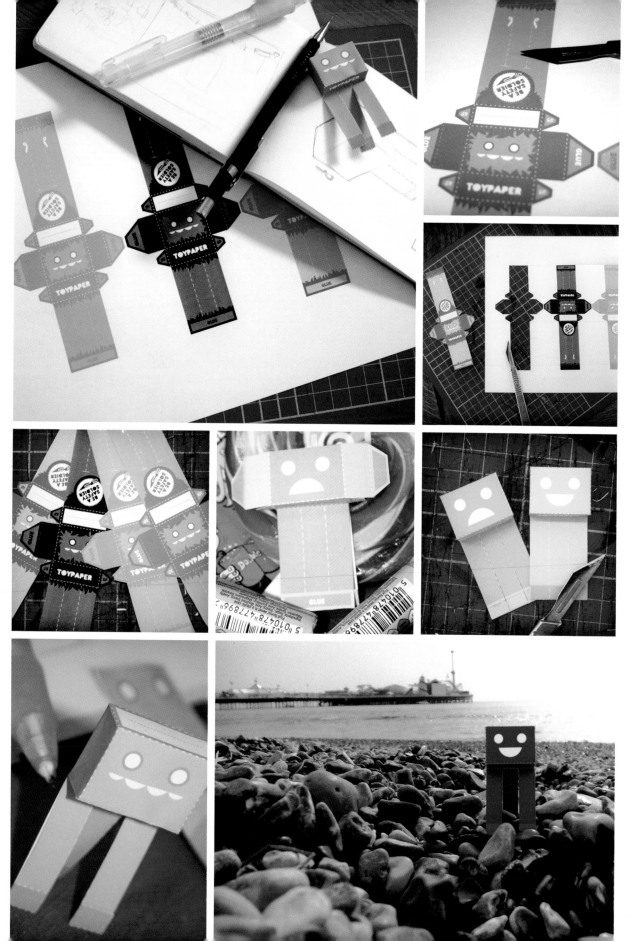

nanibird

www.nanibird.com
www.mckibillo.com
www.illoz.com/mckibillo
www.behance.net/mckibillo
www.drawger.com/mckibillo
JAPAN

"Nani is the Japanese word for 'what' and it pretty much sums up my experience of living here in Japan. I constantly find myself asking 'Nani? Nani?' But I wanted to turn the word into a thing, make it real, something I could hold and look at and, ultimately, give away. Paper seemed like a natural choice. Paper is a fast, cheap, forgiving medium to work out ideas. I love that some many talented artists and designers from around the world are using the same medium to make things that are given away for free."

This page:
THE DEARS
Paper toys.

Opposite:
HANDMADE
Paper toy.

All artwork by Josh Mckible.
All images courtesy of Josh Mckible.

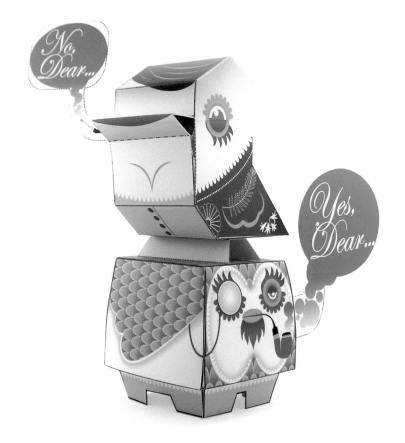

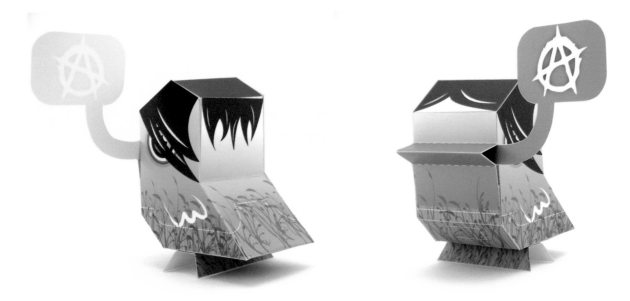

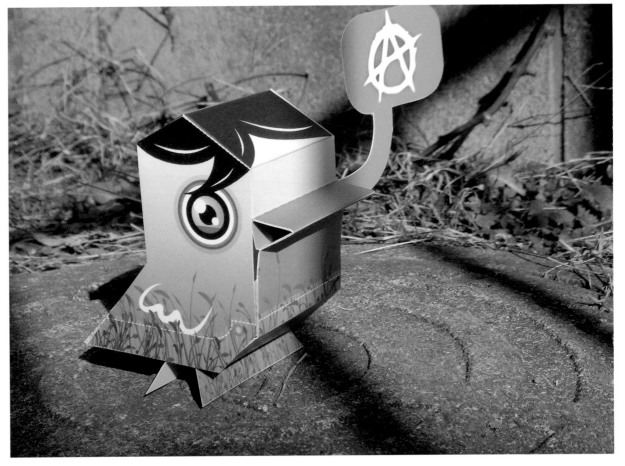

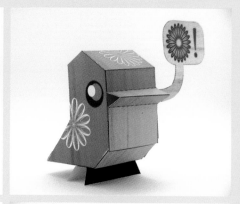

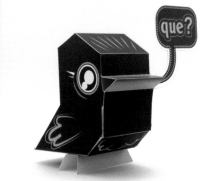

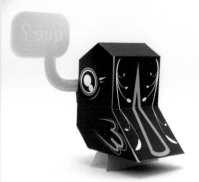

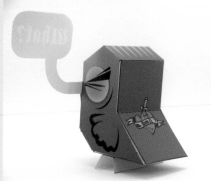

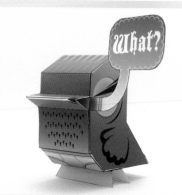

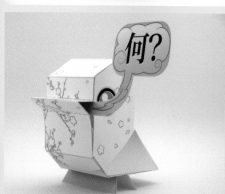

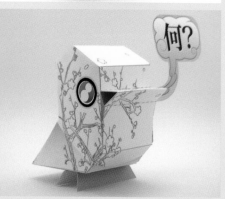

This page, first row:
WOODIE
Second row:
QUEBIRD
Third row:
DOITY BOID
Fourth row:
FUJIBIRD

Opposite:
ANARCHY FARMER
Paper toy.

All artwork by Josh Mckible.
All images courtesy of Josh Mckible.

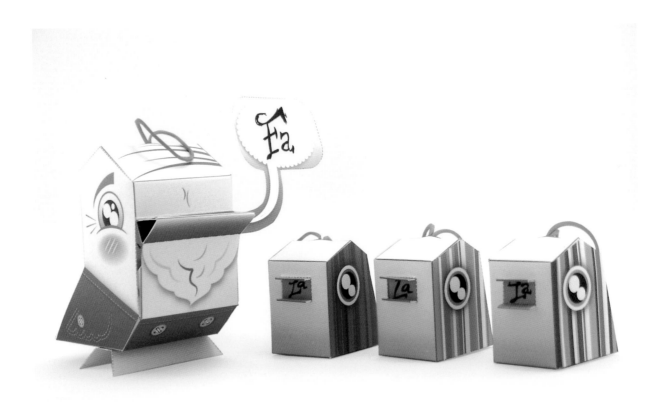

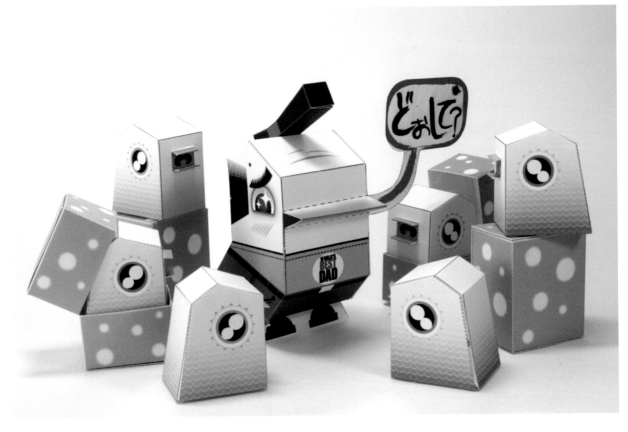

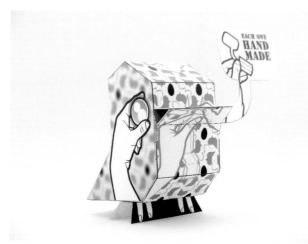

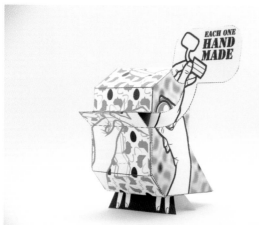

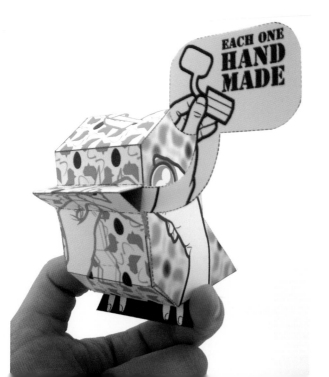

This page:
HANDMADE
Paper toy.

Opposite, top:
NANIXMAS
Paper toys.
Bottom:
NANIDAD AND THE PEEPS
Paper toys.

All artwork by Josh Mckible.
All images courtesy of Josh Mckible.

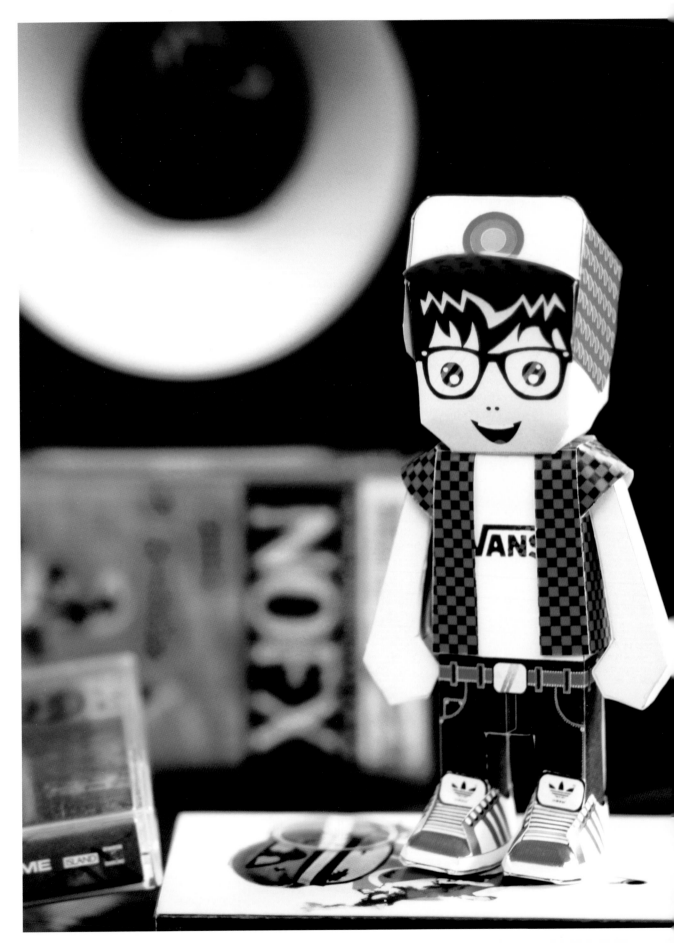

dadik triadi aka dyadik

www.dikids.blogspot.com
Jakarta
INDONESIA

"There are many reasons why I really love paper toys: they are cheap, useful, innovative, environmentally friendly, and it's easy to get and build awesome paper toys from all around the world. All you need is an Internet connection, a printer, a pair of scissors, glue, and a little time to build them. I love creating paper toy designs because it is good exercise for both my brain and my sense of creativity. Paper toys have always blown my mind, because when you see a flat piece of paper turn into a three-dimensional object, it feels like magic—from the intangible to the tangible. A paper toy is not just a toy, it is a new canvas on creating great art. That's why I fell in love with paper toys."

This page:
DUMPY PAPER TOY
First paper toy template that I have made.

Opposite:
DONNY
Paper toy.

All artwork by Dadik Triadi.
Photos by Bakti Nugraha and Rudi Purwana.
All images courtesy of Dadik Triadi.

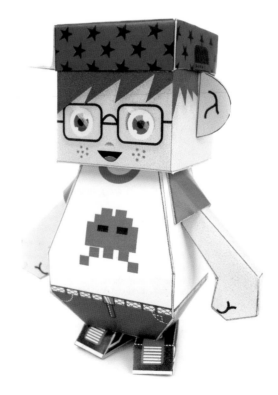

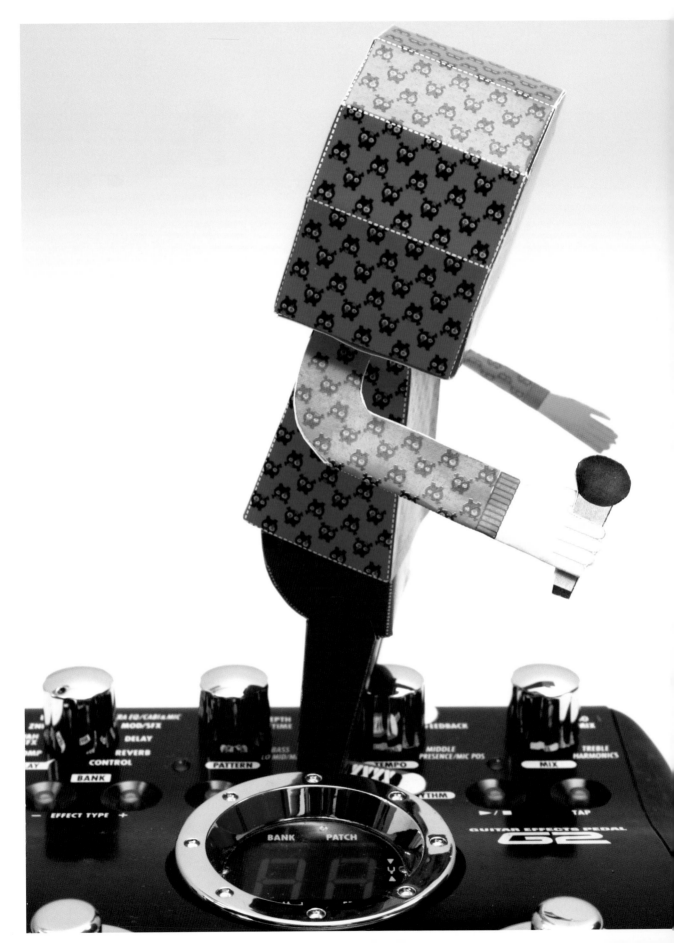

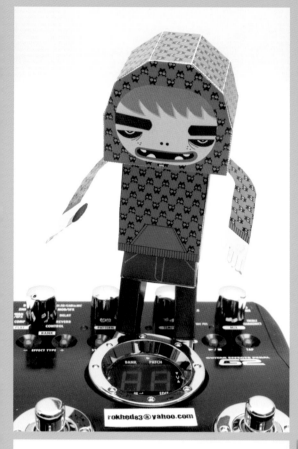

This page and opposite:
RUBY ROCK
A rock star singer paper toy.

All artwork by Dadik Triadi.
Photos by Bakti Nugraha
and Rudi Purwana.
All images courtesy of
Dadik Triadi.

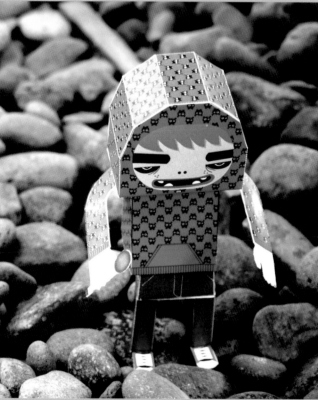

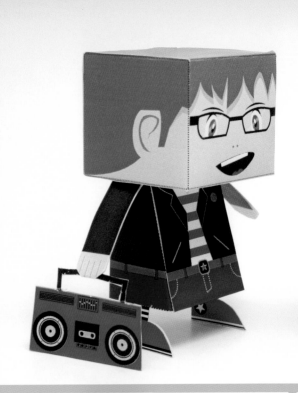
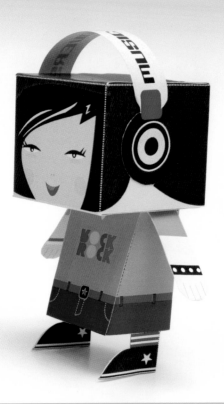

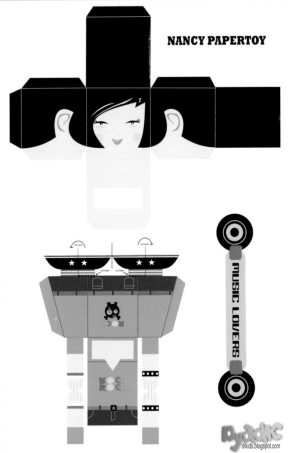

NANCY PAPERTOY

MUSIC LOVERS

dikids.blogspot.com

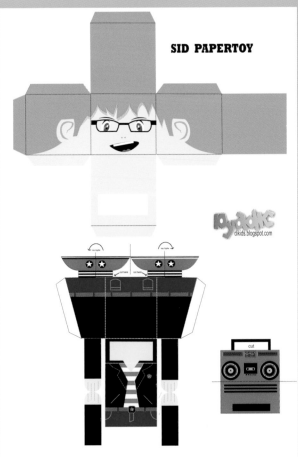

SID PAPERTOY

dikids.blogspot.com

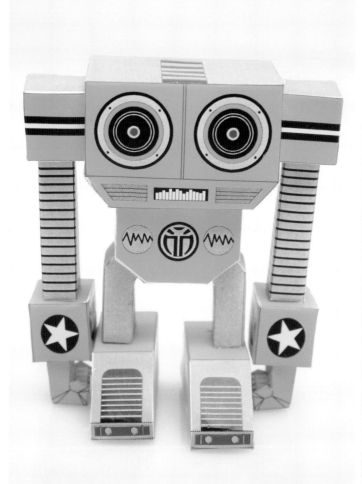

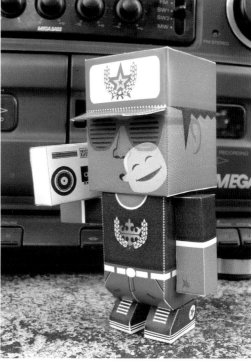

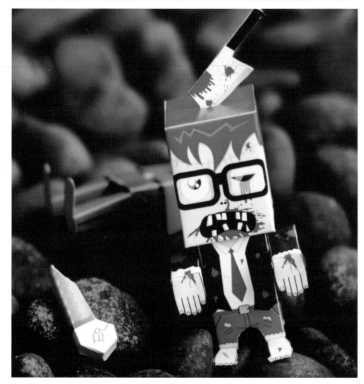

This page, clockwise from top left:
YELLOW ROROBOTAN
Paper toy robot.
DEE-J
Paper toy.
ZOMBIE BOY
Paper toy.

Opposite:
SID AND NANCY
Paper toys and templates.

Following pages:
VINI THE VIKING GIRL
Paper toys.

All artwork by Dadik Triadi.
Photos by Bakti Nugraha and Rudi Purwana.
All images courtesy of Dadik Triadi.

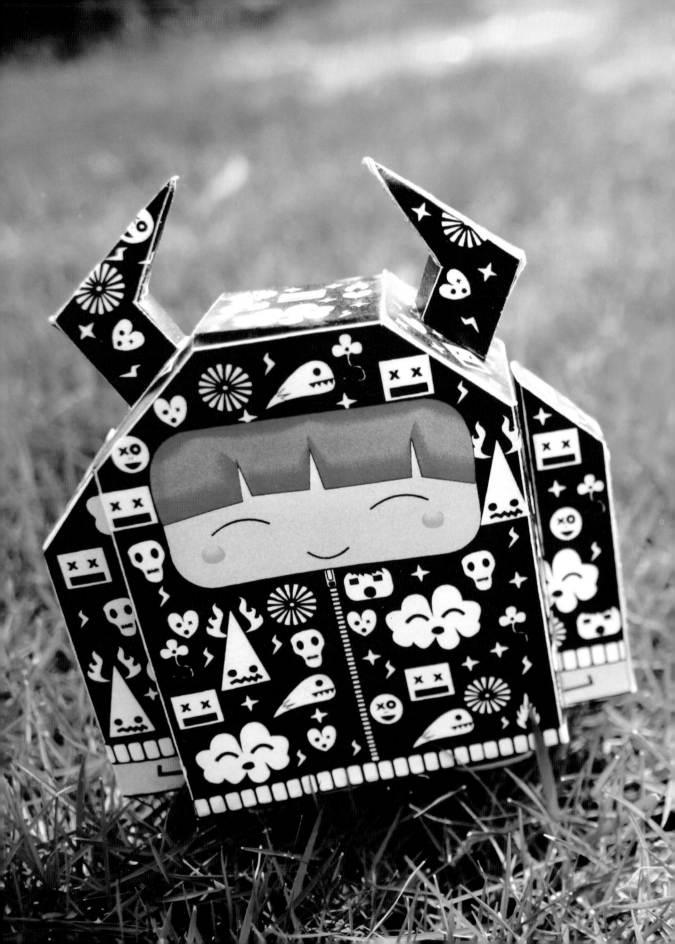

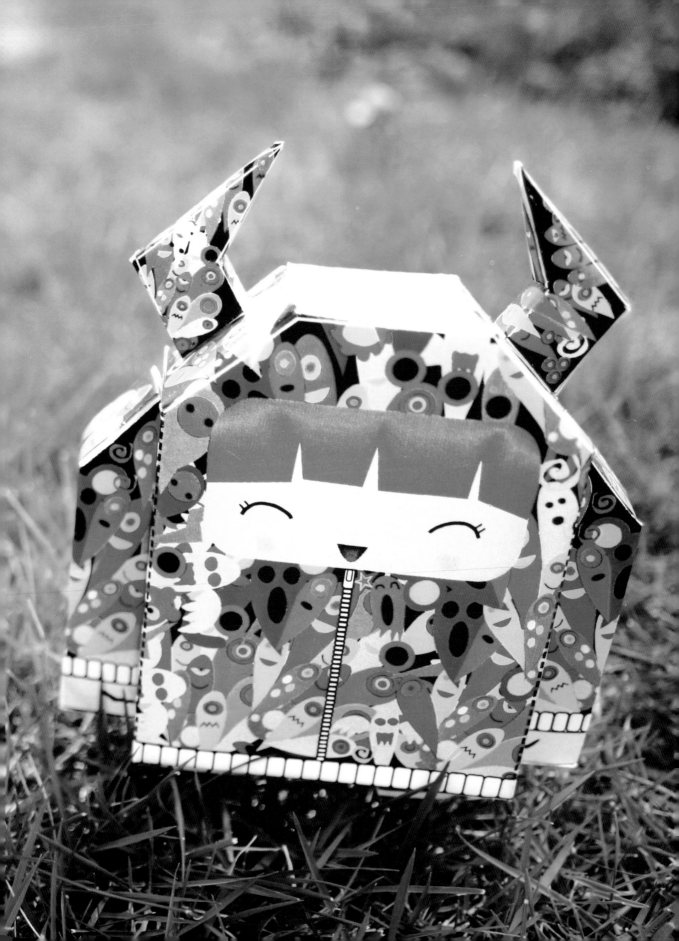

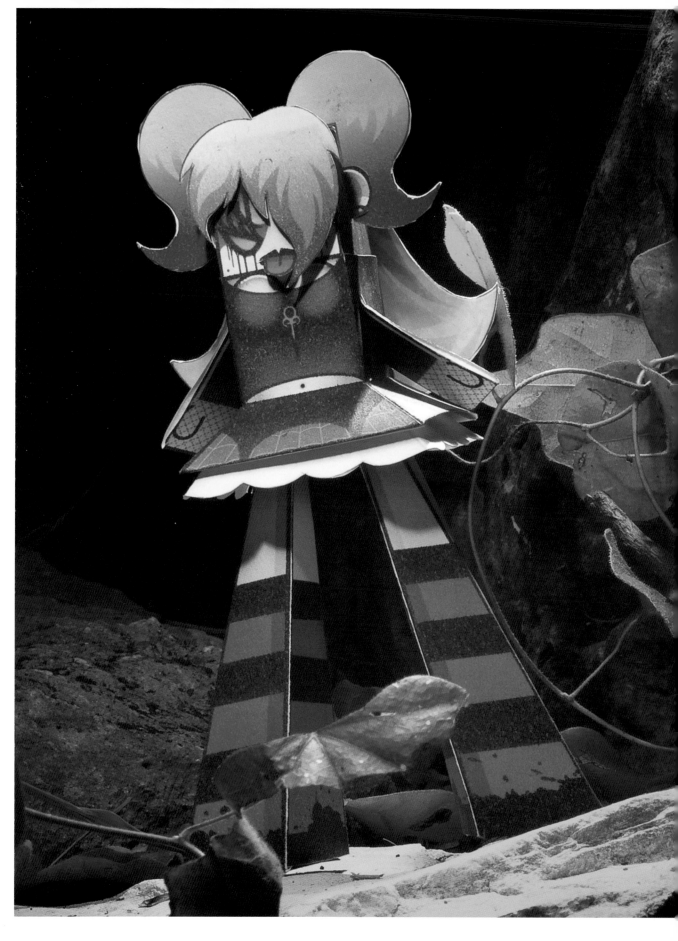

harlancore

www.harlancore.com
Austin, Texas
USA

"My love for toys goes beyond paper. I really like cute, small things, and wish to surround myself with them. I like to draw deformed and sometimes twisted versions of my favorite characters, and I am constantly challenging myself, trying to create characters that are full of life, but exist in a very confined, rectangular space. I make my toys out of paper because it is inexpensive, and the idea of sharing the templates with others on the Internet is very attractive. When I am not creating my own toys, I am downloading templates made by other artists and building them. It's very addictive; once you start, it can be very hard to stop."

This page:
THE TERROR TWINS
Paper toys.

Opposite:
LOLIGOTHIK
Paper toy.

All artwork by Jason Harlan.
All photographs by Vin Breau.
All images courtesy of
Harlancore.

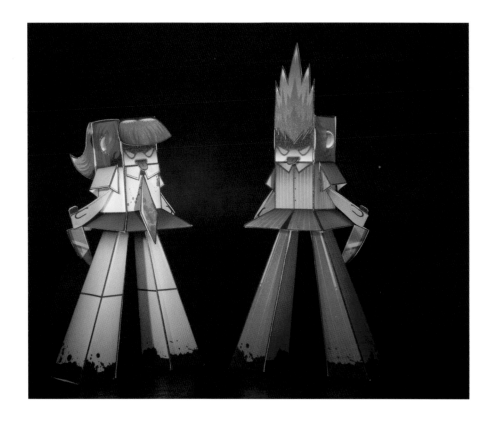

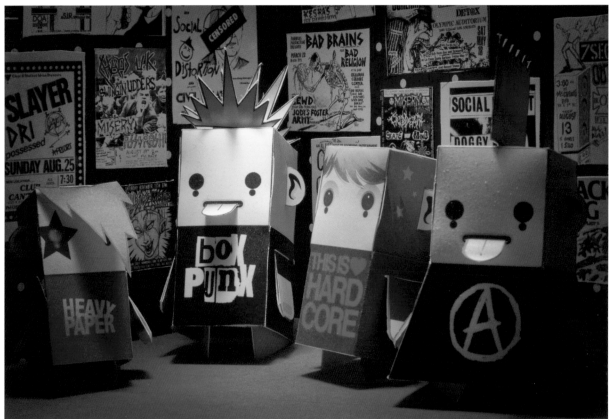

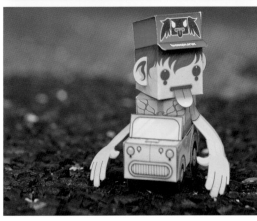

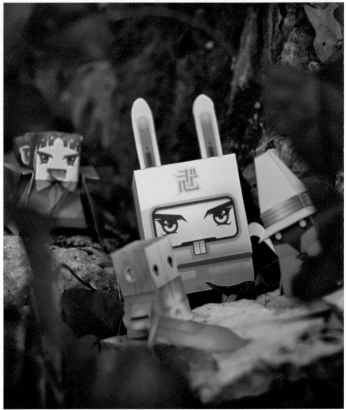

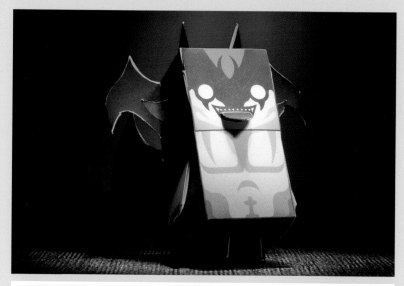

This page:
DEVILGUY
Paper toys and illustration.

Opposite, clockwise from top left:
BOXPUNX AT A PAPERCRAFT NIGHTCLUB
Paper toys.
BOXPUNX ADVENTURERS WITH SIR LEMICENT
Paper toys made for Eric Wiryanata's Lemi
The Space Wanderer series.
HOTROD SUMMER
Paper toy made for Horrorwood's Calling all
Cars! series.
BOXPUNX KITTY CATS
Paper toys.

All artwork by Jason Harlan.
Images courtesy of Harlancore.

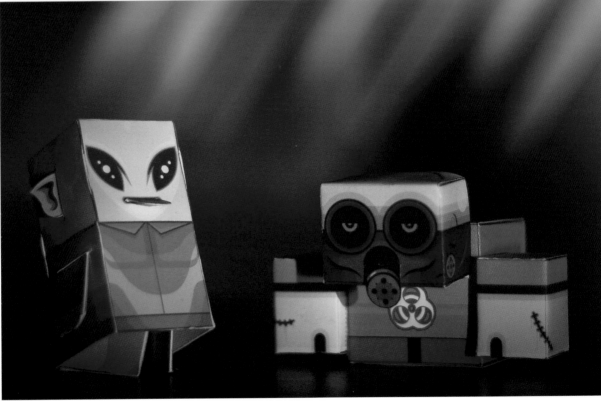

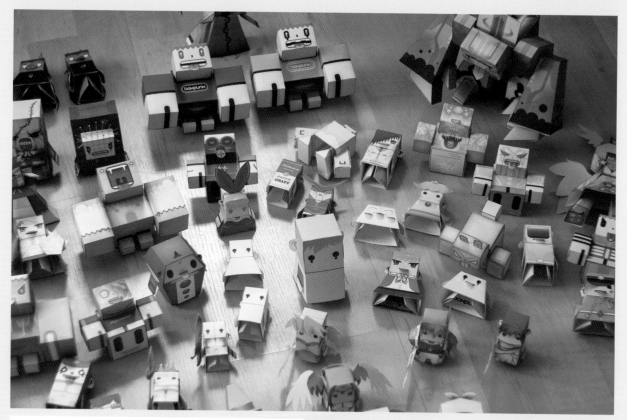

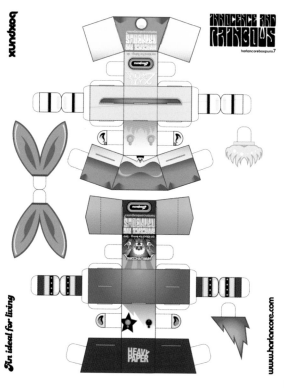

This page, top:
A HANDFUL OF BOXPUNX
Paper toys collection.
Bottom:
BRO & SIS
Paper toys template.

Opposite, top:
CHUCK THE KARATE DUDE
Paper toy.
Bottom:
ALIEN & GAS ATTACK!
Paper toys.

All artwork by Jason Harlan.
All images courtesy of Harlancore.

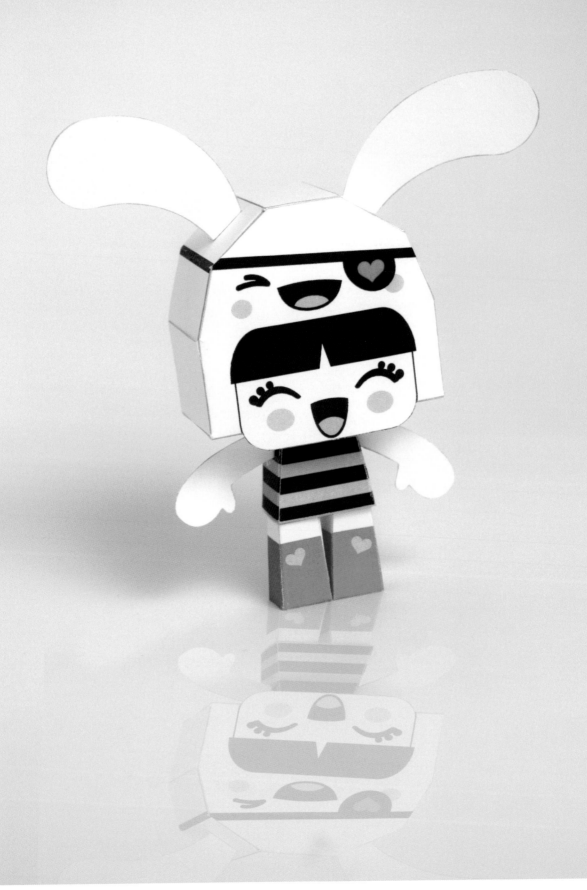

charuca

charuca.eu
charuca.net
Barcelona
SPAIN

"I love paper toys. Thanks to this technique, you can have a creation by your favorite artist for very little money, often for free. (I'm so in favor of the democratization of art.) Paper toys take away some of the solemnity and weight carried by the notion of an 'Art Toy.' They are toys, so we can play with them. It's a two-way street. It's not just the creator of the toy who plays; there is another aspect to the game where the most fun is to be had, which is enjoyed by anyone who prints and builds the paper doll. Thanks to this system, anyone can have their own toy as a physical object, immediately and without intermediaries. No monetary interests involved. Paper toys are pure art, and they are art for art's sake."

This page:
CARMI ILLUSTRATION
Illustration by Charuca.

Opposite:
CARMI PAPER TOY
Paper toy.

All artwork by Charuca.
All images courtesy of Charuca.

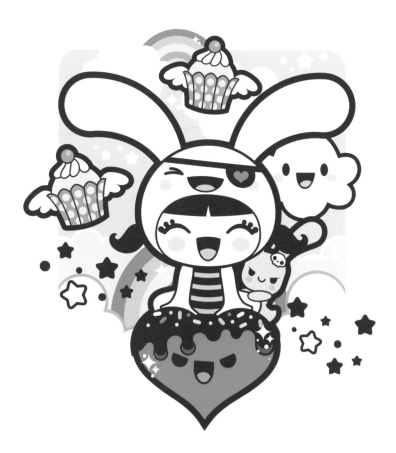

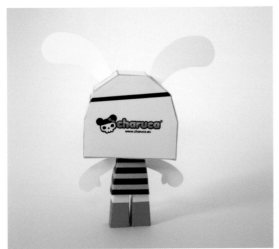

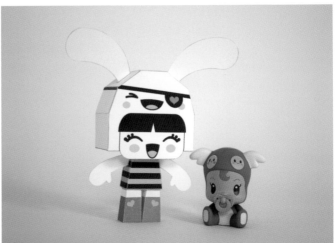

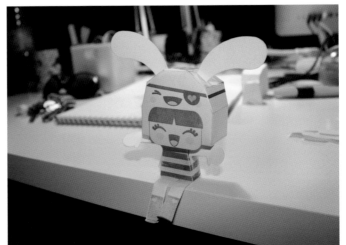

This page:
CARMI PAPER TOY
Paper toy and the making of.

Opposite:
CARMI PAPER TOY
Template.

All artwork by Charuca.
All images courtesy of Charuca.

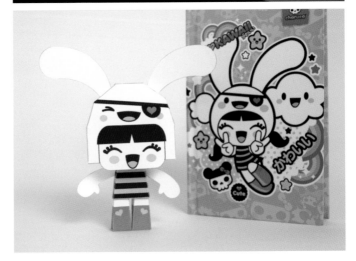

Carmi Paper Toy

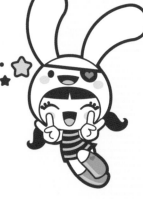

Rabbit ears

Head (front)

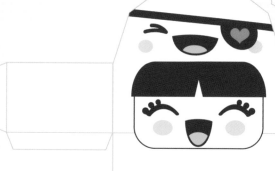

Head (back)

Arms

Legs

Body

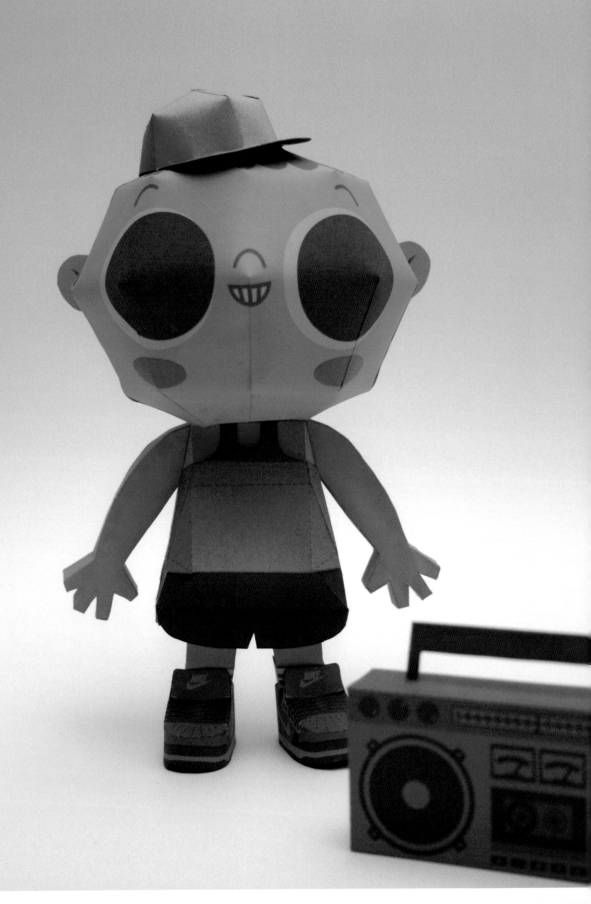

pep sanabra aka grooph

facebook.com/pepsanabra
Barcelona
SPAIN

"I love paper toys because I see them as a great way of giving expression to my designs. I love the do-it-yourself feel of this kind of figures. I can shape them as I please, and there are varied kinds of paper to build them with (different colors and golden and metallic finishes, etc.). The possibilities are endless, so if you've made up your mind about the kind of model you want to design, you can do anything. I've worked on a series of paper toys called 'da Munky Cru' and another one for which I invited other illustrators and designers to customize a model I created called 'Cap Kid.' My next projects related to the world of paper toys revolve around creating a series of figures from illustrations I made, and exploring new formats and materials to push future creations."

This page and opposite:
ANDY & KORGIE MS-10
Paper toys.

All artwork by Grooph.
All photos by Kiko Alcazar.
All images courtesy of
Pep Sanabra.

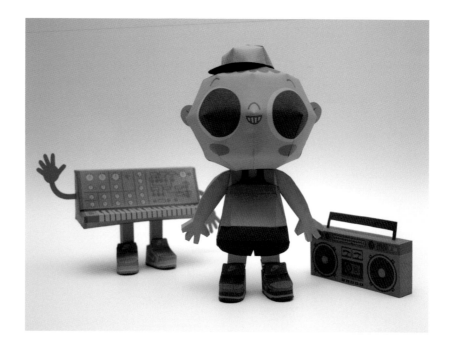

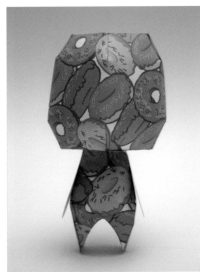
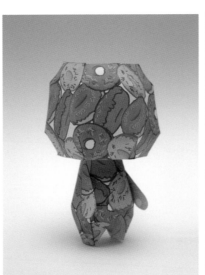
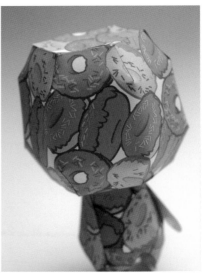
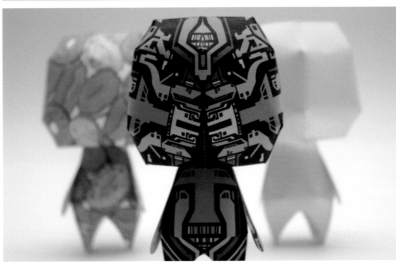
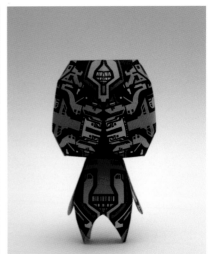
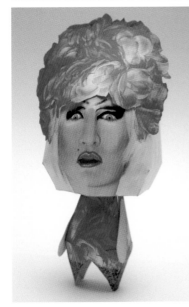
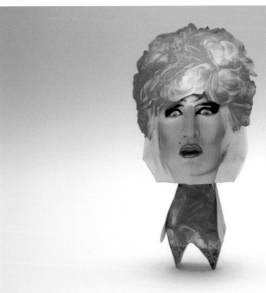

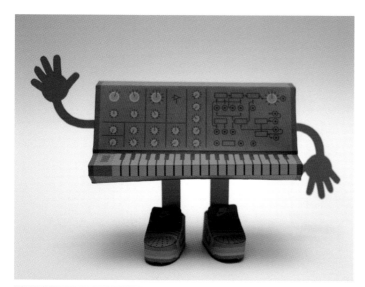

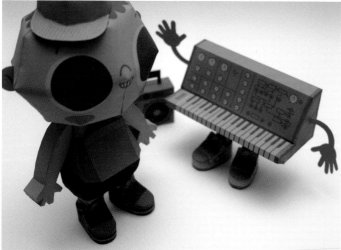

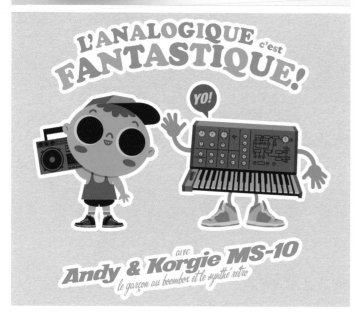

This page:
ANDY & KORGIE MS-10
Paper toys and illustration.

Opposite, top row, left to right:
GROOPHY GUY DOONUT
Middle row, left to right:
GROOPHY GUYS
GROOPHY GUY ELECTRO
Bottom row:
GROOPHY GUY YOGURINHA
Groophy Guy Yogurinha in collaboration
with Kiko Alcazar.
www.kikoalcazar.com
www.yogurinhaborova.com

All artwork by Grooph.
All photos by Kiko Alcazar.
All images courtesy of Pep Sanabra.

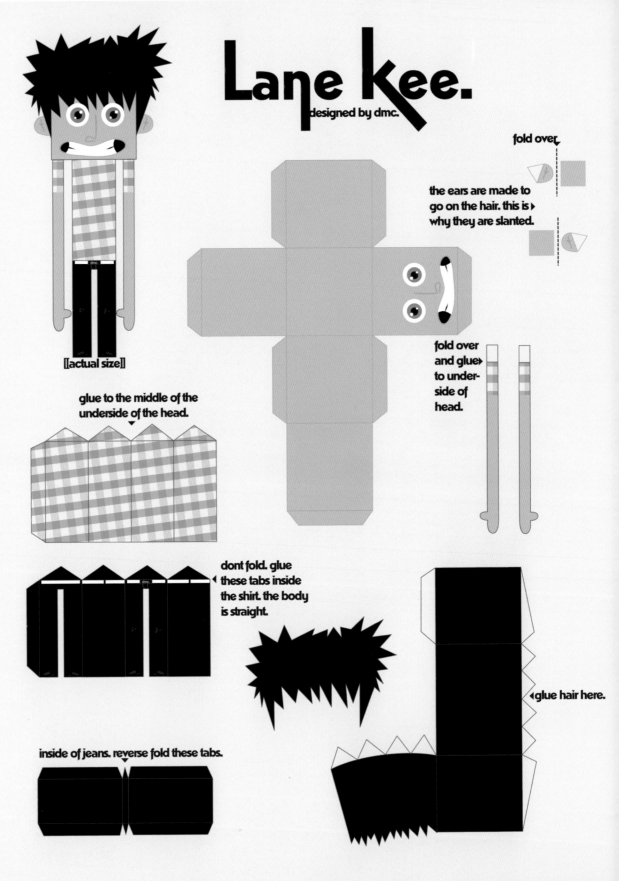

Lane Kee.

designed by dmc.

fold over

the ears are made to
go on the hair. this is ▶
why they are slanted.

[[actual size]]

glue to the middle of the
underside of the head. ▼

fold over
and glue▶
to under-
side of
head.

dont fold. glue
these tabs inside
the shirt. the body
is straight.

◀glue hair here.

inside of jeans. reverse fold these tabs.

 http://dmcsite.blogspot.com

dmc

www.dmcdmcblog.blogspot.com
www.dmchoody.blogspot.com
AUSTRALIA

"I love paper toys because they're simply awesome. Paper toys have enabled me to bring forth ideas, styles, and all sorts of things to the design scene. When I say design scene, I mean the paper toy scene. I've always been a sucker for designer toys, but they were too expensive to collect. This was so until I found Shin Tanaka; I found his models to be really unique, especially T-boy. It had that vinyl designer toy feel, and that's when I hit it off with paper toys. I'm pretty sure I built all of his available models as well as a few by Readymech. But I didn't just want to be a collector, I wanted to design. One of the two best things about paper toys is that anyone can do them. I was thirteen when I first started designing my own models. My skills were really basic—I used pen and paper as well as Microsoft Paint. These models got me nowhere. I was going in circles. But the other best thing about them, the people, really helped me a lot. No matter what I did, I was driven by other designers, who helped me with their terrific feedback. I reckon I would have given up if it wasn't for all the help I received. I would like to thank Brian for nicepapertoys.com—that site has helped me and many others, and continues to do so. Now, being fifteen, I've been able to create some nice models and develop my ideas better. I love that paper toys can be either taken seriously, like a full-time job, or just as a simple hobby."

This page:
PAPER TOYS
Just a bunch of all my toys, all thrown togteher.

Opposite:
LANE KEE
Paper toy template.

All artwork by DMC.
All images courtesy of DMC.

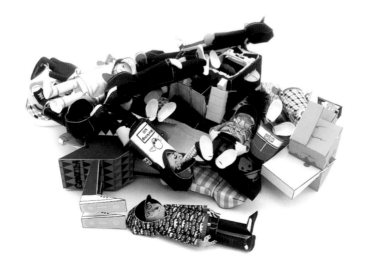

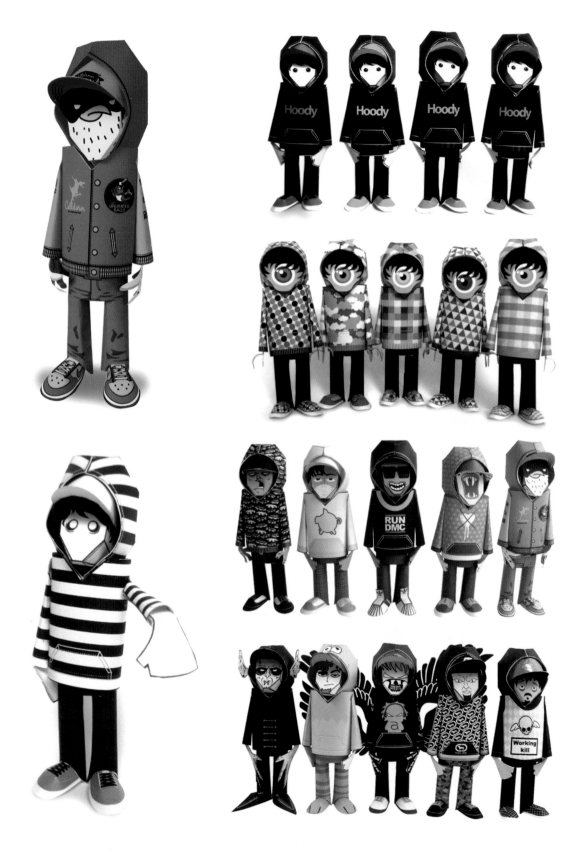

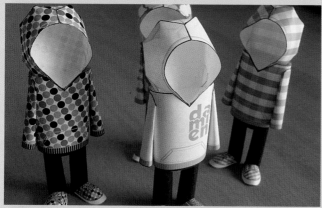

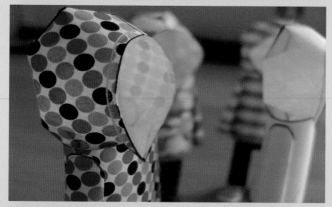

This page:
HOODY SERIES 5
Images of working on Hoody Series 5.

Opposite, top row, left to right:
HOODY
Custom by Da_ from Cell Dvsn'.
HOODY SERIES 1
Second row, left to right:
HOODY SERIES 5
Third row, left to right:
ZOMBIE HOODY
A custom by me that never got
released.
Fourth row:
HOODY SERIES 2. ARTIST SERIES
From left to right, customized
by Tougui, Carolina, Indy, Anubis,
and Da_.
Fifth row:
HOODY SERIES 3. ARTIST SERIES
From left to right, customized
by Carolina, Alguien, Freshzombie,
Ras, Tacsko, and People toys.

All images courtesy of DMC.

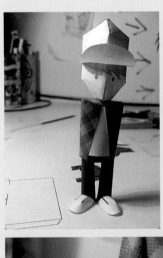

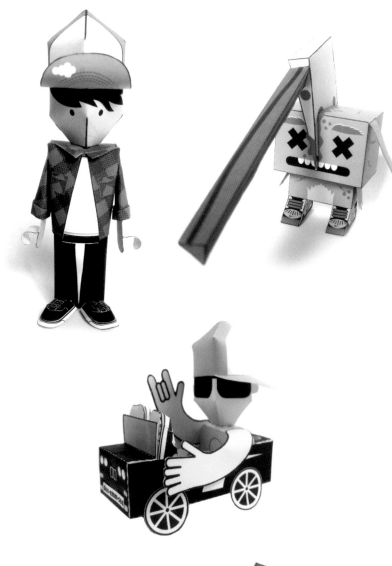

This page, top row, left to right:
KEEPS
It's final finished stage.
NO NAME
A gubie-gubie custom I completed for
Pain Killah Art. Has no name.
Middle:
OH HEY LADIES
A *Calling all cars* custom paper toy I
completed for Horrorwood,
Bottom row, left to right:
25TH HOODLUM
Paper toy designed for a Melbourne street
wear festival.
BOARDER
Paper toy.

Opposite:
KEEPS
The early stages plus a quick sketch.

All artwork by DMC.
All images courtesy of DMC.

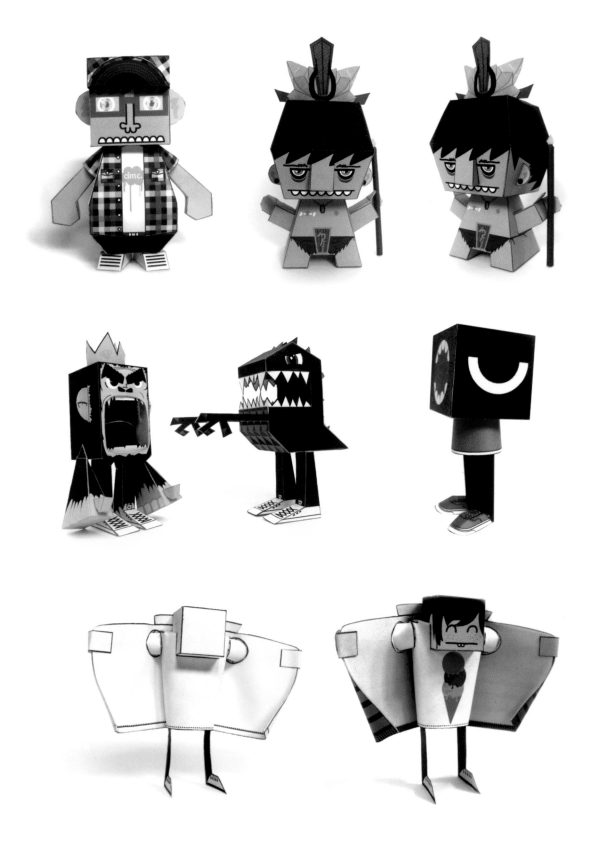

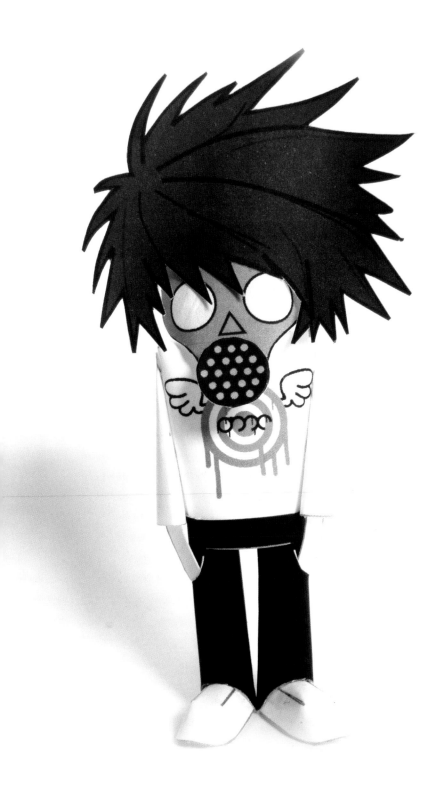

This page:
DOPE
Paper toy designed for the clothing company Dopeness Apparel.

Opposite, top row, left to right:
DMC FOR DYADIK
A custom I completed for Dyadik's Dumpy paper toy.
STAN
Customized paper toy for Attaboy.
Middle row, left to right:
KING KONG, AND GODZILLA
Two models I designed for the magazine *Be Street*.
DMC MASCOT
Designed for the header of my blog.
Bottom row:
CHUKKA
A model I designed for *I Love Papertoy* magazine.

All artwork by DMC.
All images courtesy of DMC.

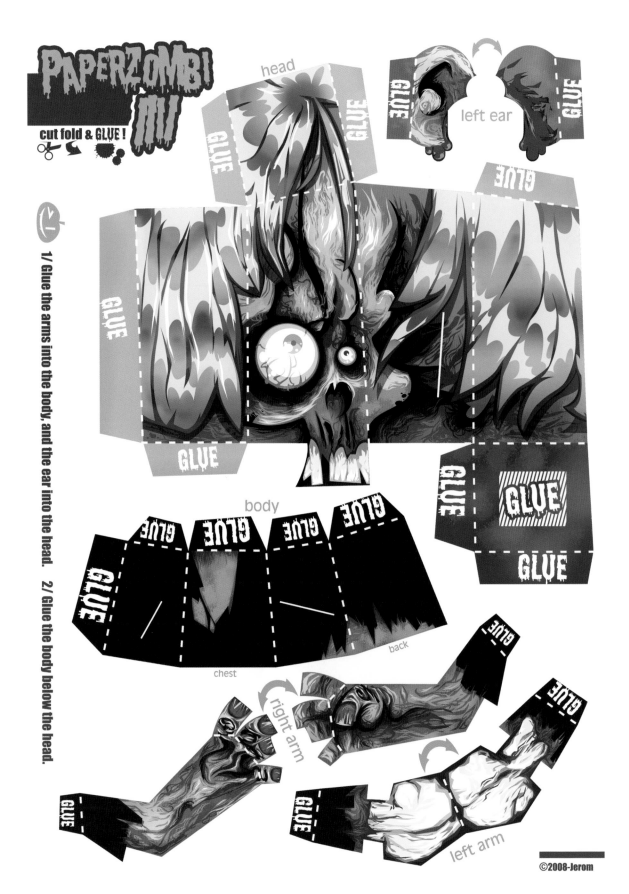

jerom

www.jerom-bd.blogspot.com
Dijon
FRANCE

"I love modeling my own three-dimensional characters with my own hands. I love every step of the creation of a paper toy: doodling, scribbling on my little sketchbook, using the pen tool in Photoshop and Illustrator for hours, and assembling the final paper toy. It's like a do-it-yourself vinyl toy, only with paper and ink. You can also easily customize a paper toy to your liking and share it with other people. I think this 'free sharing' aspect of the paper toy scene is very important."

This page and opposite:
PAPERZOMBI 4
Paper toys and template.

All artwork by Jerom.
All images courtesy of
Jérôme Thieulin.

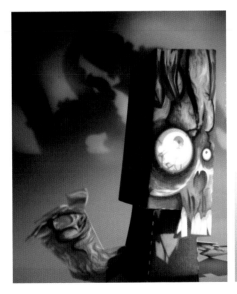

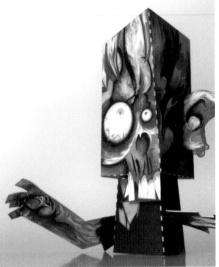

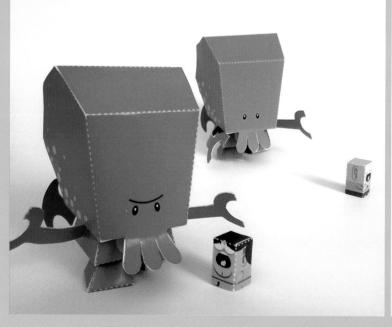
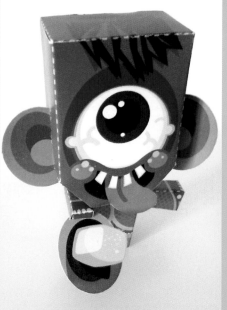

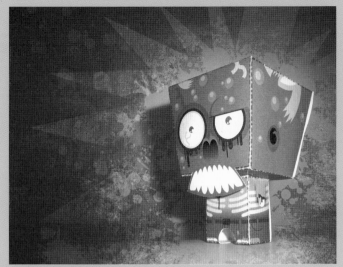

This page:
PAPERZOMBI 3
Paper toy, template, and sketchbook.

Opposite, top row, left to right:
SHUSHIS
NAMAHAG
Middle row, left to right:
KITSUNE
ONI
Bottom row:
MY LITTLE CTHULHU
PAPER TOY
Paper toys.

All artwork by Jerom.
All images courtesy of Jérôme Thieulin.

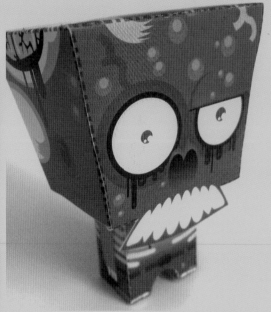

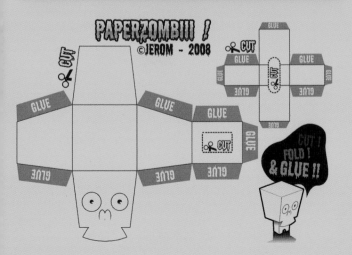

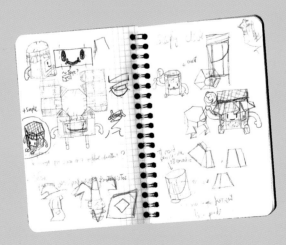

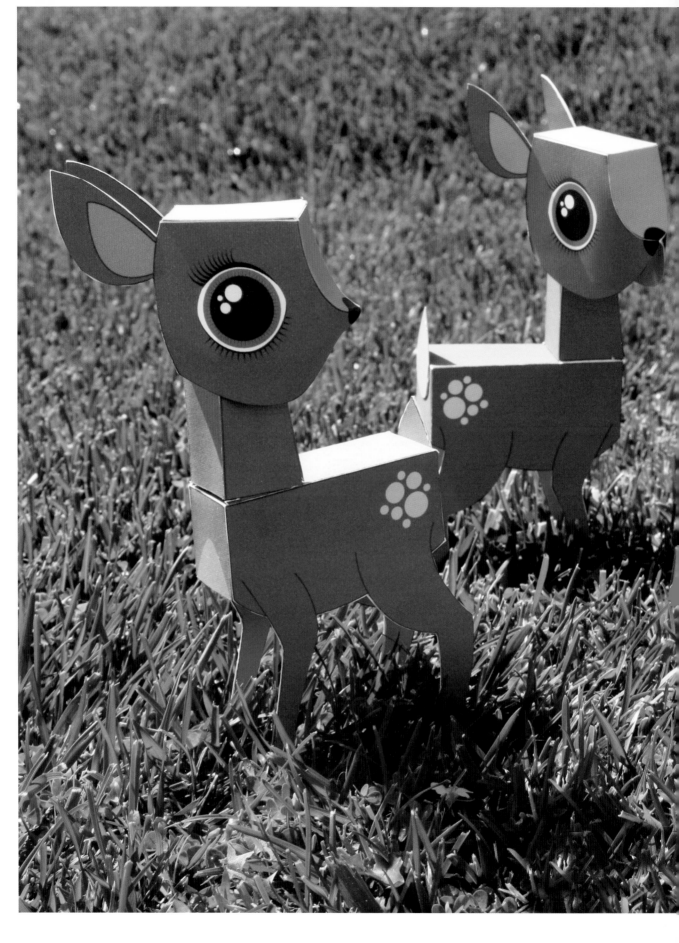

macula

www.macula.tv/papercraft
www.flickr.com/photos/macula1
CALIFORNIA
USA

"I love paper toys because they are fun to build and can be share with people all around the world. With only a few craft supplies and a little time, you can have your very own custom toy. It is one of the most inexpensive ways an artist can design their own toy. Paper toys are also like model kits; you have to invest some time into building each one, making it more of a prized possession. It is very nice to see people taking their time to build one of your creations and being so proud they made it themselves."

This page:
LEPRECHAUN
Paper toy.

Opposite:
DEER
Paper toy.

All artwork by Christopher Bonnette.
All images courtesy of Christopher Bonnette.
Photographs by Joseph Bartlett.

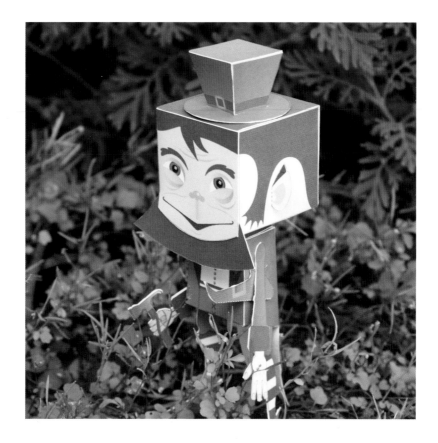

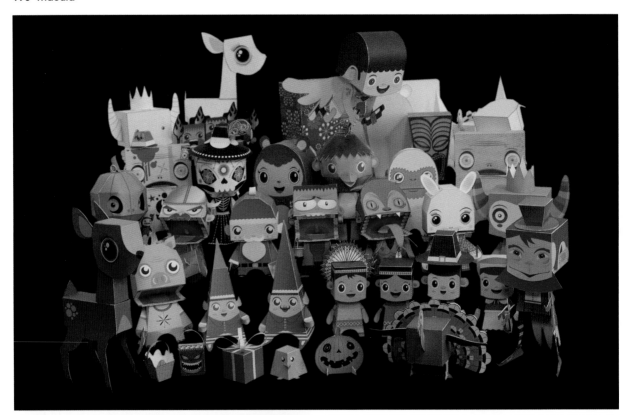

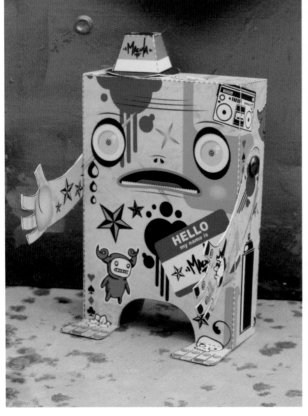

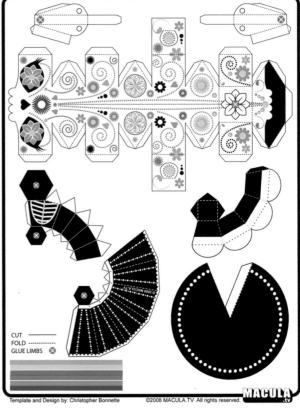

CUT ——————
FOLD ------------
GLUE LIMBS ⊗

Template and Design by: Christopher Bonnette ©2008 MACULA.TV All rights reserved.

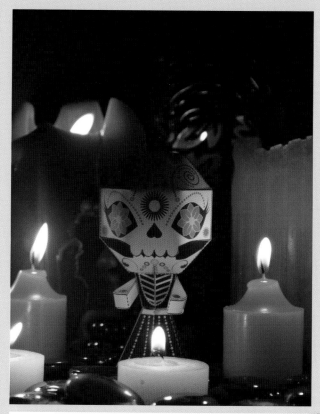

This page, top:
LA CATRINA
Paper toy.
Bottom:
CHIBI YETI
Template and paper toys.

Opposite, top:
ALL PAPER TOYS
Bottom, left to right:
NURIKABE
Paper toy.
LA CATRINA
Template.

All artwork by Christopher Bonnette.
All images courtesy of Christopher Bonnette.
Photographs by Joseph Bartlett.

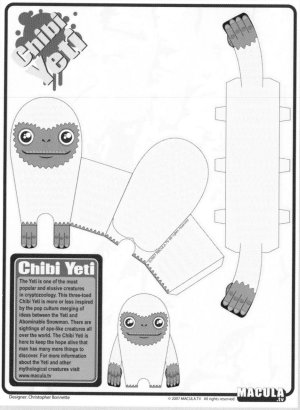

Chibi Yeti

The Yeti is one of the most popular and elusive creatures in cryptozoology. This three-toed Chibi Yeti is more or less inspired by the pop culture merging of ideas between the Yeti and Abominable Snowman. There are sightings of ape-like creatures all over the world. The Chibi Yeti is here to keep the hope alive that man has many more things to discover. For more information about the Yeti and other mythological creatures visit www.macula.tv

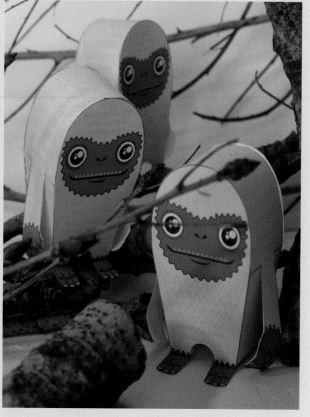

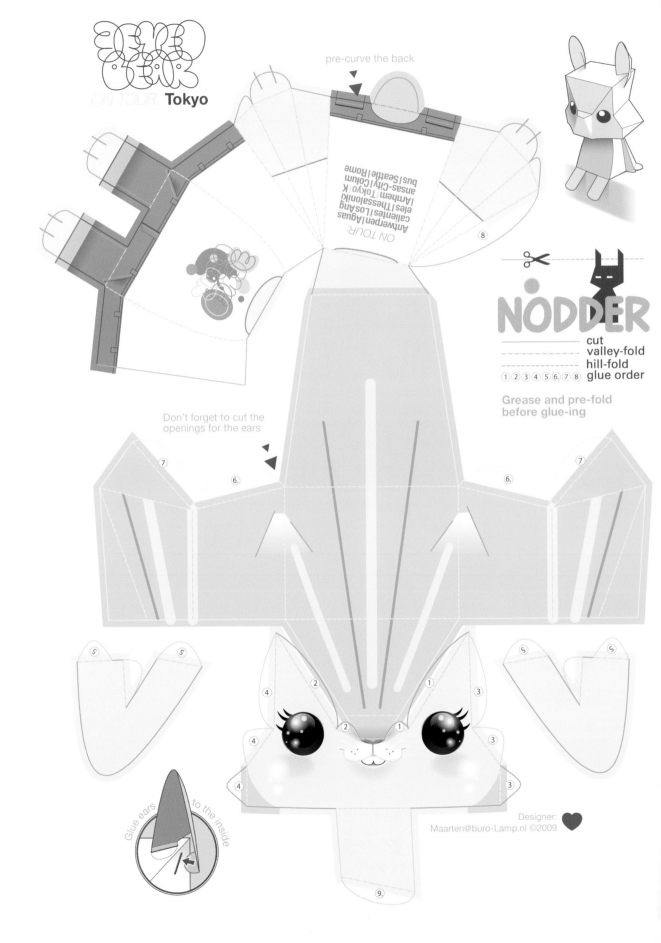

3eyedbear

www.3eyedbear.com
Amsterdam
THE NETHERLANDS

This page, top to bottom:
CARTRIDGE-ATTACK
Customized toy for
Hewlett-Packard.
PAPER TOYS
Line-up of models on a
cardboard shelf, developed
for an expo in The Netherlands.

Opposite:
KAWAII FOR TRUCKERS
Bunny, a nodder-toy flatpack.

All artwork by 3eyedbear.
All images courtesy 3eyedbear.

"To me, creating paper toys is the perfect kind of escapism. It's obscure enough for us not to be bothered by mainstream media, and critics still haven't decided in what shelf to put us; they are still figuring out whether it is craft or art, if it is for youngsters or adults, or whether it's meant to be serious or just for fun. In the meantime, I can play freely, investigate shapes and connect them with imagery, and constantly be surprised by the solutions and combinations we come up with. I feel like a sculptor, a digital 3-D artist, a graphic artist, a designer, and a creator of characters, all at the same time. Oh, and also like Santa Claus, as I just give all of my creations away for free (that is something critics find hard to understand), and in the process I make lots of friends. I'm the king of my own little paper world. Their accessibility also makes them addictive. Paper has a long history; it is elegant, enormously versatile and yet fragile. Even children understand this material and the potential of its low price and the fact that it's readily available in a vast variety of thicknesses, structures, sizes, colors, and even scents. Paper toys fit very well in today's connected world, so you can easily reach out to millions of kids and show them what can be done with it. You get immediate feedback from faraway and exotic places, as people add to your initial idea by building your models and then customizing them with new 'skins' or modified shapes. They send you photographs of one of your characters taken atop the mighty Machu Picchu or in front of the majestic Taj Mahal; that really makes your day! Thanks to this recent explosion of enthusiasm, paper toys are expanding very quickly without any remarkable practical or cultural boundaries, growing rapidly and changing trends almost on a weekly basis, and the child in me finds that really exciting."

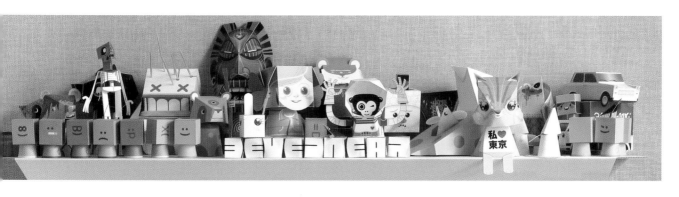

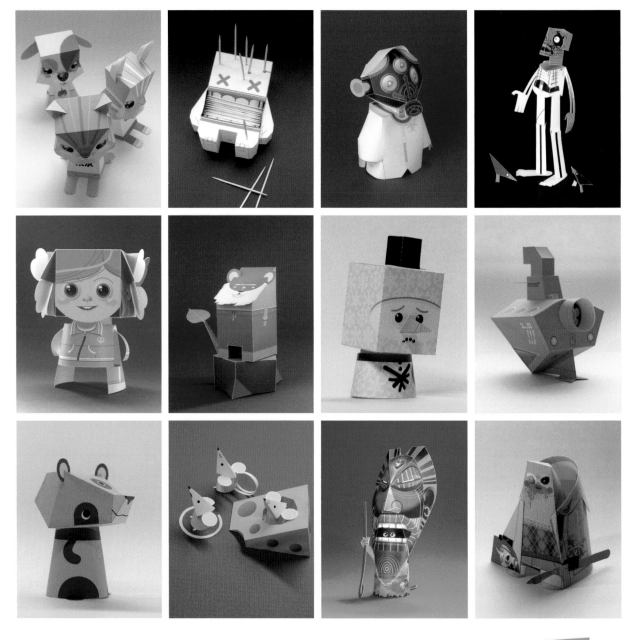

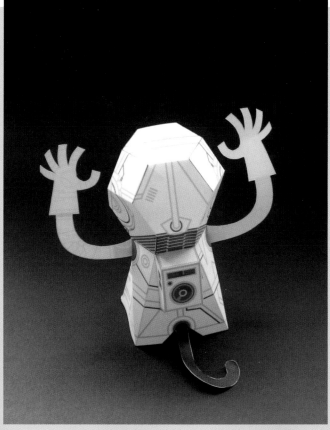

This page:
SPACEBEAR
Paper toy and template, *We Are Paper Toys!* exclusive.

Opposite, first row, left to right:
KAWAII FOR TRUCKERS
Nodder-toys, created for a Tokyo-expo.
VOODOO
Custom for Stubey by SaltNPaper.
QUARANTINE
Interchangeable and moving parts, for *Egg Up* magazine.
ARMY OF DEATH
Soldier, for *Bloeddorst* magazine.

Second row, left to right:
GIRLS
Sofia, platform-toy.
OLD WISE BEAR
SNOWBOY
Holiday-greeting for Buro-Lamp.
SUBMARINE
Third row, left to right:
3EYEDBEAR
First paperkit.
GOLDDIGGERS
BUSHDOCTOR
KILLER
For *Bloeddorst* magazine.
Fourth row, left to right:
EMOTIKITS
KITCITY: TRUCK

All artwork by 3eyedbear. All images courtesy of 3eyedbear.

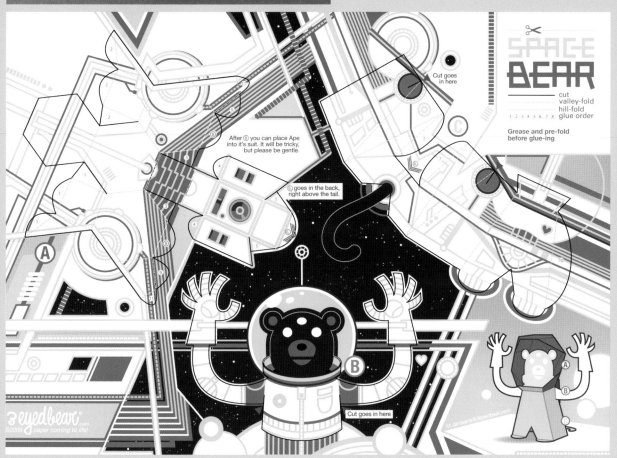

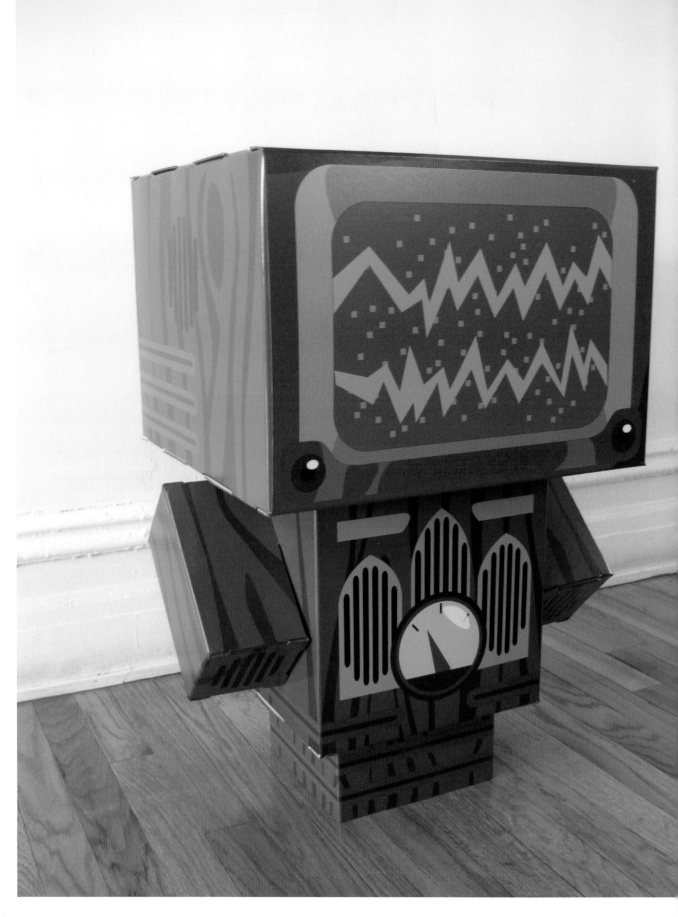

cubeecraft

www.cubeecraft.com
NEW YORK CITY

"As a creator, I love to see an idea become something real. There is a thrill in coming up with a design and seeing it through until you have a finished, tangible object. Paper provides a relatively cheap material to work with and the designs are very easy to distribute. As a fan, I love seeing all the great ideas that appear in the community and of course I love putting them together."

This page and opposite:
CUBEECRAFT PAPERTOYS
Paper toys.

All images courtesy of
Cubeecraft.

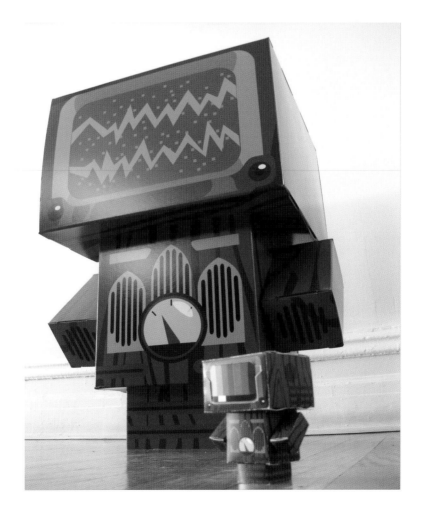

This page and opposite:
CUBEECRAFT PAPERTOYS
Paper toys collection.

All artwork by Cubeecraft.
All images courtesy of Cubeecraft.

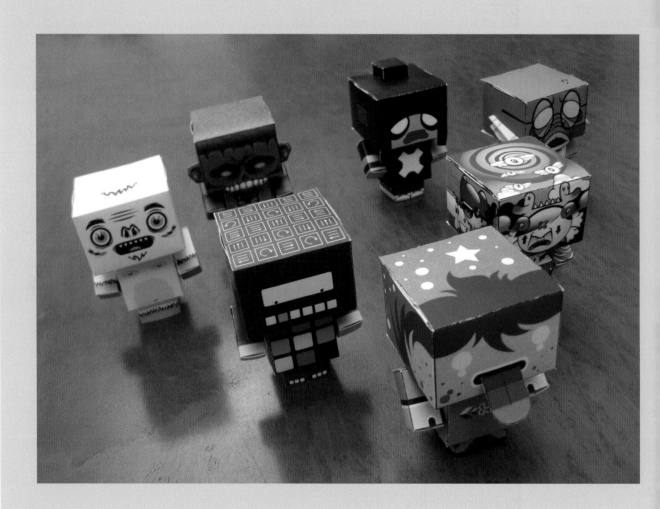

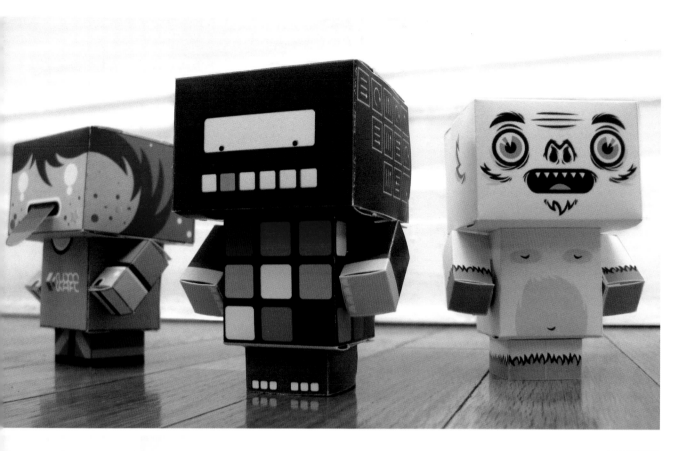

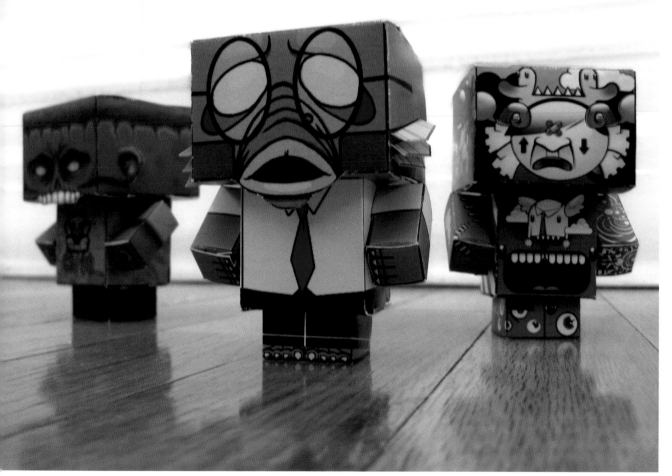

YES, WE ARE!

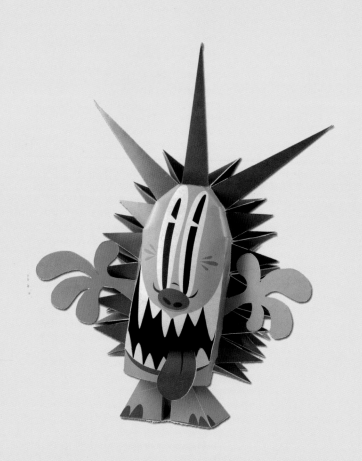